THE COMPLETE GUIDE TO Perspective

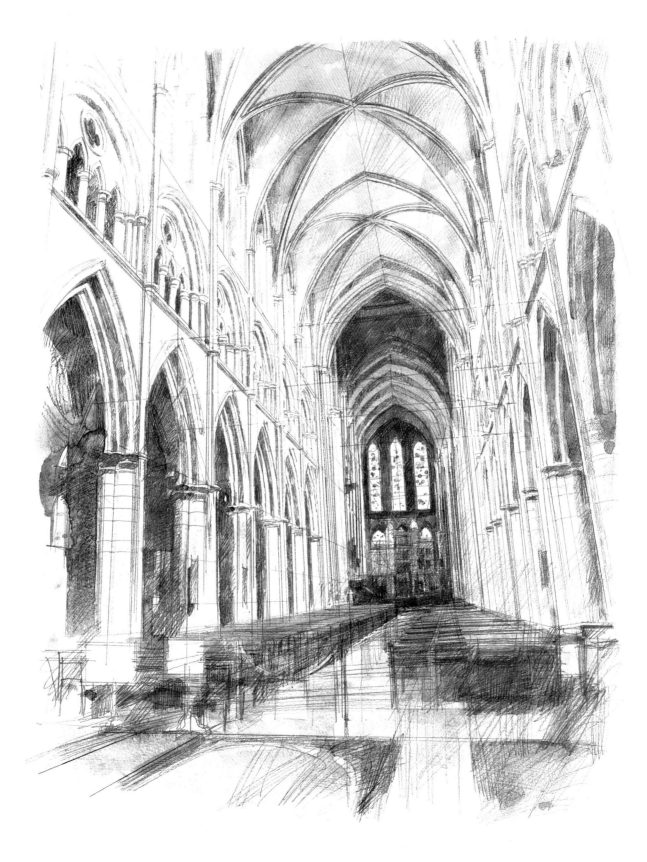

THE COMPLETE GUIDE TO
Perspective

John Raynes

COLLINS & BROWN

First published in Great Britain in 2005
by Collins & Brown

An imprint of **Chrysalis** Books Group plc
The Chrysalis Building
Bramley Road
London W10 6SP

www.chrysalisbooks.co.uk

9 8 7 6 5 4 3 2 1

British Library Cataloguing-in-Publication Data:
A catalogue record for this book is available from the British Library.

ISBN: 1 84340 087 1

Designer: Gemma Wilson
Copy Editor: Roger Bristow

Reproduction by Classicscan Pte Ltd, Singapore
Printed and bound by Times Publishing Group, Malaysia

Contents

Introduction 6

CHAPTER 1: FIRST PRINCIPLES

Frame cube and distortions 10
Terminology 12
Vanishing to 1, 2, and 3 points 16

CHAPTER 2: ONE-POINT

Photo examples 19
Setting up 20
Creating a space 22
Placing objects in space 24
Kitchen interior 26
Trees and columns 30
Canal scene 34
Using measuring points 38

CHAPTER 3: TWO-POINT

Photo examples 44
Setting up 45
Cottage 48
Grand building 52
Multi-sided 56
Using measuring points 60

CHAPTER 4: THREE-POINT

Photo examples 64
Setting up 65
Tall building – low eye level 68
Skyscraper – high eye level 72
Cathedral interior 76
Using measuring points 80

CHAPTER 5: CIRCLES AND ELLIPSES

Construction and theory 83
Bowls and mugs 88
Arched bridge 92

CHAPTER 6: INCLINED PLANES

Uphill street 96
Downhill street 100
Staircase 104

CHAPTER 7: REFLECTIONS

On mirror 108
By lake and river 112
Upright mirrors 116

CHAPTER 8: SHADOWS

Against the sun 118
Sun behind the observer 122
Artificial light 126

CHAPTER 9: IRREGULAR FORMS

Boats 128
Wheeled vehicle 132
The horse 136
Human form 1 140
Human form 2 144
Atmospheric perspective 148

CHAPTER 10: ANOMALIES

Strange shadow 152
A confusing roof line 153
Imperfect infinite regression 154
Acute-angled corner 155

Index 156
Acknowledgments 159
About the author 160

Introduction

Before embarking on formal perspective theory it must be understood that the whole system of perspective is not an exact science; it is merely a way to make judgements about the appearance of the world and objects in it so that depth can be graphically described in a convincingly acceptable way.

A fundamental limitation of perspective theory, which should be properly understood, is that it only works *from one particular viewpoint and within the zone of clear vision available to the human eye*. This zone is described as the 60° cone of vision and within this limited view, perspective rules work quite well, but they fall apart outside it.

1. Brick wall, straight ahead

This is a flat-on view of a wall, which is assumed to extend indefinitely to left and right. The top and base are represented as being absolutely horizontal and straight. Such a view is accepted as true as long as the viewer is fairly close to the wall and looking straight ahead.

2. Straight lines vanishing to left and right

Now assume our human viewer turns his or her head to the right or left to view the rest of the infinitely long wall. In this case, the top and base of the wall (and, indeed, all horizontal brick courses that it contains) will be seen to converge towards the distant horizon in each direction and, again, it is assumed that the converging lines are also straight.

But what are we to make of the slight but abrupt corner turned where the horizontal lines in the straight-ahead view change to the converging ones?

3. The reality – subtle curves

The only way to reconcile the wall diverging from a point on the left horizon, running across our view and vanishing to a point on the right horizon is for the lines of divergence and convergence to be curved, only subtly curved it's true, but most assuredly not straight.

Because we are only able to pick one section of our infinitely long wall to look at without turning our heads, the curve is so subtle that it is for all intents and purposes straight enough and is assumed to be so for all the perspective rules that follow.

4. Fish-eye lens distortion
Not really a distortion, just a view of what we cannot see in normal unassisted vision, looking well outside the 60° cone thereby combining views in all directions at once. The result? Curves everywhere, up down and across, straight lines only in the very middle of the view.

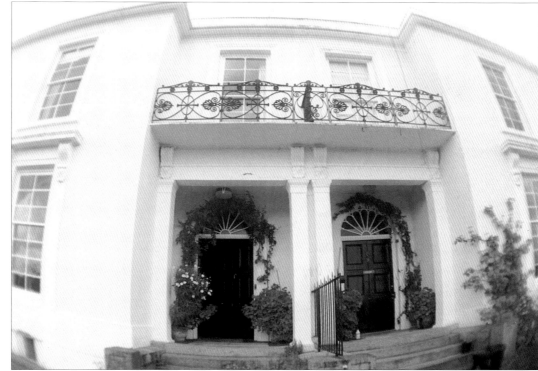

Here is another example of a perspective rationalization of observed reality.

A central tenet of perspective theory is that of the vanishing point. Considerable space in this book will be given to the way that vanishing points on the horizon help us to understand and predict how forms appear smaller as they recede into the distance.

Imagine looking out to sea and seeing a series of poles fixed to the seabed, each one extending above sea level to a height of 30 yards or meters and arranged in a line extending indefinitely to the horizon and beyond.

Each pole is colored in stripes; the first 10 yard (meter) segment above sea level being red, the next third yellow, and the top third blue.

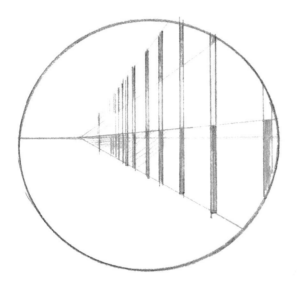

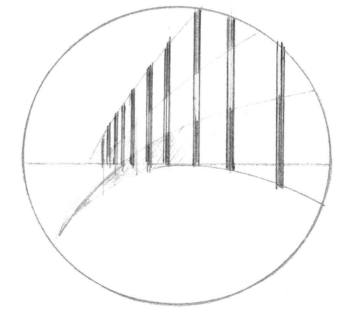

5. Theoretical vanishing point

This diagram shows what is predicted by the accepted theory of vanishing points. You will see that the poles have diminished in a regular fashion until the last one is just a point on the horizon. If we look at an enlargement of the last few poles as they approach the horizon, we see that right up to the moment when they converge to a single point, all the colored segments are fully visible.

6. The reality

This is what really happens. For most of the poles, the theory provides a reasonably accurate prediction, but as they reach the horizon something different occurs.

The pole right on the horizon is not a point: it projects above it and, importantly, the next few poles can be seen over the horizon. Each successive pole on the far side of the horizon will be less visible; the lowest segments disappearing first until only the blue segment is visible and then that, too, disappears.

7. A tall ship sails into view

This phenomenon was well known to sailors in the age of tall sailing ships when the first visible sign of an approaching vessel on the horizon was the topmost sail on the tallest mast. As it grew nearer, the lower sails emerged into view until finally the hull rose over the horizon.

You see it's curves again. The sea is not flat, it is part of the earth's curved surface, otherwise there would be no horizon. The horizon is where the earth's surface curves away from your sight, whether it is on water or land.

Perspective vanishing lines (known as "orthogonals," of which more later), follow the curve of the earth, too, but because our normal view is of a comparatively small portion of the earth's surface, they are near enough to being straight to be treated as such. Also, because we do not often have to deal with rows of structures that appear high enough at the horizon to be seen to drop over it, the concept of the vanishing point works quite well enough in most circumstances.

To summarize, perspective only works within a severely constrained angle of view where apparent convergences due to distance can be assumed to be straight, even though they are not strictly so.

Perspective theory has become a complex study and it can be a very demanding subject to master in all its many aspects.

Until recently, architects and technical illustrators were required to be familiar with the complicated constructions of measured perspective which allow precise location of points in space by reference to plans, elevations and sections of a building or other solid object. Nowadays this can be done by feeding data into a computer, which can then instantly generate multiple perspective views. This has removed the need for making long and laborious projections by hand.

Such computer-generated constructions will not be attempted in this book.

I will concentrate instead on methods that tend to involve short cuts based on initially assessed shapes. These methods are perfectly adequate for describing the general principles of perspective theory sufficiently to provide an understanding of the sometimes-confusing shapes and structures which are seen in real life. Everyone possesses, almost subconsciously, a compelling natural sense of distance and depth; these perspective principles will help the observer to recognize what is contributing to this sense and to recreate it in a picture.

Photographs of varied subjects will be analyzed according to these rules and perspective structures drawn as they apply. This is primarily to help you to understand in perspective terms what you see in photographs or reality; it does not mean that you need to make these constructions when you are drawing and painting from life. Step-by-step stages will show how to use this knowledge to assist your observation when drawing and painting in various media. I suggest that it will be easier to comprehend the theories which are presented in diagrammatic form if you have a pencil, ruler, and triangle (set square) to hand so that you can actually construct the steps yourself.

For those who may like to have a go at more demanding measured perspective, a system which allows construction of three-dimensional views from plans, elevations, and sections, I propose to give some instruction in this at the end of each of the chapters on one-, two-, and three-point perspective. These pages will be marked with a red band in the margin to indicate that they contain a degree of difficulty and can be ignored if preferred.

First principles
Frame cube and distortions

To demonstrate that perspective is real, not a drawn invention, and also to show that it is changeable, the following images show what happens when an open metal cube is photographed from a variety of viewpoints.

As you will see, how objects appear to your eye depends to a large extent on your distance from them. The first effect is that objects appear to reduce in size as their distance increases. Then you notice that the furthest parts of an object are smaller than the nearer parts, i.e. they appear to recede into the distance.

In early life we humans (in common with many animals), soon learn to accept these disparities in the space which we inhabit. Indeed these and other clues help us to make judgments about distance and height which are essential for negotiating the world safely.

The most obvious effect of this recession can be seen when looking at the sides (including the normally hidden sides) of a regular straight-sided object such as this open cube.

Less obviously, the degree of recession varies with distance. The sharpest reductions in apparent size, (I hesitate to call them distortions as they are such a natural part of everybody's vision), occur when the observed object is very close. As the distance to the object increases, perspective becomes less severe, the apparent convergence less dramatic. You will see in later explanations of this apparent anomaly that it is entirely what would be expected, but for the moment, just observe it.

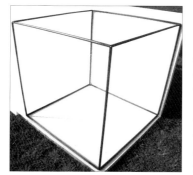

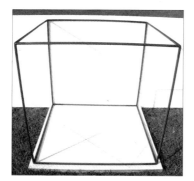

1a. (left) & 1b. (below) Close viewpoints
Here are two photographs of an open structure representing a cube in which all six faces are 20in (50cm) square. Both were taken from a close viewpoint, one from a three-quarter view and the other from straight ahead. As you can see, the rods forming the edges of the cube seem to converge quite sharply in different directions. Because it is apparent that they are near to the viewer, we accept this seeming distortion as normal and read the figures as regular cubes.

2. Distant view
Here the same open cube is seen from a more distant viewpoint. The view is straight on, just as in 1b. but it now has a completely different appearance. The uprights appear to be vertical and the vanishing edges of the top and base are much shorter (foreshortened in fact, of which more later on) and yet it still seems to be a cube.

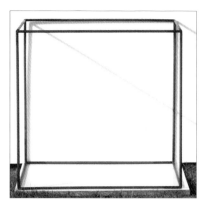

3. Close-up of distant view
This photograph shows what happens when the distant view of the cube is brought forward so that it appears to be close to the viewer. It seems to be squashed from front to back. We know subliminally that a cube this close to our eyes should have more extreme recession, therefore we judge it not to be a cube but a sort of flattened box on edge.

To understand why close-up views of distant objects have a strange appearance to our eyes it is necessary to explain how photography can change our view of objects.

Cameras with lenses of variable focal length, called zoom lenses, are now very common. Without going into the theory of optics too deeply, the focal length of a lens defines how much of a subject is included in its view. Wide-angle lenses have shorter focal lengths and include a wider view – telephoto lenses have longer focal lengths and a narrower view which magnifies the apparent size of the subject.

The human eye comes with a fixed focal length lens. It is less wide than the wide angles of many zoom lenses and much wider than nearly all the telephotos. This gives an angle of view described as the 60° degree cone which means that all objects within this cone can be seen clearly without turning eyes or head. (There is some peripheral vision outside the cone, but objects here are only vaguely seen).

Objects observed from a given distance have a degree of recession which is always the same. Close objects show relatively severe recession, far objects much less. So when we see an image of an object that is apparently close to our eyes, but has little recession, it confuses our brain and looks strange. Therefore, to make perspective views that look convincing we need to make sure that they lie within the normal human view, the 60° cone of vision.

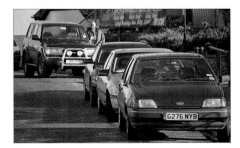

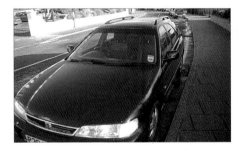

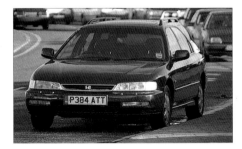

1. Long telephoto view
When the cluster of parked cars in the background of the wide-angle view is brought to the foreground by the use of a telephoto lens, they appear to be crushed together. The large vehicle at the rear looks almost to be in reverse perspective, the window lines and the bottom edge of the body seeming to diverge rather than to converge. The point to remember is that the telephoto lens is not distorting the perspective; if the resolution of the photograph permitted it, an enlargement of the same area in the wide-angle photo would give just the same effect.

2. Wide-angle view of parked cars
The lens that took this photograph gives a slightly wider view than the human eye. Note the apparent elongation of the front part of the nearest car. I can attest to the fact, however, that the distance between grill and windshield is not unusually long.

3. Medium telephoto view
The same car again, this time viewed through a medium telephoto lens. This appears to squash it when compared with the wide-angle view. The reality, that is the more "normal" view from the focal length of the human eye, is somewhere between these two.

Terminology

Before going further into the theory of perspective, we need to define some of the essential terms, most of which will be later referred to by their initial letters.

In order to understand fully the systems of perspective that underlie and explain the world you see, and which will enable you to construct solid objects in depth, there are a few concepts that must first be given names. Throughout this book we will be using terms which are fundamental to the understanding of perspective theory and putting those principles into practice. It really is worthwhile taking time to become familiar with these terms and understand them fully.

Eye level line or horizon line (HL)

When beginning a perspective drawing, one of the first things to be established is the height of the eye level.

This is a horizontal line drawn on your page that represents your eye level or the height at which your eye is above the ground. It is synonymous with the horizon line (HL) as explained later and it is fundamental to any perspective construction, simple or complex. Eye levels of differing heights can produce very different outcomes. If you are near the sea, and the visibility is good, the horizon can be seen clearly and you will notice that it appears to be on the same level as your eye however high up or low down you are.

Therefore if your eye level is low, for example if you are lying down, the horizon appears lower, so the distance between the horizon and the shore line will appear narrower than if you are standing on a cliff top when the horizon appears higher up and the distance between the horizon and the shoreline appears to be greater.

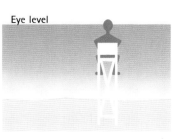

Lifeguard's view from the chair
The higher up you are the more you see of horizontal planes, in this case the sea. If you want to see more of the tops or horizontal planes of objects in your picture, then you need to assume a high eye level. This is useful if the horizontal planes contain the most information such as in a maze garden.

Standing on the beach
This shows the eye level of a person of average height standing at sea level. This would be a good eye level to use if you were drawing a group of people and you wanted to give the feeling that you were standing amongst them.

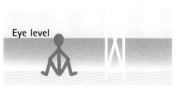

Sitting on the beach
If the eye level is low you see less of horizontal planes but more of the vertical planes. Choosing a low eye level would be useful if there was detail on the vertical sides of your subject, which you particularly wanted to show, or if you wanted a view from underneath.

1. Finding a hidden eye level
If you are sketching outdoors and for some reason the true horizon is hidden from your view, there are at least two ways of easily establishing the eye level. The first one requires you to take a thin rigid object such as a piece of card or a thin book, hold it horizontally and raise it up in front of your eyes until you can no longer see any of the top face. All you should be able to see of the book is its edge as a line. While holding the book steady, look beyond it and observe where it cuts through the scene you are intending to draw; that is where the eye level will be. This technique needs practice so, to begin with, you may wish to try it out on a building or shed. Observe where the eye level line comes on a wall and go and mark the level on the wall with a piece of tape or chalk to refer to when you are back at your sketching place.

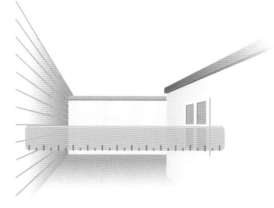

2. Another way to find the eye level

This second method also relies on your innate sense of the horizontal, but instead of holding up an object, you simply look at the vanishing lines of horizontal elements on a building and find one that you judge not to be sloping either upwards or downwards but is absolutely flat and horizontal; that, again, is the eye level. Here one of the horizontal planks on the building on the left and a glazing bar on the window of the right hand building reveal the horizon which is obscured by the blank wall in the middle.

As you may now have gathered, the eye level line and the horizon line are just different terms for the same thing but when drawing in perspective the HL is a term more commonly used than eye level.

Picture plane (PP)

The picture plane is an imaginary vertical plane placed between the spectator and the object. Think of the paper upon which the drawing is to be made as being that vertical plane between your eye and the object or scene before you. It can be thought of as a sheet of glass or window through which you can see the picture that you wish to draw. Let us imagine that the view is of a solitary tree standing, rather improbably, on a huge, flat lawn.

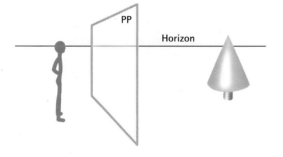

Standing figure looking at a tree
This is a visual representation of you the viewer, the glass and the tree. Note the position of our figure's head right on the horizon and the way that the tree projects a little above this.

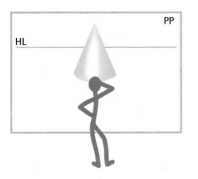

The view that you see
This is what it would look like if there really was a sheet of glass between you and the tree.

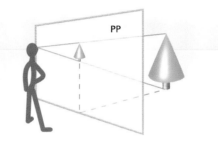

Drawing the view on the picture plane
The rays of light that bring the picture to you are assumed to be reflected from the object through the glass to your eye and thus can be plotted on the glass as they pass through. It is as if you can reach out and trace on the glass what you see, creating a scaled-down image. Achieving a final drawing of the desired size and scale is often difficult. The position of the PP in relation to both the spectator and the object plays a vital part in the final size of the drawing.

A good exercise is to tape a piece of transparent film to a window and, using an appropriate pen, trace an object that you can see beyond the window and observe how much your tracing of the object has reduced in size from the size of the actual object. It is quite important to look through one eye only for this.

You may find it helpful to use a viewfinder to serve the purpose of the PP. A viewfinder can be made from a piece of card with the center cut out and cotton attached at regular intervals to form squares. The same number of larger squares is then drawn on the paper and what is seen in each square through the viewfinder is drawn in the corresponding square on the paper. Again, this works better with one eye closed.

Ground plane (GP)

If you imagine that the ground you are standing on is completely flat (as far as this is possible given the curvature of the earth), and extends as far as the eye can see or to the horizon, then this entire flat plane is known as the ground plane (GP). Of course this is a concept only; real landscape is rarely entirely flat.

In measured perspective, the distance that your eye is above the ground plane is of utmost importance and can affect the final drawing dramatically.

The GP on land
The whole area below the horizon, here colored green is the ground plane.

The GP on the sea
The sea is even better as a representation of the ground plane because in reality it is generally flat, waves notwithstanding.

Ground line (GL)

This is a horizontal line that represents the bottom edge of the PP, where the vertical glass meets the horizontal ground plane. When preparing your page for perspective construction you will have to draw the GL some distance below the HL. The distance between them represents the height of your eye above the ground; we will tell you later how to determine this.

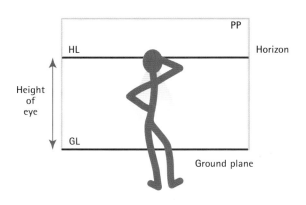

Center of vision (CV)

Now that you have the HL and GL, the next thing you will need to establish is the center of vision.

This is a point on the HL directly in front of the eye and is the vanishing point used in one-point perspective.

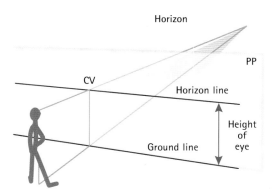

1. Finding the CV
As you can see in this representation, the CV is in line with and at the same height as the eye of our stylized figure.

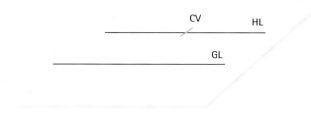

2. The first marks
If you are making a completely new perspective drawing, your page will look something like this. Here the CV is in the center of the HL but it does not necessarily have to be in the center, it can be anywhere to the left or right on the HL depending on the view you require.

Vanishing point (VP)

VPs are where sets of parallel lines appear to vanish. When making a sketch and observing perspective, if lines are continued from the parallel edges of an object away from you into the distance, it can be seen that they converge and appear to come together at a final point. This point would be their VP and the same VP would be used for any other edge or line that is parallel to the edges of the object.

Each set of parallel lines requires its own VP. A single drawing may need several vanishing points if the objects are positioned at differing angles to one another or there are a number of different angles within a single object.

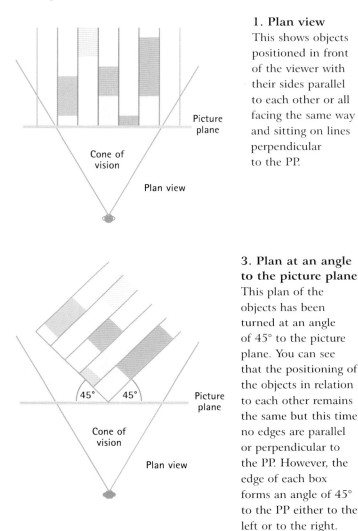

1. Plan view
This shows objects positioned in front of the viewer with their sides parallel to each other or all facing the same way and sitting on lines perpendicular to the PP.

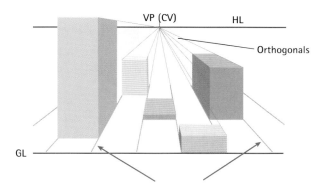

2. Perspective view
The same objects are now seen in perspective and it can be seen that all the parallel lines perpendicular to the PP are converging at the same VP. The construction lines representing these are known as "orthogonals".

3. Plan at an angle to the picture plane
This plan of the objects has been turned at an angle of 45° to the picture plane. You can see that the positioning of the objects in relation to each other remains the same but this time no edges are parallel or perpendicular to the PP. However, the edge of each box forms an angle of 45° to the PP either to the left or to the right.

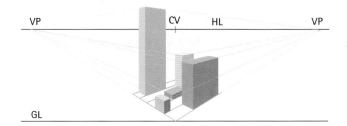

4. Two vanishing points
In this perspective view, there are two vanishing points. All the edges of the objects which tilt at 45° left are appearing to converge towards the left VP and all the edges which tilt at 45° right converge towards the right VP.

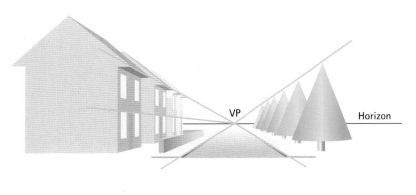

5. Vanishing points in everyday situations
You will see examples of how objects converge towards vanishing points all around you in everyday situations. This drawing shows a road leading straight ahead, the sides of which appear to converge at a point on the horizon. The trees stand in a line parallel to the road so a line drawn through their tops appears to lead to the same VP. This principle applies to other edges that are parallel to the road, such as features on the house.

Vanishing to 1, 2, and 3 points

The photographs and diagrams on the previous pages demonstrated the reality of what you actually see when viewing regular, straight-sided objects. Now we look at the perspective explanations in greater depth.

Imagine that you are looking at a cube, resting on a horizontal plane (think of this as the ground although it may not always be so), and with one face of the cube facing you but with some of the top or one side or both just visible.

We have seen that the edges of these other sides (each side being a square) appear to converge and if they are extended, eventually they meet. The point where they meet is always on a line that represents the horizon. This applies to all lines which represent receding horizontal parts of an object and the point on the horizon where they meet is called a vanishing point.

Perspective rules speak of three types of projection. They are one-point, two-point, and three-point.

One-point

A cube positioned close to the center of your view and more or less on your eye level can be visually explained by the use of single-point perspective, its sides across our view deemed to be parallel, the top, if it is visible, and the sides, going away from our view and vanishing to one point on the horizon.

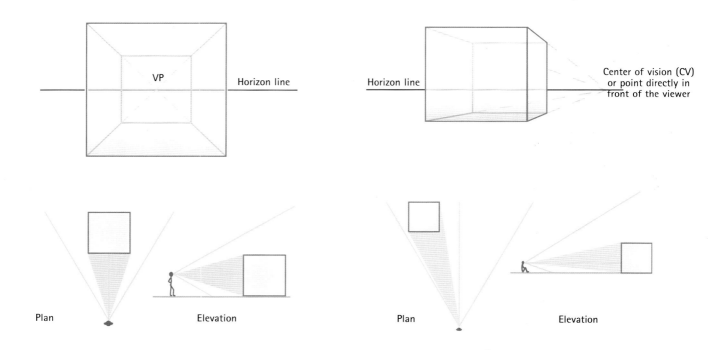

1. Cube on eye level and in the center of vision
In this view you can only see one face of the cube. The plan and side views show how it relates to the observer, the yellow area denoting the normal human field of view. The orange wedge indicates just how much of each face of the cube reaches the eye of the observer.

2. Cube on eye level positioned to left
This time the cube is positioned to the left of the viewer so that one side of the cube can be seen as well as the front face. The eye level height is a third of the height of the cube.

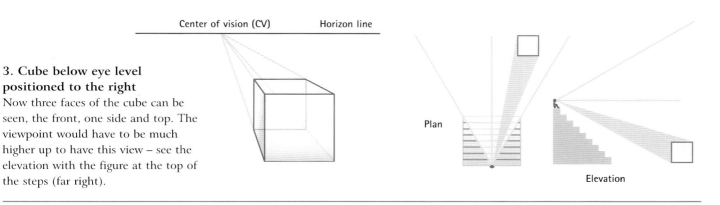

3. Cube below eye level positioned to the right

Now three faces of the cube can be seen, the front, one side and top. The viewpoint would have to be much higher up to have this view – see the elevation with the figure at the top of the steps (far right).

Two-point

If the cube is rotated a little so that both visible sides converge on points on the horizon it will be in two-point perspective. Usually one side converges to a nearer point on the horizon than the other one. This is by far the most common situation that you will encounter. In two-point perspective, the object/s are assumed to be resting on a horizontal plane with the vertical sides turned at an angle to the viewer so that both sides are visible.

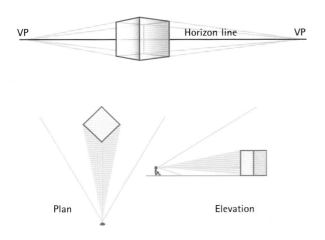

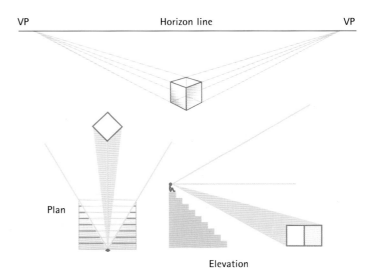

1. Cube on eye level

The cube is positioned directly in front of the viewer, with the left side turned at a steeper angle than the right side. The level of the eye is at half the height of the cube so just the two sides can be seen.

2. Cube below eye level

The cube is positioned directly in front of the viewer and below the eye level so that the top face is visible as well as the two vertical sides.

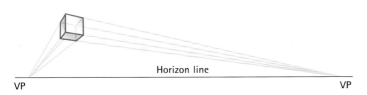

3. Cube above eye level

The cube is positioned slightly to the left of the viewer and well above the eye level so that the underside is visible and the two vertical sides. Note that in the elevation, the cube is shown suspended in mid air!

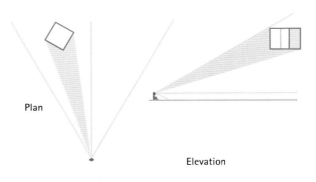

Three-point

If your viewpoint is well above or below the cube, the uprights, previously considered to be vertical will be seen to converge on a third point. This is called three-point perspective.

As the photographs on pages 10 and 11 demonstrate, almost all views of a cube are, in reality, three-point perspective but, unless the up or down convergence is extreme, this is usually disregarded and the sides are then assumed to be vertical and the view treated as being in two-point, or even one-point, perspective.

If the viewpoint is such that it looks down on the cube from a considerable height or, the converse, looking up from a very low view, it will be necessary to deal with it in three-point.

If, instead of a cube, it is a pile of cubes, one on top of another, and your viewpoint is close up, the upward or downward convergence is dramatic and inescapable.

1. Looking up at a tall building

Viewing any building from a relatively close position on the ground will always result in an upward convergence of its sides and all other vertical features. If the structure is very tall, as many city center buildings are nowadays, the effect is extreme.

2. Looking down from on high

There is no similar limitation when the view is from a high position. Both the top and base of the building can be encompassed in the same glance. If you turn the page up the other way you will see that this is comparable to looking up at the building which has now mysteriously launched itself into the air.

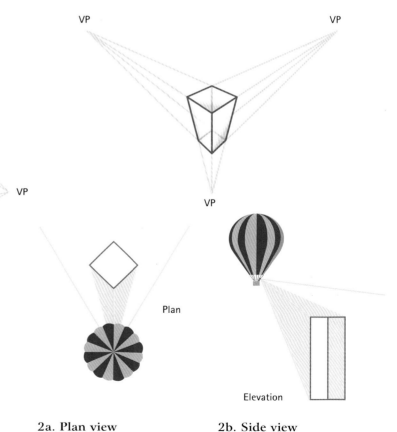

1a. Plan view
As you can see, even from a short distance away both sides of the building are well within the 60° cone of vision.

1b. Side view
This shows that from the same viewpoint you can look upwards to include the topmost floors in your view but the field of view will then exclude the base of the building (note green circle above).

2a. Plan view
The balloon vantage point again shows how the sides are well in view.

2b. Side view
Even from a quite close viewpoint, the view from above can easily be included in the 60° cone of vision.

One-point
Photo examples

Photographs of the open cube on this page shows how difficult it is to match the theory of one-point perspective with reality; as you can see there is often convergence in two, or even three, directions.

In reality there can only be one perfect example of a cube in one-point perspective and that is a cube right in the center of your vision and equally placed above and below the horizon. In this case, a solid cube would show only one square face, the sides, top and base all converging on a point hidden behind it. In practice, as long as the front face is not too far from the center of vision or too far above or below the horizon, one vanishing point will be sufficient to explain and construct it. If, instead of a solid object, the center space is effectively empty and defined by parallel features such as walls and road edges as in the trees and columns project on pages 31–33, one-point perspective is perfectly acceptable.

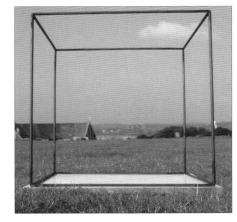

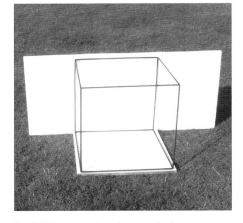

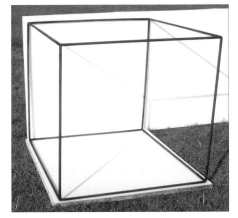

1. One-point cube – for certain
This view from directly in front shows the sides, top and bottom of the cube, all converging on one point. The uprights are parallel to each other as are the horizontals so this view is truly in one-point perspective.

2. Still one-point but only just
Here the viewpoint has shifted to one side and is higher, but the sides still vanish to one point. However, the horizontals are just beginning to converge to the right and the verticals to converge downwards. They are only slightly off parallel and, if they were corrected to be precisely horizontal and vertical, they would still look right.

3. View too close to be one-point
Now the converging of the horizontal elements to a second, far distant vanishing point on the right is inescapable so the cube is really in two-point perspective.

The verticals are also showing signs of converging downwards to the third vanishing point although "correcting" them to be truly upright and parallel, would look acceptable.

Setting up

One-point perspective is also known as parallel or single point perspective. Before beginning to set up a drawing in one-point perspective it is necessary to be clear about what is implied by the term.

The rules of one-point perspective apply to objects which appear to stand on a horizontal plane such as the ground and that have one of their vertical sides parallel to the picture plane (PP). The construction is based on the fact that all the receding horizontal parallel lines or, in other words, all the lines at right angles to the PP, converge to one single vanishing point on the horizon line, at the center of vision.

Possible views in one-point perspective
To be truly in one-point perspective objects must be situated exactly in front of the viewer and directly on the eye level. But as long as they are not placed too far to either side of center, or too far above or below the horizon, the view is acceptable as one-point.

In setting up a drawing, the first decision to be made is where on the page to place the horizon line. If most of the objects you wish to draw are at or near the eye level (blue) then the most sensible placing for the HL is in the center of the page. For objects above the height of your eye (red) it is sensible to place the HL low down on the page and for those below the eye level (green), placing the HL high up on the page gives more drawing space.

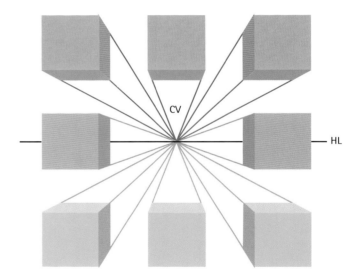

Including the ground line
Now that you have the HL and the CV, the next move in setting up is to establish the ground line (GL).

The distance between the HL and the GL represents the height of your eye from the ground (see illustration 1, page 14). Since the GL represents the base of the picture plane (PP, see page 13), you can then make measurements on it. True measurements can always be marked off on the PP.

To find where to draw the GL you first need to think of a suitable scale for everything. Imagine that you are looking along a road with simple houses on each side measuring approximately 23ft (7m) high and 16ft (5m) wide, viewing them from a height of 6ft (1.9m). A scale of 1:100 would make a house about 2¾in or 70mm high, 2in or 50mm wide with an eye height of ¾in or 19mm. You could use this scale to draw in the HL and GL and the sides of some houses, which together with the width of the

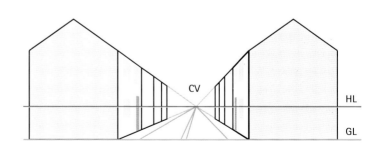

road can be measured directly on the PP. Any other features could be added by comparing their sizes with ones you have already drawn. At this stage, estimate by eye the distances receding beyond the PP, although true measurements can be made by a method explained fully on pages 38 to 41.

Measuring depth

Any regular, parallel-sided area can be visually halved by drawing in its diagonals.

This simple fact is the basis of a complete system of measuring depth in perspective.

If the corners of a square or rectangle are joined by diagonal lines, the point where they cross marks the center of the figure. A straight line can be drawn through this point, either vertically or horizontally, to divide the area into two exactly similar halves. This is obviously true when the square or rectangle is viewed straight on but, less obviously, it is also true when the area is viewed in perspective.

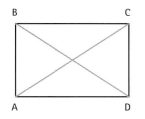

1. Plan view of a rectangle
Here is a rectangle with diagonal lines drawn corner to corner. To help later descriptions the corners of this rectangle are lettered A,B,C,D, as shown.

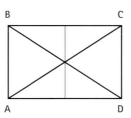

2. Vertical bisection of rectangle
Now a vertical line is drawn through the intersection of the diagonals, dividing the rectangle into two smaller, exactly equal shapes.

3. Bisecting in perspective
The rectangle is put into perspective by extending the upper and lower edges to a vanishing point on the HL, (any VP will do) and guessing its apparent length. Constructing the diagonals and the vertical in the same way as before reveals that the vertical division has moved further towards the vanishing point. This is as it should be and shows just how the distant half of the rectangle appears to be smaller. (See photograph of cube with diagonal strings, page 44.)

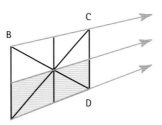

4. Horizontal bisection
Returning to the original rectangle, a horizontal division is made through the crossing point of the diagonals.

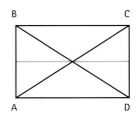

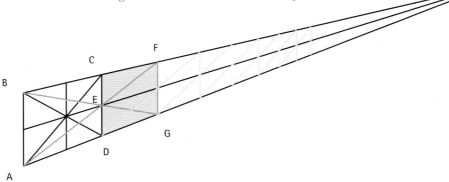

5. Projecting into the distance
When this is put into the same perspective, the top, middle, and base lines all vanish to the same point.

6. Constructing a new rectangle
Project a line from the bottom corner of the rectangle A through the point where the middle vanishing line cuts the far upright edge, marked E, until it contacts the upper vanishing line at F. Although it is not necessary for the construction, it will clarify what you have actually done if you then project another line from the upper corner of the rectangle B through the same point E to cut the base vanishing line at G. Join F and G. Now consider what you have done. The new rectangle, ABFG is now twice the size of the original rectangle ABCD because its diagonals (which bisect it) cross exactly on the vertical CD, which means that its nearest half is ABCD and the farthest half is now DCFG.

This extension of equal spacing can be done over and over again using only one diagonal for each move instead of two and dropping verticals from the extension points.

Creating a space

**Once the principle of halving by diagonals is fully understood, whole constructions
can be made from one rectangle. Although the depth of the original unit was a guess,
it can be replicated repeatedly with total accuracy.**

Later in the book we will explain how to use systems of
measurement that replace the initial guess of the
appearance in perspective of the first rectangle from
which all other identical ones are constructed.

For the present, let us continue with what can be
achieved from such a simple assumption. Looking again
at the photographs of cubes on pages 10 and 19, you will
see that any given side or top of a cube, a shape that is,
of course, a square, has a certain appearance and this
varies depending on the angle and the distance from
which you view it. The more of these squares in
perspective that you see, the better you will be able to
make a guess as to its shape in other circumstances.

Try tracing one or two and, using the method described
on the previous page, project the shape forwards and
backwards. If your guess was reasonably accurate it will
still look right, but if it was wildly wrong it will
immediately become clear.

1. Using the estimated square
Once you are satisfied that
your estimated square in
perspective is reasonably
accurate, you can bisect it with
the diagonals to find the
middle vanishing line and
construct a row of them
extending towards the VP as
you have learned to do on the
previous pages.

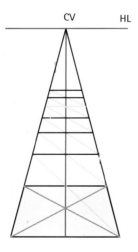

2. Extending the parallels
Because this is one-
point perspective we
assume that all lines
crossing our field of
vision horizontally
are parallel and
unaffected by
perspective. Therefore,
extend all parallels to
the left and right.

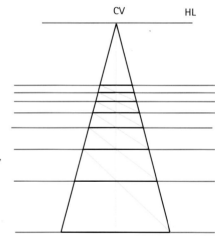

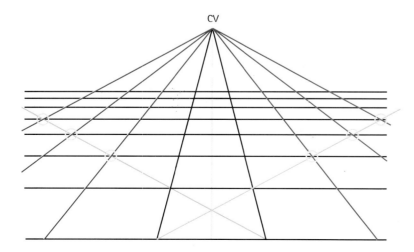

3. Adding more rows
If you have drawn the receding squares accurately, all
you need to do now to map out the other rows is to
extend the diagonals of the first square (green) and
others, as necessary, across the extended horizontals.
Receding parallel lines can be drawn through the
points where the diagonals cross the horizontals. You
will then have rows on each side of the first one that
you constructed.

Another way of creating space

Receding squares can also be created using another method that relies on the use of a vanishing point for the squares' diagonals. We have included the use of a scale with this method to help you to gauge size.

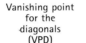

Equal units

4. Choosing a scale
Having chosen a suitable scale, establish the HL and GL and mark off units of measure along the GL. Then project lines from the unit marks towards the CV. These represent parallel lines on the ground stretching out in front of you to the horizon.

5. Using the diagonal to measure depth
Estimate the depth of one square as near as possible to the central line of sight (CLS, that is a line drawn perpendicular to the PP straight in front of the eye ending at the CV). Then draw a diagonal line through the square and on towards the HL. Where it crosses the HL is the VP for all diagonals. Where the line cuts through each receding parallel, horizontal lines can be carefully drawn to form squares in perspective identical to the first one. If necessary, diagonals can be drawn through any other squares to the VP to create more of them, as many as you want.

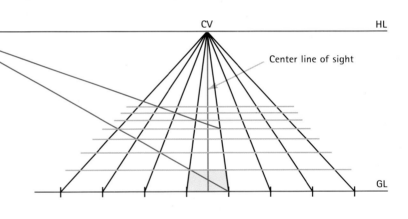

6. Creating a three-dimensional space
Now that you have a floor plan of squares in perspective you can create a three-dimensional space by drawing verticals up from the front edges of the floor to form walls and across the top to form the ceiling (green). Remember that the ceiling will be higher than the eye level or HL. Project lines back towards the CV from the tops of the walls (you will notice that they slope downwards) and draw in the back wall. The walls could be squared up easily now using the front wall markings projected back towards the CV and the floor squares used to establish the verticals. It would be possible now to place objects in the space using squares on the floor and walls as a guide. Turn to page 47 to see how this is done.

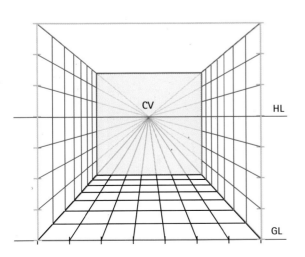

Placing objects in space

Now you are able to create space and distance in one-point perspective, this project will show you how to place a number of objects in it so that they are all the correct size relative to one another.

Let the objects represent human figures and, to simplify the process, let them all be the same height standing on a flat plane. Assume that you, the viewer, are also the same height and standing up. In this way, with minimum effort, you can create an interesting and effective scene with as many figures as you want, all the correct size for their position in the picture. Once you have created a crowd of standard people you can add the variety of shapes and sizes that people exhibit in reality.

The same system can be used for placing any objects of similar size, and it will be a sound base for creating more complex subjects.

List of Abbreviations
HL = Horizontal Line
GL = Ground Line
VP = Vanishing Point

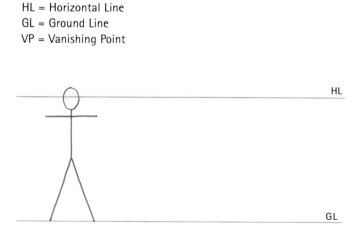

1. Draw in the HL and the GL, assuming that the height of a person's eye when standing on the ground is 5ft (1.5m). Draw your first person with feet touching the GL.

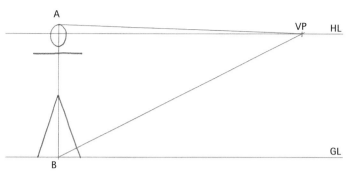

2. Give your figure a center line from the top (A) to a point directly below on the ground (B). Draw lines connecting the top and the bottom of the figure (A and B) to a single point on the HL (VP). This point can be anywhere on the HL as long as you leave enough room to draw more figures inside the resulting triangle A, B, and VP.

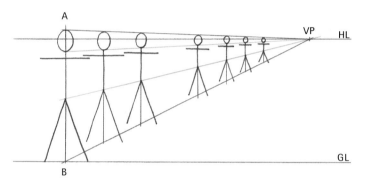

3. Draw more guidelines as you feel are necessary at strategic points taken from the first figure as shown in green, to help you to add more figures of similar height. At this point the figures are all standing in a straight line perpendicular to the picture plane.

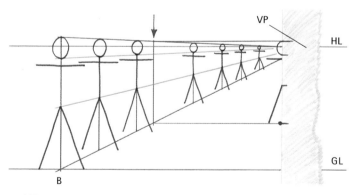

4. When figures are required in other places they can easily be added by first deciding where you want them to go and marking a spot on the ground. Then draw a horizontal line along the ground until it reaches line B-VP and draw a line vertically to establish the height of your new figure.

Draw a center line to represent the figure and transfer the height and any other necessary measurements across to the original dot. This can be done by marking off the height measurements along the edge of a piece of paper and taking it to the spot where the figure is required.

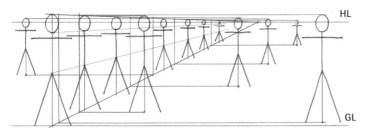

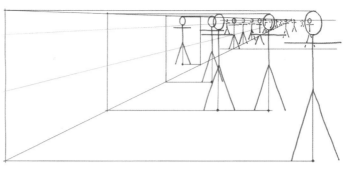

5. This procedure can be repeated as often as you like to create any number of figures placed wherever you wish across a flat landscape, left or right of the first figure. As you can see, all these figures are the same height, their eye lines coincide with the HL. This is highly unrealistic but is a good starting point and adjustments can easily be made as shown later on.

7. To create figures that appear even closer to the viewer the guide lines can be extended further.

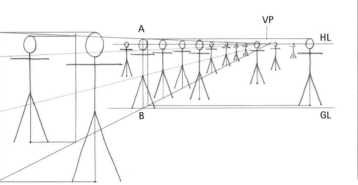

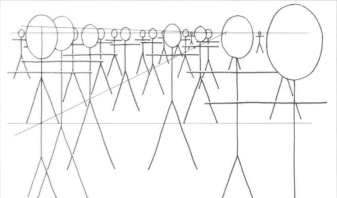

6. It is possible to create your figures in front of the PP thus achieving a feeling of being nearer to, or even amongst the crowd. To achieve this, you must extend lines A-V.P. and B-VP forward of the PP.

8. Once the figures are scaled correctly you can move forward by pulling in on the frame so that the foreground figures are partially cut off.

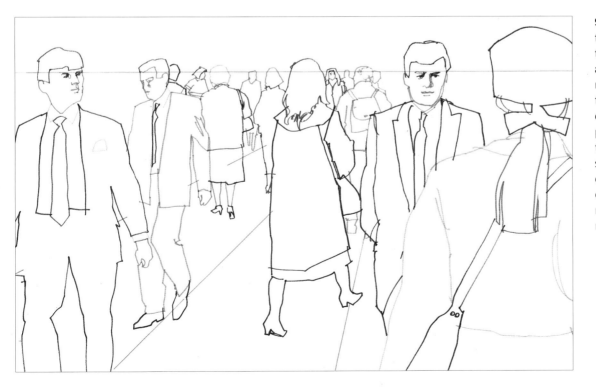

9. Real figures can then be drawn in at the same heights as some, but not necessarily all, of the stick figures. Of course in reality people are not all the same height, so to make your composition totally convincing their relative sizes would need to be adjusted.

Kitchen interior

This project shows how to take the plan of a kitchen and by the use of one-point perspective, create a convincingly realistic three-dimensional view.

The principles of perspective can be employed in two rather different ways.

The first one, which I call interpretive perspective and is the method on which this book will concentrate, uses knowledge of the rules to enable you to work out and interpret an object or view from direct observation.

My term for the second way is predictive perspective, because it enables you to construct a view from information given. For technical illustration the latter is the only way but for an objective artist the former is more useful.

However, occasionally you may find it useful to know how to breathe life into a flat plan drawing by rendering it as a picture, so just this once, here is how you can do it.

One problem, as always with one-point perspective, is that the further you spread the view from the center of vision, the less credible does the lack of another vanishing point seem to be.

As long as you keep the front faces of any objects to a minimum, quite wide views have a reasonable appearance. This is despite the fact that all front faces that are to the left or right of the center of vision should have their own vanishing points even though they would be way out of picture. It is just one of the acceptable anomalies of perspective – never forget (we will never allow you to forget!) that perspective is a system that makes recession and depth believable between certain proscribed limits. All perspective begins to look bizarre when spread beyond the 60° cone of vision and single point represents the greatest departure from reality. So, if you are featuring solid objects in the middle of the view, it is best to keep the picture compact. For an open space like this kitchen interior in which there are few front faces on view, single point perspective works well.

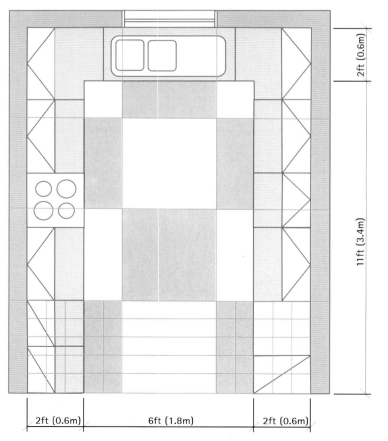

1. To simplify the translation into 3D I have kept the dimensions of this plan as regular as possible and used units that can represent whatever measures you choose. The plan is divided into 12 of these large units (green lines) which can be subdivided into 5 or 10 smaller units.

To have all the information that you will need, elevations are also provided. The side elevations are 2½ large units high and 4 units wide, while the end one is just 3 units wide, as is the grid representing the picture plane upon which all the basic dimensions are measured.

2. Left elevation

This is the left-hand elevation giving you the information that you need about the widths of the storage units and the stove.

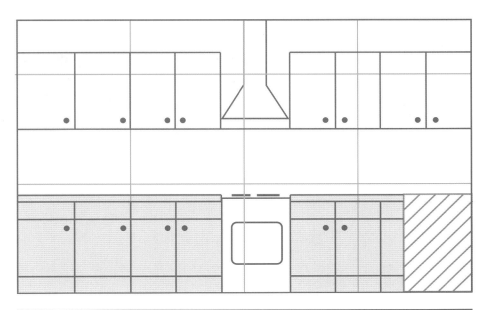

3. Right elevation

Similarly the right-hand elevation tells you how much space is taken up by the refrigerator and the tall storage unit.

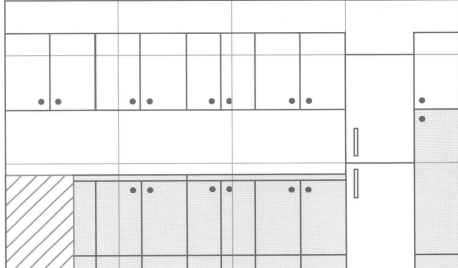

4. End elevation

Finally the end elevation shows the dimensions of the sink unit and the central window.

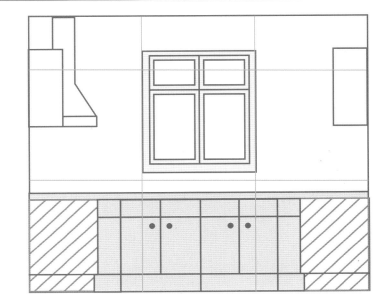

1. Draw a rectangle at a suitable scale to represent the width and height of the kitchen. The width of the kitchen in this case is 3 large units and its height is 2½ units. These large units can be subdivided into 5 or 10 smaller units. Then mark the width of the work units along the base, three-fifths of a unit in from each side and the height of the work units upwards at each side nine-tenths of a unit, as seen by reference to the elevations. These shapes (red) now represent the cross-section of the work units.

2. Choose a central vanishing point at any eye level you like – this one is at about 1.6 units, or somewhere near to a normal standing height. Extend the sections of the work tops to the vanishing point.

3. Draw lines from A, B, C and D to the vanishing point. Now comes the guessing bit; draw a horizontal line to make the middle square look convincing in perspective (colored green). Project this square, as on pages 22 and 23, until you have four of them representing the 4 unit length of the kitchen. Now ABEF is the floor of the room.

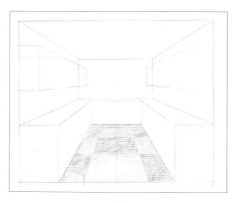

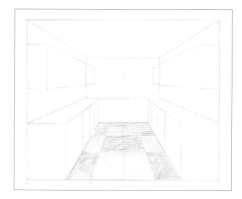

4. Verticals from E and F are drawn to intersect the vanishing traces of the ceiling height lines and these two points connected to form the back wall. Another guess can be made for the base of the kitchen units against the back wall: you know they should be sitting at a little more than halfway over the furthest large unit square on the floor and although it should perhaps be a little further away than I have drawn it, some license has been taken in order to have a better view of the worktop where the sink will be.

5. Sections of the wall units can now be drawn and projected back in the same way. For simplicity the visible parts of the unit square floor panels have been colored in, although in reality you would probably have smaller tiles or other floor covering.

6. To determine the kitchen unit divisions as they recede into your picture, refer to the plan. You can see that the first two units on each side are in line with the back edge of the nearest floor panel, so draw verticals there. The next ones on each side are a little less than a large unit further and so on.

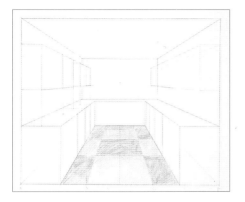

7. The equivalent measures for the wall cupboards, which are half the depth of the floor units, can be found by drawing the divisions halfway across the work tops and then raising verticals.

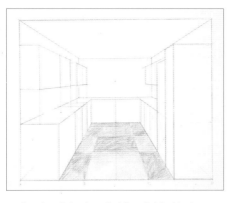

8. On the right-hand side of this kitchen the first cupboard is a tall one just 40cm wide or two-fifths of the first unit in. The refrigerator takes up the rest of the unit. Draw them to their appropriate heights as shown on the elevation.

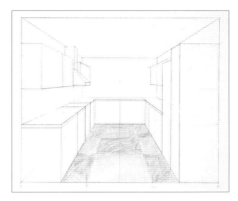

9. Stove hood and worktop thickness can now be added more or less by eye.

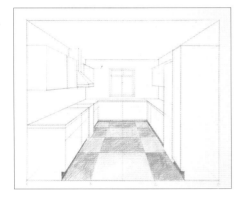

10. Refer to the elevations to continue adding details such as drawer depths and base boards and the window in the center of the end wall.

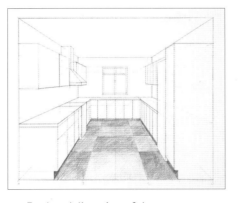

11. Further delineation of doors can now be made, remembering that shapes can be halved by joining the diagonals.

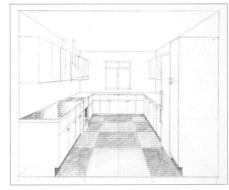

12. Continue to add details such as door handles, oven door, and hob.

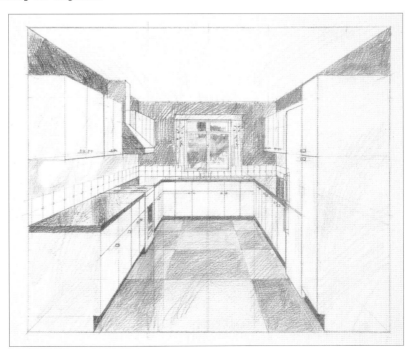

13. Finish with worktop color and shine, wall tiles, wall color, curtains etc. as you like.

Trees and columns

The appearance of evenly spaced columns as they recede towards a single vanishing point can be accurately predicted and plotted as can trees and other irregularly shaped objects and the spaces between them.

This is a photograph of a building on the Mall, a famous London street. It is provided for you to work from, but the preparatory constructions opposite enable you to find the vanishing point and hence the horizon line and could equally well be employed in a real outdoor situation.

These are, first of all, to demonstrate that the principles do apply to real views, which are somewhat more complex than open cubes.

Secondly, the constructions are there for you to copy the actual perspective underlying the photograph – if you wish. Thirdly, it is to show you how the scene could be constructed without necessarily using exactly the same viewpoint as that of the photograph.

The construction to find the window placing is only necessary when the reality is not actually before you.

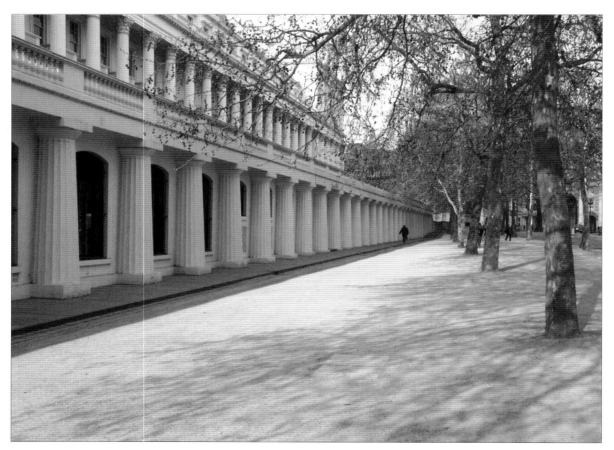

1. The Mall
All three tiers of columns and the gaps between them vanish to the same point on the hidden horizon. A line of evenly spaced trees opposite them shows the same apparent reduction in the gaps between them as they recede into the distance. If each tree were the same as the next you would see vanishing lines joining all the salient points of the branches but as this is clearly not so it is more a matter of observing how the general thickness and length of the branches becomes smaller as the trees recede.

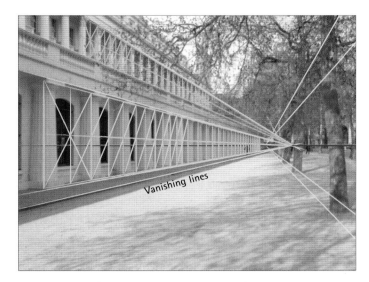

2. Main vanishing traces superimposed

You can see that the VP of the building is not quite the same as that of the trees which means that the building's façade and the line of the trees are not parallel to each other as they originally appear to be. Because that also means that one of the two is not at right angles to the picture plane, the whole picture is not strictly in one-point but it is so close that I would be prepared to bend the rules and accept it as such.

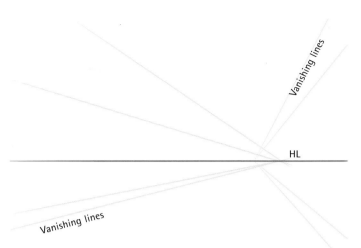

3a. The construction

The vanishing lines on their own show by their convergence where you can draw the horizon line. This is not of vital utility in this instance but it's always nice to know where it is, if only because it is also your standing eye level and therefore a line which would be an indication of the eye heights of similar sized figures.

3b. To work out how the pillars should recede, first estimate the centers of the two nearest pillars and draw the perspective rectangle that connects them..

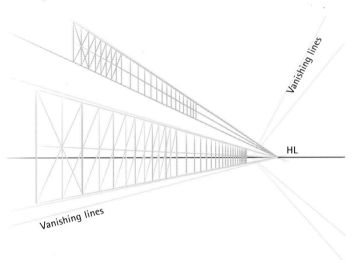

3c. Then draw in the diagonals and project the spaces into the distance as described on pages 22 and 23.

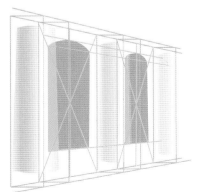

3d. Finding the hidden part of the window

Joining the square top and base of a pillar shows the near edge of a contained section of wall so that you can see where the hidden part of the window commences.

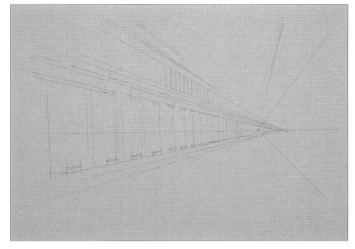

1. Establish the perspective lines on the drawing. This can be done by tracing over the photo and transferring them to the drawing.

2. Now add the tops and bases of the columns as they recede into the distance.

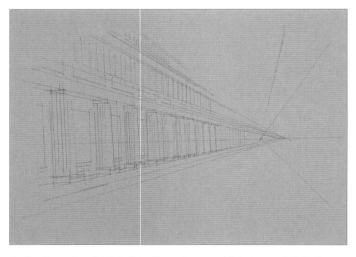

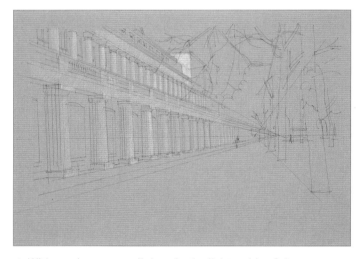

3. Continue to add detail to the columns which taper slightly from the base upwards. Add the fluting detail to the main columns. Begin drawing the window spaces that are visible between the first of the main columns and continue the upper collonade. As the photograph was taken from a standing viewpoint any figures that appear in the drawing will have their heads on the HL.

4. With a pale gray pencil draw in the lighter side of the colonnades and the face of the higher building catching the light. Varying the pressure on the pencil will allow you to represent the differing tones of the light areas. Add the main structures, the trunks and branches of the trees, and plot them along the receding perspective lines.

5. With a black pastel move to the other end of the tonal scale and draw the darkest tones of the windows between the main columns. Add other dark details such as the small figures on the horizon and tree details. Use the same pencil to lightly add grayer tones in the tree shadows and the upper windows of the building.

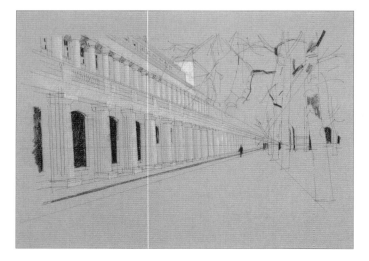

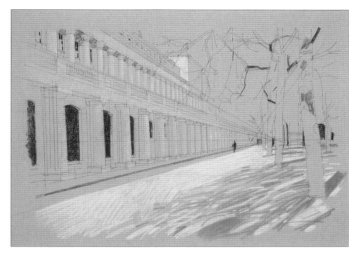

6. Begin adding color to the drawing and define the plane of the ground surface with a light yellow pencil. Draw in the shadows of the trees using a dark gray pastel, make use of the paper's color to vary the tones of the shadows. Work in lighter details of these areas with the yellow pencil.

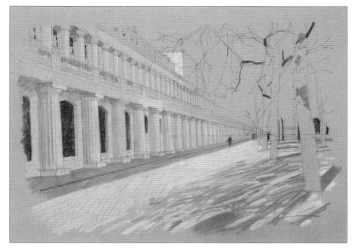

7. To avoid smudging the drawing use a light coating of fixative spray. With a mid gray pastel add lighter shadows around the columns whilst leaving others defined by the paper's color. The now redundant construction lines will begin to disappear beneath the colored and tonal rendering. Revert to a white pastel to add definition to the structure of the columns and their fluting. With the dark gray pencil render the pavement area immediately in front of the building. Using a mix of white and the two grays add the varying shadow details of the underneath of the balcony.

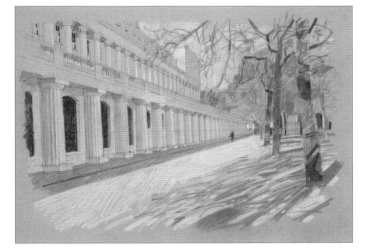

8. Use raw sienna and raw umber pastels to add color to the trunks of the trees and their autumnal foliage. Scumble the colors together for chromatic variety. With a pale blue pastel add the sky, defining both the outline of the building and the trees. Use the a mid blue to add color to the darker sky areas on the right. blend the two blues where they meet to form a continuous tone.

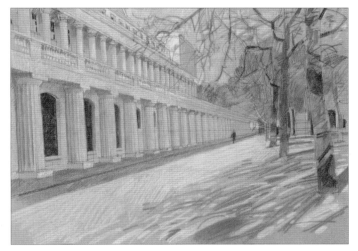

9. Use the fixative spray again to protect the recent drawing. Use a cool gray to add shadow detail to the upper collonade before defining the architectural decoration on the balustrading in front of the balcony. Add overall definition to the shadow areas using a variety of tones, losing more of the construction lines as you do so.

Canal scene

Canals have a number of characteristics that make them ideal subjects for studying and demonstrating one-point perspective.

As it passes between Beaucaire and Tarascon in southern France, this canal is arrow straight as far as the eye can see. Buildings, bollards, trees, even the boats follow the canal edge, all their lines of perspective vanishing to the same point. The gangplanks to the mooring posts seem to be regularly spaced too, although in this view, where you would expect to find the third one from the front, there is, unaccountably, a gap. Looking closely, you can see that the stepped platforms from which the trees emerge seem

not to be quite in sequence with the gangplanks and darker paved strips. The square bollards, however, are very neatly confined to two between each lighter strip of pavement.

Searching out such relatively minor variations like these may seem to be pedantic but once you are attuned to seeing perspective around you, you will notice these anomalies that seem not to obey the rules.

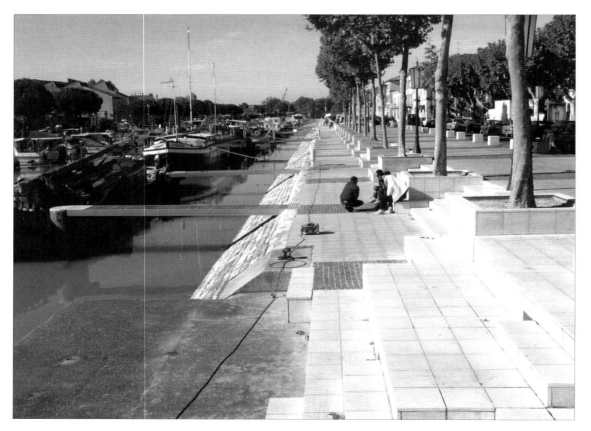

A French canal
Although this scene is viewed in one-point perspective there is a complex web of recession lines formed by the steps, the trees, the boats, and the houses on the right.

A hidden step

Highlighted in red are two intermediate steps in the canal scene's foreground. The right-hand one is quite obvious and easily observed but the left-hand one is almost invisible until highlighted in this way. Its presence is betrayed by a slight misalignment of the floor tile divisions and a tiny visible fragment of a grating of some type which is present just beyond each of the steps (black triangles). For this drawing it is clearly not a vital consideration, but it is good to be alert to such anomalies – in another situation it might be more important.

1. Use a B pencil to render the major lines of recession of the parallel plinths and paving slabs on the canal bank to establish quickly the VP and HL. Beware, though, man-made structures are not always as perfect as they may seem; if the receding lines don't appear to converge exactly on the same point, take a mean average and stick with it.

2. Draw in the prime horizontals (see previous spread and pages 22 and 23). A handy tip for consistency when drawing parallel lines is to lay the longer of the right angle edges of a triangle (set square) along the horizon and then position a rule against the angled side holding the rule firmly in place. (Or use sticky tape to secure it.) The triangle can be slid down the rule to the required height and new lines drawn. (This technique can also be used for parallel verticals using the short, right-angled side of the triangle.)

3. Using the previous technique begin to build up the detail of the canal-side structure. Look for anomalies in the perspective such as the almost hidden step in the foreground. (See previous spread.)

4. When presented with such an obvious perspective grid, as in this scene, establish this early, partly as visual guide before adding the less mechanical elements later, such as the trees and figures. Leave spaces for these or draw them faintly and erase when required.

5. Now details such as the boats' gangplanks can be added. Notice that as these are not equally spaced they do not immediately follow the perspective rules of diminishing rectangles. (See pages 21 and 22.) When drawing the boats themselves their complex structures may appear to defy perspective. Look for any parallel elements, though, such as the sides of the boats, and follow their lines through to the VP. Build the pattern of the boats' details against this, using lightly sketched guide lines if needed.

6. Using a freer approach add the trees and their masses of foliage. Always be aware that even in seemingly abstract shapes, such as these, the laws of perspective and diminishment of scale are always in evidence, albeit less obviously. Add simple tone to define shapes and areas before rendering in color.

7. When the underdrawing is complete begin to add color. Make a generous but dilute wash of black watercolor with indigo added to cool the hue. This basic wash is used to define the horizontal planes on the right-hand side of the image.

8. Now add other large tonal and color areas. Use a fluid wash of cobalt to define the sky. The canal itself is rendered with a mixture of cobalt and Prussian blue. Keep the washes fluid and their application free.

 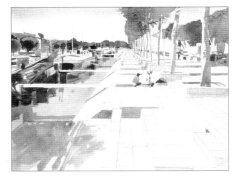

9. Begin defining the image by adding mid-tone shadow areas. A good, basic shadow color can be achieved with a mix of raw umber and ultramarine. Use color and tone to enhance the sense of recession and space in the image – darker, stronger elements in the foreground changing to weaker, lighter elements in the distance.

10. The trees' foliage is now added using a fluid mix of pthalo green and gamboge. Vary the quantities of each color as you work to give color variety in the foliage areas. Alter the amount of water, too, to give tonal variety to the wash. The VP has now disappeared in the distant trees.

11. Within the general clutter of the boat decks warm colored areas can be seen on the left of the image. These are added using vermilion or a similar sharp red. This is also used for the person in the middle of the picture. Use a warm blue to render the abstract shapes within the boats. Once again, accentuate scale by contrasting large shapes in the foreground against much smaller shapes in the distance.

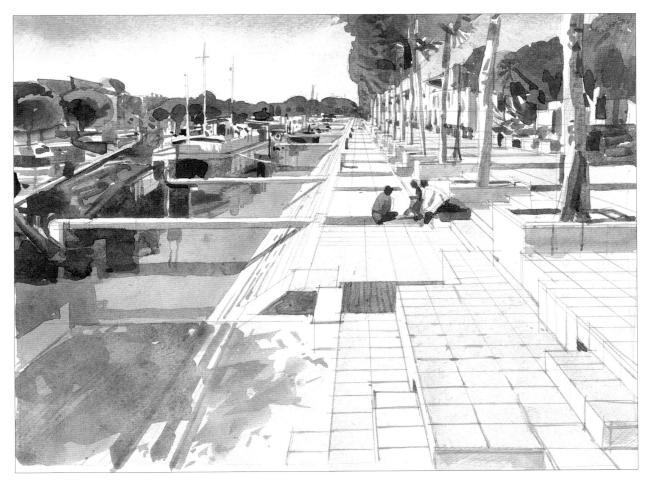

12. Finishing touches are now added. In keeping with the rest of the image render these in a free, loose manner without recourse to unnecessary detail. A fine brush is used to draw into the edges of the paving slabs and steps to diminish the mechanical quality of the original pencil drawing. Finally, add shadow details to the main line of trees. Once again, to stress their recession into the picture plane, use larger marks to define the foreground gradually diminishing to smaller ones in the distance.

Using measuring points

The previous method (pages 22-25) showed how to create the illusion of depth in perspective by beginning with a certain level of guesswork. Most of the time – and for most people – this is totally acceptable. However, if accuracy is of the utmost importance, or you simply do not trust your own judgement, then the following method of construction can be utilised.

For this somewhat difficult setup, a few extra concepts must be added.

When making a perspective drawing we only draw that which can be seen clearly in one fixed look. As mentioned earlier, we can only focus clearly on objects that fall within a 60° cone of vision which can be thought of as a megaphone pointing straight out from your eye, with a line through the center of the cone called the main or central line of sight (CLS). The cone extends to infinity or until it hits or is bisected by the picture plane (PP).

At the PP it forms a circle of relatively clear vision and anything falling outside the circle can look distorted.

With this in mind, now you need to know how to make sure that everything in your drawing fits within the cone and that no distortion occurs. Whether it fits is determined by the size and position of the object in relation to the position of your eye. This can be judged by making two simplified and scaled-down drawings.

A quick sketch of how you want the final drawing to look will have decided the position of the object right or left of center, its size, and the height of your eye, so the only thing that has to be found is the distance of your eye from the object.

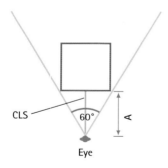

1. Checking the cone of vision on a plan

First make a plan drawing (view from above) of the object/s you wish to draw. There is no need to draw the plan in detail; all that is really needed is an outline of the overall shape. Choose a simple object such as a 3ft (1m) cube and decide on a suitable scale to work to. This drawing doesn't need to be very big, so a scale such as 1:100 is acceptable.

Add the central line of sight and measure out the 60° cone from a point on the CLS, which will represent the eye. It is very important that the box is placed the correct distance to the right or left of the CLS. Drag the cone back along the CLS until the whole object fits within the cone. At this point the eye is as near as it can be to the object (distance A) when viewed from above; any closer and distortion is likely to occur on the final drawing.

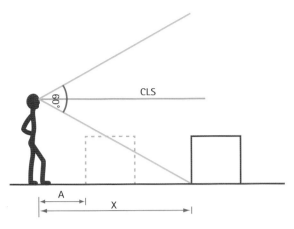

Take whichever is the larger distance from the eye to the object, that of the plan or the elevation, in this case the elevation (see X) and use it to help set up the drawing's perspective framework. The PP can be placed anywhere between the object and the eye, but its position affects the scale of the drawing; the nearer the PP is to the object the bigger the drawing will be. If the object is small enough it is a good idea to position the PP so that it is touching the object; this makes the construction easier as true measurements can be made against the PP.

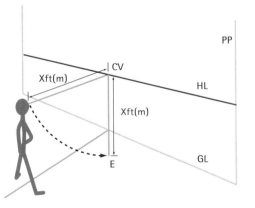

4. Representing the situation on a flat piece of paper
In order to start the construction drawing, this three-dimensional situation with the eye coming out at right angles to the PP, has to be represented on a flat or two-dimensional piece of paper. This can be done by taking the CV as a center point and the distance to the eye as a radius and inscribing an arc to meet a line drawn vertically down from the CV on the PP. This new point will now represent the eye E and true directional angles can be measured from here using a protractor. If you had decided that the PP was to be some distance from the object then the method of putting 'E' on the paper would be the same, remember it is the distance from the eye to the PP that is taken down from the CV, how far away the object is will be dealt with later.

2. Checking the cone of vision on an elevation
To check that the object fits in the cone from the side, an elevation drawing (view from the side) is made. Use the same scale as you did for the plan, and assume your height of eye is about 6ft (1.8m). Start by placing the eye the same distance from the object as you ended up with on the plan, e.g. distance A, if the object does not fit within the cone with the eye at this distance from the object, then drag it back along the CLS, as before, until the object sits completely within the cone. You may find it easier to move the object rather than the eye and the cone.

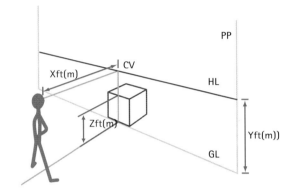

3. The situation from the side
Remember that when you are using measured perspective you are trying to replicate a real situation as far as possible. This is a view of the set up from the side with the picture plane X ft (m) from the eye, the eye Y ft (m) above the ground, the object Z ft (m) cube and the PP touching the cube.

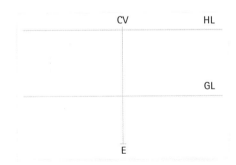

5. The construction framework
Having made small-scale drawings to check the cone of vision, a larger scale can be chosen to fit the construction comfortably into your page. For example, on A3 paper you could use a scale of 1:25 so an eye height of say 65in or 1.7m would be drawn as 2½in or 65mm. This is how your drawing will look before constructing the cube, the eye height being the distance from the HL to the GL and the distance of the eye from the PP being measured from the CV vertically down the PP ending at E. At this stage the object/s or cube cannot be added until more has been explained.

Measuring

Since we know that objects appear to get progressively smaller as they get further away, it means that you cannot use a rule to measure distances and heights anywhere other than on the picture plane (PP).

When you want to measure anything that does not already touch the PP it is measured by making the true or scaled-down measurement on the PP and projecting it back or forward following lines of perspective. It is easy to measure distances to the right and left of the spectator by simply taking your rule, measuring along the PP and then projecting a line back towards the CV (vanishing point for all lines going straight ahead of you). But when you need to locate a particular point a certain distance beyond the PP it is necessary to use measuring points.

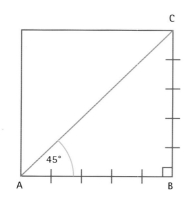

6. How measuring points work

Measuring points are easy to use and the way they work is based on this logical notion of measuring the sides of a square. If you know the length of one side of a square AB, draw lines at right angles to it at either end and measure a 45° angle from one end, e.g. A, the 45° line will cut the line projected from B at C so that BC measures exactly the same amount as AB. Note well what has been done here; BC has been measured using the 45° line, not a rule. This is the principle which will be used to measure back when drawing in perspective, because, although it is possible to use a rule to measure from right to left, it is not possible to do the same for measuring back or forwards from the PP.

7. Finding the measuring point

So, if the same square is to be drawn in perspective we need to establish the angle at which 45° lines should be taken back; because angles cannot be measured in perspective with a protractor anywhere other than from E. If a vanishing point for 45° lines is located on the HL then all 45° lines can be taken back towards that point. Because true angles can be measured from E, to find the VP45° a 45° angle can be measured at E and continued on until it reaches the HL This point is then the vanishing point (VP 45°) for all lines receding from the PP at 45°.

The VP 45° is also called the measuring point for the center of vision (MPCV) because it is used to measure distances straight ahead of you on lines vanishing towards the CV. Generally a left and a right MPCV is established so that either can be used whichever is the most convenient. Now you can add this to your cube framework (fig 5) on page 39.

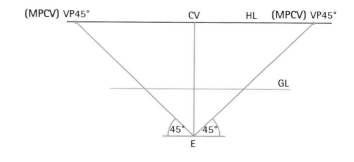

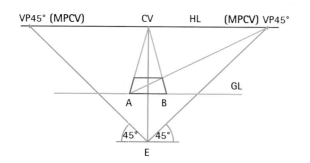

8. Using the measuring point to measure a square

So now that we have the VP45°, the 3ft (1m) square can be constructed as if it lies on the ground plane with AB touching the PP. The method of measuring back then follows that of the square shown at 6 (above). Lines can be drawn towards the CV to represent the sides of the square, then the 45° line can be drawn from A towards the VP45° or the MPCV, and where it cuts through the side projected from B is where the back edge of the square will be. Now you have the base of your cube.

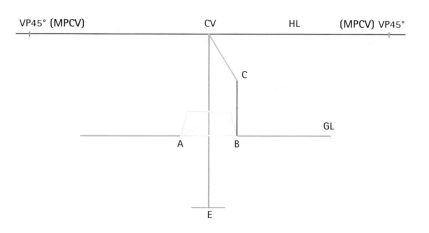

9. Measuring heights against the PP

We have already established that you cannot use a rule to measure distances and heights beyond the PP. However, you can measure heights against the PP with a rule, just as you can for distances right and left.

This diagram shows the height of the cube as 3ft (1m) measured up against the PP as the line BC. If a line is projected from C back towards the HL to the CV then this line represents the height of 3ft (1m) in a straight line ahead of you or the spectator as far as the eye can see. You can now add the height of your cube against the PP.

10. Completing the cube

At this point we have all the information we need to finish constructing the cube. Draw in the other edge of the cube DA and project a line back to the CV as you did for CB. The depth of the cube has been determined by the square on the ground plane so you can project vertical lines up from the back corners of the square J and F until they intersect with the height lines at H and G.

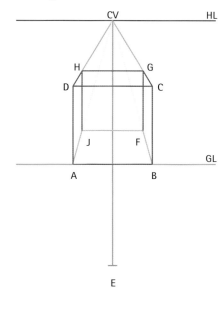

11. Knowing where a point is beyond the PP

So far a square has been used to demonstrate how to measure beyond the PP, but this method of measuring back is applied to the measurement of any single point beyond the PP. Think of locating a point as you would on a map with a grid reference. Assume the grid is on the ground plane with the lines running parallel and perpendicular to the PP. The point should be thought of as being so many units to the right or left of the spectator and so many units straight ahead beyond the PP.

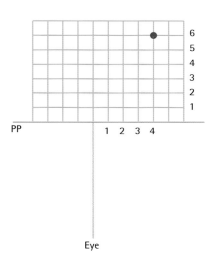

12. Locating any point beyond the PP in perspective

Create another perspective set-up similar to that in the diagram, any size, and assume that the point you want to find is 4 units (units can be any size but must be equal) to the right of the spectator and 6 units beyond the PP. To find the point measure 4 units to the right along the GL to give you A and take a line back from A to the CV (this is representing a grid line straight ahead to the horizon). From A measure 6 units to the left to find B and draw a line from B to the VP 45° (MPCV). Where the lines cross at C is the point required.

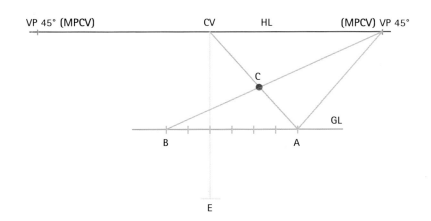

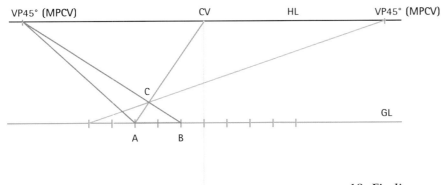

13. Finding a point using the other VP45°

Which VP45° to use is up to you; they will both produce the same results but one will usually be easier to use than the other. If you measure to the left you use the VP45° right and vice versa. The diagram shows the use of both the right and left VP45 ° points to find C, but as you can see it would be better in this case to use the VP45° left because it is nearer to B and the angle where the two lines cross is steeper and therefore more accurate than if the VP45° right was used. On the same set-up try finding point C located 3 units to the left and 2 units beyond the PP.

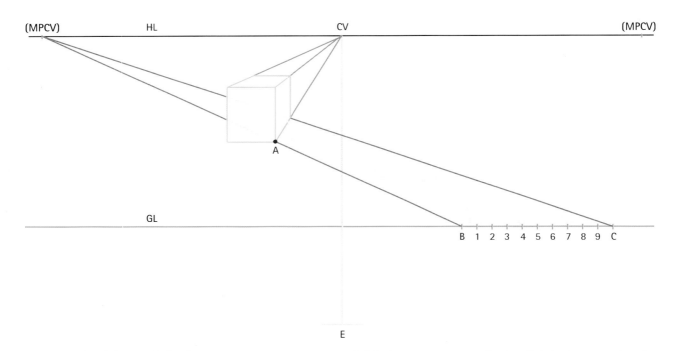

14. Measuring back beyond the PP

You may already have a point somewhere on the GP from which you wish to measure a distance; for example, if you know visually where you want to put a house but need to make sure that it measures 10 units back. In this case measuring back is very simple, all you have to do is think which point it is you want to measure from and in what direction you want to measure. In this case we want to measure from A and in the direction of the CV. Therefore A has to be connected to the

MPCV (measuring point for the CV) by drawing a line from a MPCV through A to the GL at B.

The depth of the house can then be measured with a rule against the PP to find C and a line from C is then taken back to where you came from, the MPCV. When measuring in perspective you will notice that the construction creates triangles. In other words you always take lines back to the point you started from. This is good to remember for later on when things get a little more complicated.

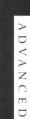
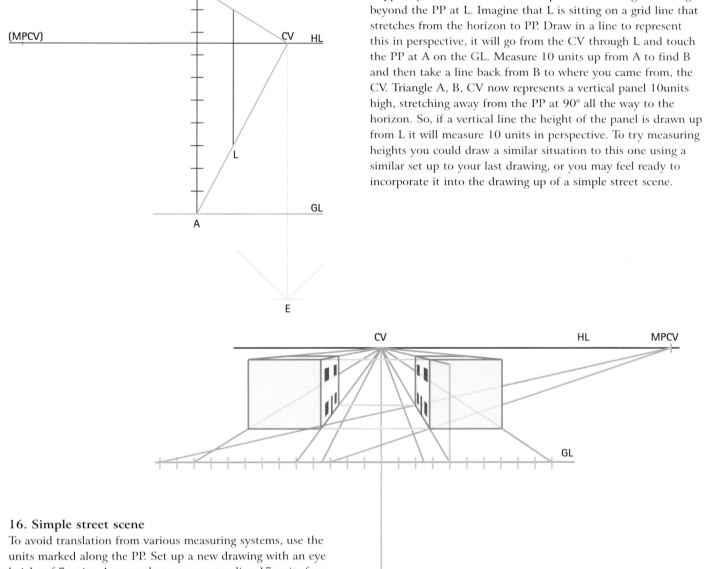

15. Measuring heights beyond the PP

Suppose you needed to measure a post 10 units high standing beyond the PP at L. Imagine that L is sitting on a grid line that stretches from the horizon to PP. Draw in a line to represent this in perspective, it will go from the CV through L and touch the PP at A on the GL. Measure 10 units up from A to find B and then take a line back from B to where you came from, the CV. Triangle A, B, CV now represents a vertical panel 10units high, stretching away from the PP at 90° all the way to the horizon. So, if a vertical line the height of the panel is drawn up from L it will measure 10 units in perspective. To try measuring heights you could draw a similar situation to this one using a similar set up to your last drawing, or you may feel ready to incorporate it into the drawing up of a simple street scene.

16. Simple street scene

To avoid translation from various measuring systems, use the units marked along the PP. Set up a new drawing with an eye height of 7 units. Assume that you are standing 17 units from the PP and looking straight down a street vanishing to the CV. This figure shows the construction for the right-hand house. Its near, front corner is 4 units to the right of the CLS and 7 units beyond the PP. It is 6 high, 10 wide and 6 units deep. The sidewalks (pavements) are 1.5 wide and the road 6 units wide. Using these specifications to start your drawing you could add details and more buildings on both sides of the street either by eye, using the few measured items as reference, or by applying more careful measuring.

Hopefully you will feel confident now to construct a drawing in one-point perspective. Don't be put off by the time it takes or the many lines involved or the fact that you may not have grasped everything first time. Be patient because once you have mastered measuring simple shapes in perspective you need never worry about how to get your drawings looking right again. It is not necessary to measure every little detail. Even if a box is all you can manage to draw in measured perspective, remember that everything can be thought of as being boxed-up, all you have to do is know the size, construct the box correctly and then sketch in the rest!

Two-point
Photo examples

Two of the photographs on this page are examples of our cube in two-point perspective. Such views represent by far the most commonly used convention despite the fact that most of the objects we see around us have in fact, three vanishing points, although the third one is often so subtly distant that it is usually disregarded.

As you can see, when the observed objects are quite close to the eye level of the viewer, the uprights are vertical – or nearly so. For these to remain vertical it is necessary to be some distance from the cube. When it is seen from a near viewpoint and from above, the uprights are no longer vertical and three-point vanishing is unavoidable.

Therefore, to draw a scene in which two-point perspective is the dominant explanatory theme, you need to be a sufficient distance from the nearest object for its upright edges to appear to be nearly vertical.

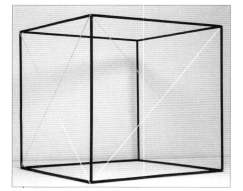

1. A two-point cube
This photograph was taken from a distance at least five times the width of the cube and with an eye level about halfway up its height. As a result the uprights look vertical and the perspective is not extreme. The VPs are rather far apart, the right-hand one well off the page.

2. Still two-point – but only just
A higher eye level and horizon line is beginning to affect the uprights, which show signs of converging downwards but are still within the acceptable parameters of two-point. See how small the picture has to be to encompass both VPs.

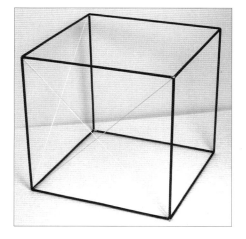

3. View too close to be two-point
A close viewpoint and a high eye level combine to make all the sides of this cube converge and vanish to three VPs, therefore it can no longer be dealt with by the use of two-point methods. Straightening up the verticals would be possible of course, but it would present an unconvincing appearance.

Setting up

Two-point perspective, sometimes known as angular perspective, is the system that applies to most views that you are likely to observe from a position on ground level, i.e. at a normal eye level, neither very high or very low.

Before we begin setting up a drawing we need to be clear about what is meant by two-point perspective.

If an object is viewed in two-point perspective, it means that it appears to stand on a horizontal plane; its side planes are turned at an angle to the viewer and all its vertical lines are parallel to the PP. When drawing an object viewed in two-point perspective, two VPs are used

and horizontal lines appear to vanish to the left or right VPs. The following diagrams and instructions will show you how to construct a three-dimensional grid in similar steps to those in the one-point set-up. As before, we will start with a square in perspective, the shape of which you judge by eye to be right.

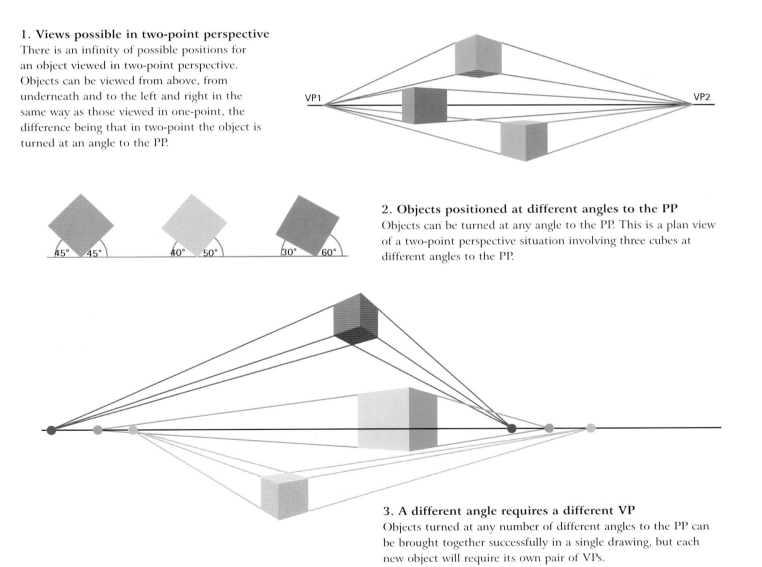

1. Views possible in two-point perspective
There is an infinity of possible positions for an object viewed in two-point perspective. Objects can be viewed from above, from underneath and to the left and right in the same way as those viewed in one-point, the difference being that in two-point the object is turned at an angle to the PP.

2. Objects positioned at different angles to the PP
Objects can be turned at any angle to the PP. This is a plan view of a two-point perspective situation involving three cubes at different angles to the PP.

3. A different angle requires a different VP
Objects turned at any number of different angles to the PP can be brought together successfully in a single drawing, but each new object will require its own pair of VPs.

Measuring depth and height and creating a space

The simple method used for measuring depth in two-point perspective is based on the same theory as for one-point. It depends on constructing a grid based on an estimated first perspective square. Either of the methods used in one-point for measuring using diagonals can be adopted for two-point; we have chosen to use the method which uses a vanishing point for the diagonals.

4. Setting up the framework

Begin in exactly the same way as in one point by deciding on a suitable scale and drawing in the horizon line (HL), ground line (GL), center of vision (CV) and central line of sight (CLS). Mark off true scaled units of measure up the CLS. Unless your drawing is very small, it may be difficult to fit all your VPs onto your paper, especially if the angles of the objects are very severe. But this need not be a problem; just extend the HL on to an adjacent surface with a long rule or string and elongate the vanishing lines, mark the spot where they cross it and use it in the normal way.

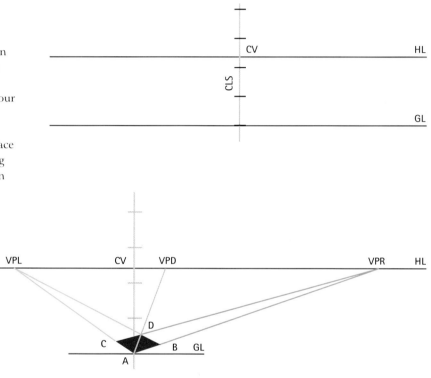

5. Estimate the first square

When guessing the first square ABDC, position it near the CLS to avoid distortion, and make sure that angle CAB measures more than 90°. Its sides must vanish to points on the HL and it will look good if one VP is nearer to the CV than the other one. In this instance the chosen angle that side AB makes with the picture plane is shallower than that of CA therefore AB will have less foreshortening and appear longer than CA but each side will measure less than the already established vertical unit. The vertical units of measure on the CLS or PP are the only units that can be physically measured in two-point using a rule; all other units of measure will be smaller than these.

To enable you to measure squares on the ground it is necessary to find the vanishing point for the diagonals. To do this draw a diagonal line through the guessed square and beyond until it bisects the HL at vanishing point for the diagonals (VPD).

6. Squaring up the ground plane

Adding more squares is simply a matter of drawing in lines representing the diagonals and marking off where they bisect lines of vanish to the left and right. Start by drawing a line from C towards the VPD (you could actually start from either corner of the square). Where it cuts line B–VPL at E is where a second grid line can be drawn F–VPR

Line F–VPR cutting through A–VPD provides us with G, another point to run a grid line through to VPL giving us H–VPL. This procedure of taking lines to the VPD and using points of intersection to determine the location of measurements to the left and right can be repeated to produce the required number of squares or equal measurements.

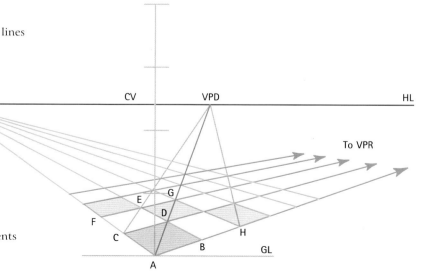

Constructing a box in perspective is not just useful for drawing houses; many objects can be visualized as fitting into a box of suitable dimensions. If you can draw the box in the correct perspective the chances are that the contained object will look right too.

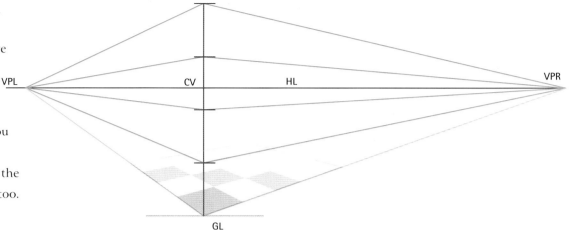

7. Creating height lines

Having constructed a flat grid of squares on the ground plane, as described on page 46, you can begin to erect a vertical grid around it to create a squared-up box or wire crate. First it is necessary to project the height lines back from the vertical unit marks on the PP towards their respective VPs right and left.

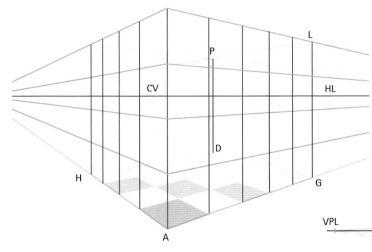

8. Adding the verticals

Vertical depth lines can then be projected up from the grid on the ground plane to form the two sides. The top back corner P can be found if necessary at the intersection between a vertical drawn up from D and a vanishing trace from L towards VPL.

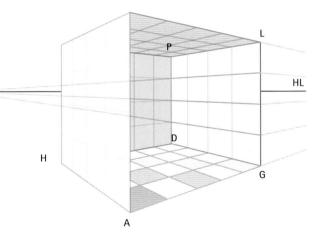

9. The box as an interior

The same box could be used for a room interior. One side needs to be left open, in this case the right side. The same construction is required as in the previous grid, but where the height lines on the right hand side of the cube meet the edge at line LG they are taken back towards the vanishing point left (VPL) to mark up the inside wall. There are now enough measurements to square up all the inside surfaces.

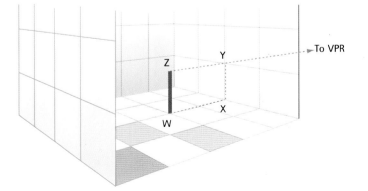

10. Finding points in the room

Any objects or features can now be placed in the room in the correct place and at the correct size by counting and following the squares. Height can be calculated by counting up on the outside of the box and projecting back into it following the correct vanishing line.

The object here has been placed two units back from the front of the room and three units in from the left. To make it 1 unit high, first project the vanish line from its base W across to the outer wall at X. Then measure 1 unit up to Y and follow the grid lines back to the correct height at Z.

Cottage

**After a cube, the most frequently encountered two-point subject is probably
a building with conventional vertical walls and right-angled corners.**

Unfortunately, walls are not always at right angles to one another (nor, indeed, are they always vertical) and there are often additional features which complicate the overall view. However, for a first exercise I suggest that a simple straight-sided building, such as this cottage, will demonstrate the principles involved.

There is an extra rule that we haven't yet dealt with

and that is the one that you need to draw a pitched roof. Any sloping face of a building, or anything else, is described as a rising plane, so the assumption that we have used so far, that planes have all been horizontal, has now to be extended.

The following diagrams and captions show how easy it is to include this new (and later to be very useful) concept.

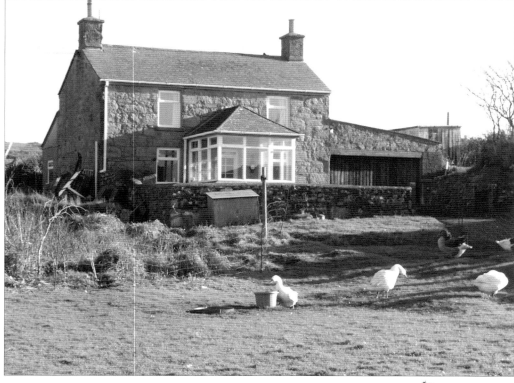

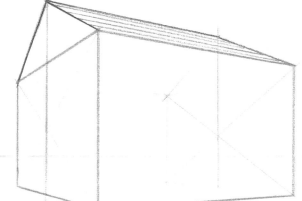

1. A pitched roof
Most roof ridges are central and parallel with the walls and can be placed by vertically extending the center line of each end wall (found by drawing the diagonals). The two pitches of the roof will now meet on these lines to form the gable end. It is your choice how high to place the ridge and therefore how steep to make the slope of the roofs. All horizontal tile or slate lines will have the same VP as the long wall.

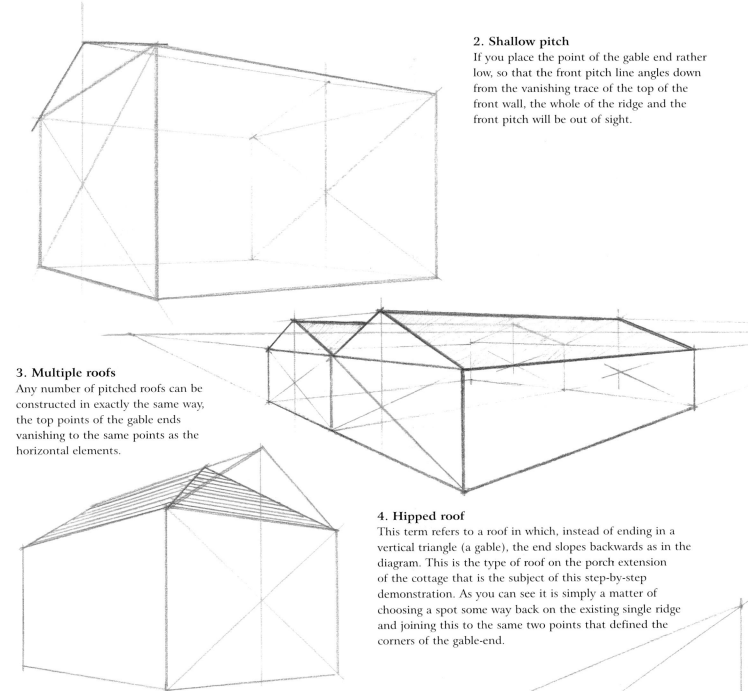

2. Shallow pitch

If you place the point of the gable end rather low, so that the front pitch line angles down from the vanishing trace of the top of the front wall, the whole of the ridge and the front pitch will be out of sight.

3. Multiple roofs

Any number of pitched roofs can be constructed in exactly the same way, the top points of the gable ends vanishing to the same points as the horizontal elements.

4. Hipped roof

This term refers to a roof in which, instead of ending in a vertical triangle (a gable), the end slopes backwards as in the diagram. This is the type of roof on the porch extension of the cottage that is the subject of this step-by-step demonstration. As you can see it is simply a matter of choosing a spot some way back on the existing single ridge and joining this to the same two points that defined the corners of the gable-end.

5. Pitched roof VP

To find the other VP of a pitched roof, which you may need in order to line up parallel rows of pantiles for instance, extend the edges to a convergent point which will be in the sky vertically above VP2 of the main building. (The unseen descending pitch will vanish to a point the same distance below VP2.)

1. Using a selection of colored pencils on tinted paper establish the left-hand vanishing point and horizontal eye line. (As this building is erected on rising ground this is surprisingly low.) The perspective of a distant building is subtle with VPs some distance away. Either guess at these or add scrap paper to the sides of your drawing paper to accommodate. If guessing, check the distances between receding parallel horizontals; although the distances between will diminish as they converge the ratio of the spaces between should remain the same.

2. Draw in some major verticals. As this building is drawn in two-point perspective these will be at a constant 90° to the eye level. A quick check to see if the pitch of the roof meets at the center of the building can be made by completing a rectangle on the building's shorter side, drawing in the diagonals and running a vertical line through where they meet towards the apex of the roof. (See previous page.) Add the main outlines of the outbuildings. The pitches of their roofs (drawn in red) do not relate to the perspective lines of the rest of the building. These must be judged by eye.

3. Construct the pitch of the porch roof and observe how the front plane is tipped back and is not parallel to the building's façade. Add the two chimney stacks; these should follow, in miniature, the receding perspective lines of the main building but beware, details such as these on old buildings are often not true. Finally start to add some horizontals and verticals of the stone fabric. Although these are randomly shaped, close observation will reveal recurring true horizontals and verticals.

 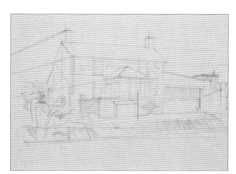 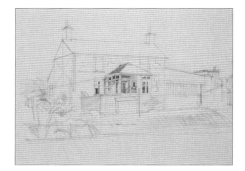

4. Continue adding extra visual information to the drawing noticing where these link to the overall perspective, such as the small window in the side of the outbuilding at the rear, and where they do not, such as the tilting bunker built against the front wall.

5. The perspective of the ground on which this building sits is masked by being both uneven and rising. Shadows on the ground will help define the differing angles of the ground. Add the visible horizon behind the building. Once again, as this scene is viewed from a low viewpoint, this is positioned considerably higher than the eye level horizon. Lightly add the side shadows to stress the building's three-dimensional nature.

6. In preparation for completing the drawing erase any unwanted construction lines. With a dark conté pencil define the smaller elements of the porch, constantly referring to the lines of recession and noticing where these relate, such as on the glazing bars.

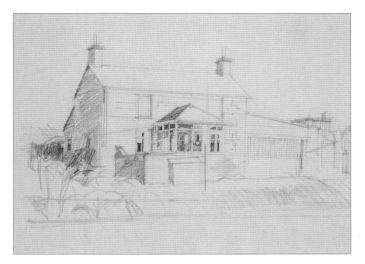

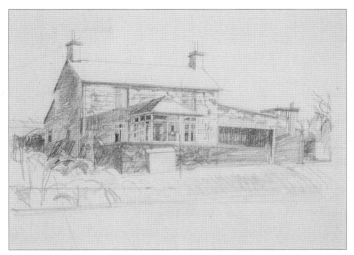

7. Blend blue and brown pencil drawing to enrich the side shadows and add others in the same plane such as those on the sides of the chimney stacks. The darkest shadows are those where the roof slightly overhangs the rear side of the building and the back outhouse.

8. With a pale blue pencil render the reflections in the upper windows. Now, using a mid-gray pencil, add the cast shadows made by the porch on the left-hand side of the cottage and on the left-hand outbuilding. Although the front garden wall appears to be parallel to the front of the cottage when seen from this view it is in fact angled to it, with the right-hand corner further forward than the left. This explains why this wall is in shadow and not lit by the sun, unlike the cottage's façade.

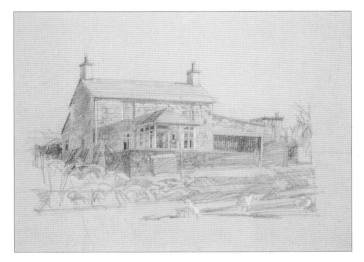

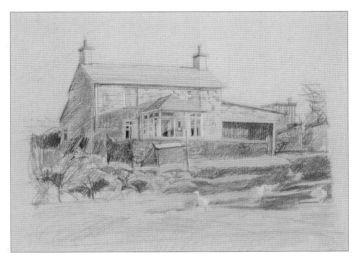

9. With a white pencil define the glazing bars facing the light. Use the same pencil to render the geese on the grass in front of the cottage. Use light gray to softly add local color to the cottage's roof and porch. Use this same pencil to add more local color to the building's façade.

10. Finally, use a broad technique to color the grass and sky, areas generally unaffected by the obvious laws of perspective. Use a warm green pencil to render the sunlit grass and a darker, cooler green for its shadow areas. Keep the drawing technique for these two areas broad and vigorous to give a lively edge to the drawing. Finish by working over areas of the drawing with a black conté pencil to accent the darkest areas.

Grand building

The perspective principles involved in drawing a large building are much the same as those you have already used to draw a simple cottage.

Most buildings have plans that are based on regular, parallel sided figures, i.e. squares and rectangles. Even quite complex-looking buildings, when looked at closely, are often just a larger version of a smaller building with more floors, windows, doors etc. Sometimes they can be essentially a conglomeration of smaller buildings.

In such buildings there will only be two vanishing points, all the parallel features converging in perspective on one or the other

It doesn't make any difference to the basic principle whether there are two, twenty, or two hundred windows; if they are all set in the same wall they will vanish to the same point and so will the windows and doors and other horizontals in all the walls which are parallel to it. All the horizontal elements of walls at right angles to these will vanish to the other vanishing point.

Natural History Museum, London
Although there may be some evidence of three-point perspective in this photograph I have ignored it and drawn all the uprights as true verticals. Only the eight-sided top floor on each of the two towers departs from the principle of four walls with two VPs. These octagonal structures can be thought of as squares with the corners cut off. For a closer look at the construction of slightly more complex versions of these, see the next project.

1. Using a 4B pencil on a rough watercolor paper a basic framework of the major vertical and horizontal features is constructed. (Remember to keep a soft pencil constantly sharpened when using it on textured paper.) Remember, too, in a drawing such as this, it is more important to have the drawn lines following the right directions than having them drawn mechanically and rigidly straight.

2. Concentrate on the nearest tower – the key element of this perspective composition. The front face of the tower recedes towards a right-hand VP, not far outside of the picture area. The side face has much subtler perspective distortion with a VP far to the left of the drawing.

3. As the top of the nearest tower is out of the picture the apex of the further tower is now drawn in. (Do not be confused by the white line of the flag pole which makes it appear that the furthest mini-tower on the left hand corner is detached from the main structure.) Add other details such as the window openings to this area of the building. Note that they all recede to the left-hand VP. To accurately plot the center of the tower's pinnacle construct a box around the top of the main part of the tower and bisect this with parallels. A vertical line drawn through this will locate the central, vertical axis (see illustration page 48).

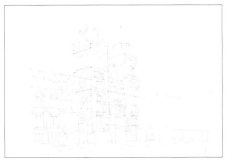

4. Now work on the central element of the building containing the main entrance. Notice how the "contained" arches of the windows, and the entrance in particular, are offset against each other. Start adding the railings and supporting pillars, making these follow the overall two-point perspective structure.

5. Now plot the overall structure of the remaining parts of the building, carefully allowing these to relate to the two VPs. Once these are completed return to the finer details of the nearest tower, noting how these replicate those on the further one, albeit larger.

6. Where details of the building's façade are obscured by external elements, such as the tree in the middle ground, it will be possible to complete these details by following the rules of two-point perspective. Render them all to accurately establish the complete façade. The tree can be overdrawn later.

7. Prior to adding watercolor washes use the pencil to tone the darkest shadow areas such as the window recesses and the deeper decorative features.

8. Continue to add further tonal areas to the overall drawing to enhance the building's three-dimensional qualities. Some of the horizontal striped patterns in the brick work and roofing can be suggested but take care not to let these dominate the drawing. Other details, such as the trees, can also now be added.

9. The initial pencil drawing is completed by adding the final touches to the building's left side. This area of the image, being closest to the viewer, reveals the most detail including the window panes and the reflections bouncing off them, all of which add to the drawing's sense of depth.

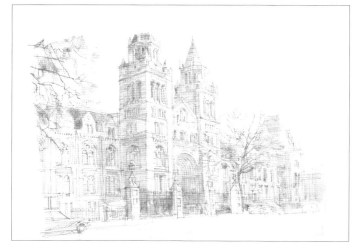

10. Erase unwanted construction lines before mixing a thin watercolor wash of raw umber and ultramarine. Apply with a medium-sized brush and pick out the broad shadow areas, diluting as necessary to achieve a range of tones. A reasonably heavy watercolor paper should not need stretching before adding washes providing that these are lightly added to small areas at a time.

13. Heighten the overall contrast by adding extra tonal glazes to some of the darkest areas. Finally, with a fluid wash of cobalt, complete the drawing by freely adding a broad glaze to the sky leaving areas of white paper reading as cloud formations.

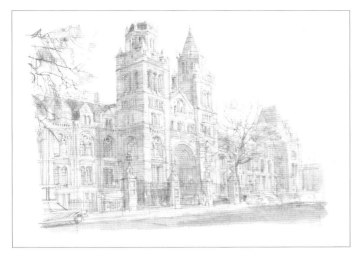

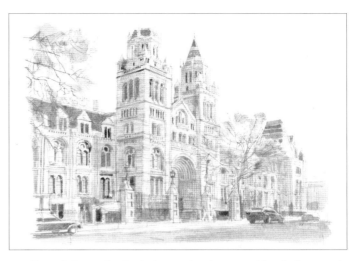

11. The darkest tones of the building are rendered with a stronger wash of ultramarine and raw umber. Now, with a smaller brush, strengthen the overall draftsmanship by accentuating finer details such as the arches over the windows. Work over the whole image with pencil, strengthening the original drawing where necessary.

12. Use a light wash of cobalt to color the near side windows and the blue tiles on the roof areas. This blue-gray color is also broadly applied to the road surface. Lightly scumble a wash of burnt sienna over the warmer toned areas of brick work on the façade, keeping this thin and fluid to avoid overpowering the pencil drawing beneath.

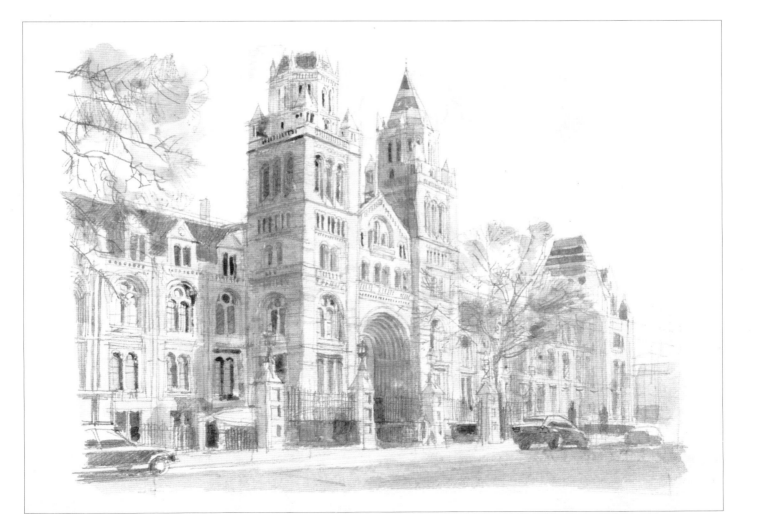

Multi-sided

Most buildings are rectangular or composed of several rectangles. But sometimes they are composed of other figures – pentagons, hexagons or octagons. How does perspective apply to these shapes?

As we have seen, the walls of a rectangular building may have one, two or, at the most, three vanishing points. Each wall of a five-sided structure needs its own vanishing point although you will only be able to see three of those sides at any one time. If the building is six- or eight-sided, although there will still be pairs of sides which are parallel to each other therefore sharing VPs, there will also be extra ones.

The appearance of these extra VPs does not change this from being basically two-point perspective; it is just as if several buildings were overlaid on one another, with all the VPs on the same horizon.

If we assume that the structure is not transparent with its far walls visible, then the number of walls that you can see may give a clue to the total number. Three walls visible may indicate a pentagon but it could also be six-sided. If the only way that you can see three walls is to be almost flat on to one of them it is likely to be five-sided. If you can see a large amount of two walls and a little of a third, it is more likely to be six-sided.

If you can see something of four sides it must have at least eight. A regular structure with more sides than eight is best dealt with as basically circular and therefore elliptical in perspective.

Regular octagonal buildings, or parts of buildings, are often set in conjunction with square structures. When this happens, four of its eight sides are usually in line with the square part of the building and converging on the same VPs.

1.Medieval market cross
Although basically octagonal, the subject of this exercise includes some square and rectangular elements (see illustration 1).

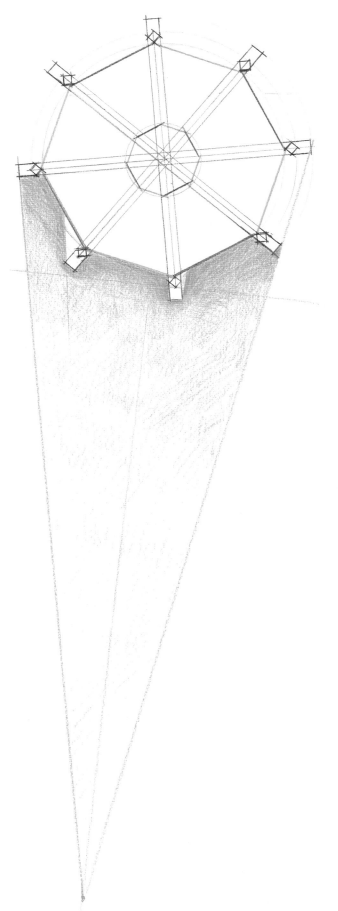

1. Plan view from a deduction

Without access to actual plans, much can still be deduced by observation, even from only one viewpoint. Even more information can be gained, of course, if it is possible to walk around the structure. In this diagram I have drawn pairs of parallel walls the same color.

Although only one of each of these pairs of walls can normally be seen from any one viewpoint, apertures through them and projections upwards from their corners may reveal their common VPs.

Also, a close look at the photograph shows that the faces on the buttresses are not parallel to any walls. As you can see here, this is because the buttresses are radial, i.e. their centers converge on the center of the whole structure. Further examination shows another variation; the mini towers at each corner are square section and rotated 45° on their buttress support.

In addition I have assessed the position from which the photograph was taken (orange). Note that a little of the purple wall can be seen but that the green one can only be sensed by reference to the two buttresses.

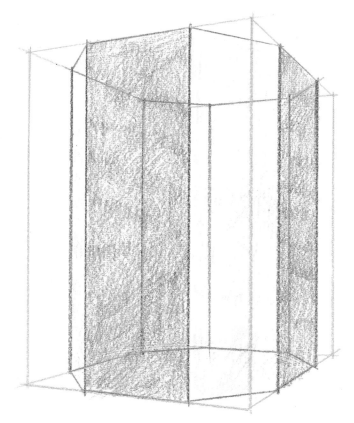

2. Octagonal structure

A useful way to visualize an octagonal building is to imagine a cuboid (in effect a tall cube) structure erected on a square with the corners cut off to make the other four faces. Then two of the faces that you can see will always make a right angle with each other. In this case the red pair are on the original green square and the blue ones, if extended, would also meet at a right angle.

1. When drawing with pen and India ink, as here, a pot of clean water to dip into in order to dilute the ink on the nib is useful, especially when plotting fine details. Have a piece of scrap paper to hand as well so that the density of the dilute ink can be tested before drawing. Begin by establishing the five towers at the corners of the four visible faces. (This includes the barely visible face on the extreme right.) Also, render the centers of the arches as a basis of adding further detail later.

2. Continue by drawing further structural detail to build the basic form of the building. Add the visible arches of the furthest sides. Plot the overall shapes of other major elements such as the clock face. (See Ellipses, pages 83-84). Keep the ink pale and dilute for these initial plotting exercises. Notice how, although this multi-sided structure is seemingly complex, it still obeys the laws of two-point perspective with the right-angled, alternate faces of the building behaving as the adjacent sides of a rectangular structure.

3. Check the drawing against the actual building for accuracy. Correct if needed. When you are satisfied begin to add stronger elements such as the points around the base. Notice how this building, which is illuminated by directional sunlight, has much of its surface defined by shadows. Distinguish between these and the projected shadows of any surrounding buildings.

4. Using a less dilute ink start to draw the building's apex, including its curved supports, and observe how these relate to the base structure. Work over the whole of the drawing, gradually building up areas of structural detail. In an old building, such as this, freehand drawing emphasizes the eroded quality of its stone fabric.

5. As you become confident of the accuracy of the plotting of the drawing continue defining the surface shape and structure. As in step 2, be constantly aware of the basic rules of two-point perspective and check and correct, if necessary, elements with common VPs. Add fine lines to define these if it helps. Remember, too, that all surface detail relates to the planes of perspective and is not merely superficial patterning.

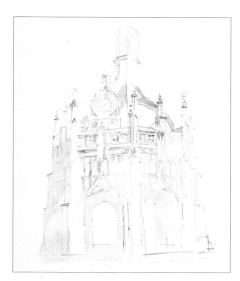

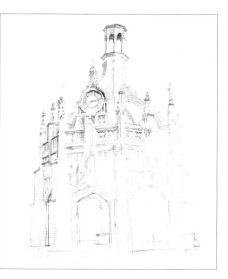

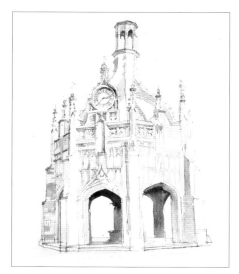

6. Having rendered the major elements of the line drawing start defining some of the major planes in shadow by using a light wash applied with a brush. Introduce a warm element to the image by using a very dilute mix of raw sienna and black inks. Keep these light and simple at first, they can always be given extra as definition later.

7. When drawing the top section of the structure notice how it is also octagonal and therefore follows the perspective lines of the structure below, even though it is seen from a much lower viewpoint. Reverting to pen and ink again, work over the image, strengthening the lines of the original drawing and adding further definition and solidity.

8. Apply darker areas of wash with the brush to the deep shadow areas to give further form and definition to the drawing. Use the brush to pick out areas of stone patterns such as in the base of the left-hand column.

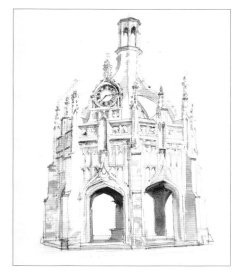

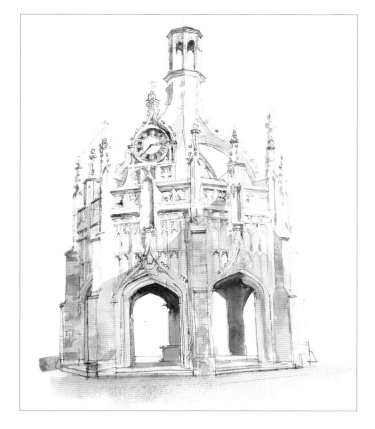

10. Finally, with the brush loaded with dilute ink, add the large projected shadow from the building out of shot, to give the image an overall context.

9. With both brush and pen, work over the whole picture, sharpening details, strengthening tones and further defining areas of drawing until the basic drawing is complete.

Using measuring points

By now you should be familiar with the way objects look when drawn in two-point perspective and be able to create a perfectly acceptable two-point drawing based on guessing the first square.

For those who would like to take it a little further, the following method explains how to construct everything without the first piece of guesswork. This method follows the same pattern as that for measuring in one-point perspective but now uses two measuring points.

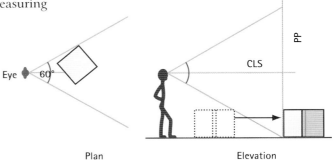

Plan Elevation

1. Checking the cone of vision on the plan and elevation
As before (see One-point, page 38), check that the object fits comfortably within the 60° cone. Note the cube is now at an angle to the viewer.

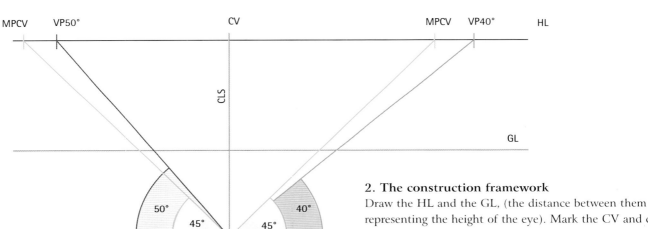

2. The construction framework
Draw the HL and the GL, (the distance between them representing the height of the eye). Mark the CV and draw the central line of sight (CLS) downwards to E, the length corresponding to the minimum distance that you have just calculated between eye and PP. In case you need to place points behind the PP, add the MPCVs (no 7, page 40).

Add vanishing points to accord with the angle that the object makes with the PP. The plan in diagram 1 shows that in this case the angles are 50° left and 40° right.

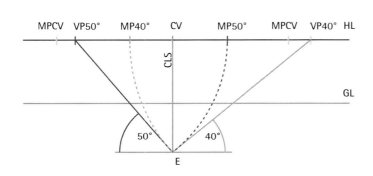

3. Establishing the measuring points
In order to measure in the direction of either of the new VPs, measuring points must be used. Each MP is found by taking the distance from the VP to the eye (E) and laying it along the HL with the VP as the pivot, or putting a compass point on a VP and inscribing an arc through E up to intersect the HL.

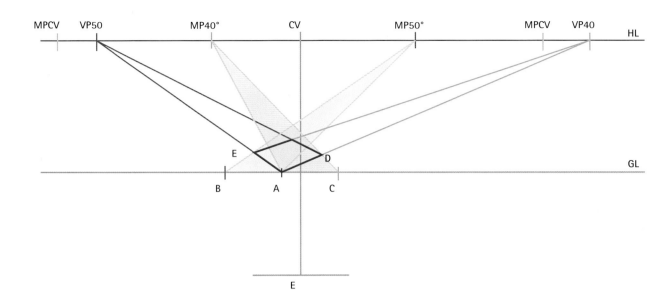

4. Using the measuring points to measure a square

Choose a position on the PP for the near corner of the cube (A), (left of the CLS, see diagram 1) and project from this to both VPs (VP40° and VP50°) to form the front two sides of the cube base. To measure along these lines of vanish, the relevant MPs must be used.

For the base line length from A towards VP50°, first draw a line from the MP50° to A (not strictly necessary in this case, but a good habit for when the point you need to find is behind

the PP). Then measure the true scale width of your cube along the GL to B and project a line back again to MP50. For the other one, measure along the GL to C and then back to VP40°. The crossing points E and D define the base of the cube.

Notice that your constructions have formed triangles (colored green and blue). When using MPs your constructions will always do this – if they don't then something is wrong!

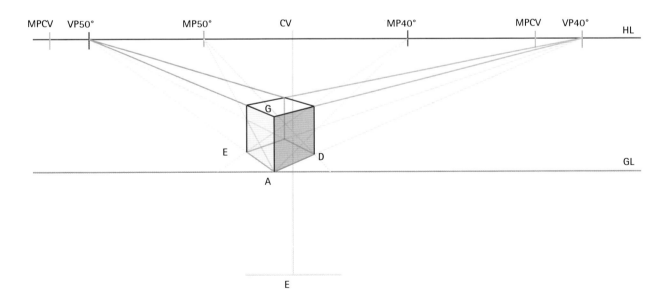

5. Measuring heights against the PP and completing the cube

Height is measured against the PP with a ruler as in one-point perspective. Completing the cube is simply a matter of measuring up from A to find G, projecting verticals up from the back corners of the square and drawing lines from G vanishing towards the relevant VPs. The box is formed at the points of intersection.

ADVANCED

6. Measuring to the left or right beyond the PP

If more measurements need to be made along the same lines of vanish as the cube they can be added along the GL. Imagine the cube measures 1 unit and another 1 unit cube stands on line A to VP40° at 1.5 units from D. If you want to measure in the direction of 40° to the PP you must use the MP40°. Assume you have just drawn the line from MP40° through D (which is the point you want to measure from) to the PP at J. Then

measure 1.5 units from J along the GL to L and complete the triangle by projecting a line back to the MP40°. Where this line cuts the vanishing line A to VP40° at M, is the spot where the second cube will start. Repeat the procedure for the width of this cube; from MP 40° through M to L, measure 1 unit along to N and back to MP40°. The rest of the cube can be found by projecting to the vanishing points from the first cube.

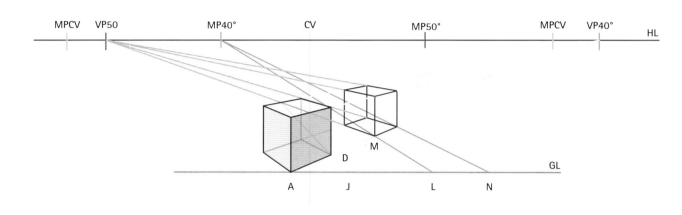

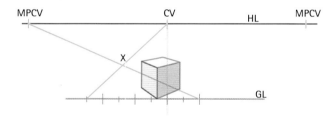

7. Measuring any point beyond the PP

If you need to find a point beyond the PP which is unrelated to the first object, use the VP45° in exactly the same way as for one-point (caption 12, page 43) i.e. by the intersection X, of lines from measured points on the GL to the CV and the MPCV.

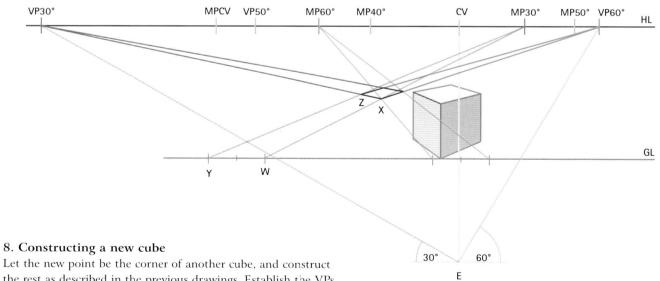

8. Constructing a new cube

Let the new point be the corner of another cube, and construct the rest as described in the previous drawings. Establish the VPs and the MPs (if they are different from the first cube) then draw in the vanishing lines from the corner X and measure the sides using the appropriate MPs. For example, to find Z, draw from MP30° through X to W, measure along the GL the appropriate width of the cube to Y and return to MP30°.

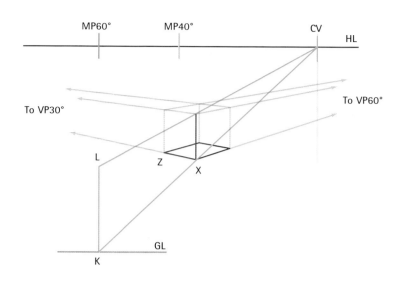

9. Measuring heights beyond the PP

To measure a height at X, since heights can only be measured against the PP, a connecting line must be made with it between the HL and the GL as if a line was drawn on the floor from somewhere on the horizon passing through X and forwards to the PP. Where the line intersects the GL (K), the height can be measured to L. A line from L to the HL at the CV now represents this height all the way to the horizon, rather like a fence, so a vertical drawn at X or anywhere else on this line will be the correct height.

Although the point on the HL used in the diagram is the CV, it doesn't need to be; once the height has been established from the GL, your "fence" can go in any direction to the HL and can then be used for vertical measurements from any points. Alternatively, the same point could be used on the HL with multiple measuring lines at the PP.

<div style="writing-mode: vertical-rl">ADVANCED</div>

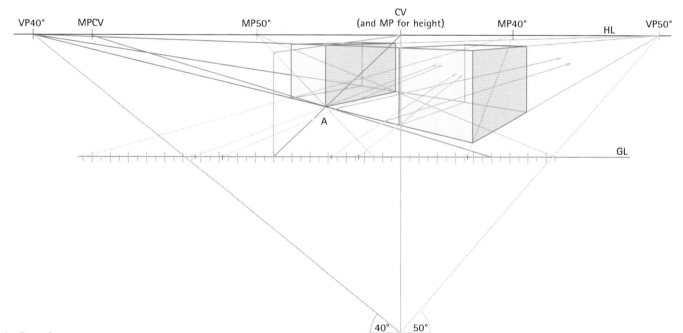

10. Simple street scene

This is the same street scene as diagram 16 on page 43 but viewed slightly from the side. You could set this drawing up using the same measurements for the framework, height of eye 23ft (7m) with the eye 56ft (17m) from the PP. This time the nearest corner of the house on the left (A) is 7 units to the left of the CLS and 12 units beyond the PP. The right side of the house makes an angle of 50° to the PP and therefore the left is at 40° to the PP. The house is 20ft (6m) high, 33ft (10m) wide and 20ft (6m) deep. The sidewalks are still 5ft (1.5m) wide and the road 20ft (6m) wide. Again you could use these specifications to start your drawing and then add your own details by eye.

Three-point
Photo examples

As I have already mentioned, almost everything you see is in three-point perspective although the third vanishing dimension only becomes unavoidable when you are looking down on an object or a scene from on high or from a very low viewpoint.

Most of the time, at normal eye levels, the omnipresent third vanishing point is relatively subtle. Even when it is "corrected" and all up or down converging lines returned to vertical, the sense of depth and rightness seems unimpaired and for this reason the up and down vanishing is usually ignored.

When you look up at a tall building, you normally have no difficulty in judging, without conscious thought, whether its sides are vertical. So instinctive is this that the fact these sides are visually converging is often missed entirely. Only when the view is recorded by the camera does it become obvious how severe this convergence can be.

Curiously, the same does not seem to apply when looking down from a high building, when the convergence is all too real, a really tall building seemingly balanced on an impossibly tiny base. Clearly a sense of survival is involved here.

The following projects address the situations where vanishing to three points is so obvious as to be unavoidable.

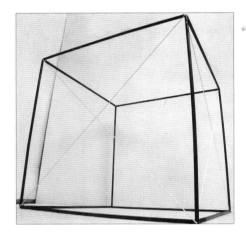

1. Looking up
Now the sides of the cube converge upwards towards the third VP. Note that the diagonal strings now cross at a point nearer the top than the base.

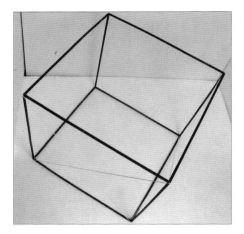

2. Looking down
Now the cube's base and top each have two vanishing points but the vertical sides converge downwards towards a third one. The situation demands the use of three-point perspective.

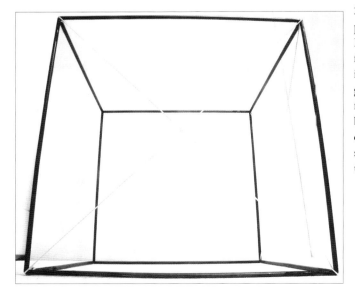

3. Back to two-point?
Looking up or down from a point directly in front of the cube gives only a single VP for the top and base but the upward convergence remains, so it is technically two-point.

Setting up

Starting from three-dimensional cubes, like those on the opposite page, whole buildings can be constructed.

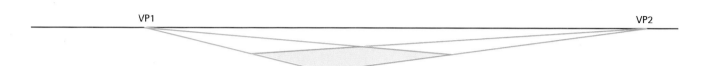

As with the other "setting up" constructions, this begins with a cube which looks correct. The cube must be in three-point perspective and it should be even easier to judge its correctness because this is the perspective most often encountered in real life. By now you should be able to quickly imagine such a cube but, taking every opportunity of observing and drawing the real thing from a variety of view points, will help you to make increasingly acute judgments.

But why would you want to do this? In the introduction I stressed that my prime intention was to introduce concepts of perspective that would assist in understanding what is observable in the real world rather than creating measured 3D versions from plans.

Well, first of all, I think that these exercises help to fix the laws in your mind so that when you look at objects and scenes you recognize the patterns. Also, if you would like to visualize a completely imaginary collection of buildings or objects, this method will allow you to do so without having to tackle the much more arduous measured perspective procedures. In view of the enormous variety in the appearance of objects when seen from different viewpoints – although it may fall short of absolute accuracy – it would be hard to deny its veracity at a practical level.

1a. A building viewed from its base.
Using two VPs, assess a square on the ground plane near to the eye level. Not particularly easy to do but it will become apparent as you progress if it is grossly wrong in which case you can adjust it.

1b. Choose a third vanishing point vertically above the center of the ground plane square and erect the sides of your "building". The greater your chosen height for VP3, the more distant your viewpoint will appear to be.

1c. Complete the cube by assessing its height and drawing its top edges to VP1 and VP2.

1d. A complete building can then be constructed by diagonals (red) as described on pages 22–23. The cubes can be subdivided as many times as you would like in the same way.

VP1 VP2

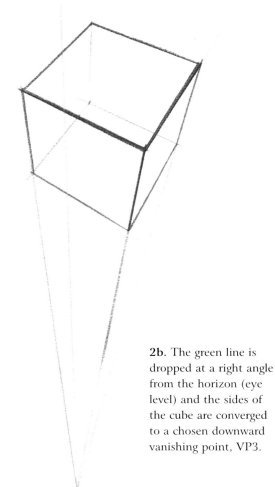

2a. Looking down on a rising structure.
(a) This is an assessed perspective square viewed from a high (out of picture) eye level.

2b. The green line is dropped at a right angle from the horizon (eye level) and the sides of the cube are converged to a chosen downward vanishing point, VP3.

2c. To make a rectangular block a second square is added by the halving and doubling method (pages 22–23 and d, see opposite).

2d. By the same process the double cubes are projected downwards to make a multi-storeyed building.

2e. Other features can now be added, it could even be transformed into an entirely different structure, a space rocket and its support tower perhaps, all from one basic building block.

The essential point of this exercise is to demonstrate that, given one building block in the form of a convincing cube in perspective, the constructions that can be extrapolated from it are virtually limitless.

Tall building – low eye level

Ancient and modern high-rise buildings alike can display diagonals and curves as well as the more usual vertical and horizontal elements.

This office building is largely constructed of glass and steel, adding transparency and reflectivity to the general pattern of three-point perspective.

It could be considered to be more than three-point as the ascending escalator in the foreground has another VP. This is because it is a rising plane. An uphill road, a flight of steps, a pitched roof – all these are rising planes with VPs above or below the horizon depending on whether they are ascending or descending from your point of view

(see pages 96-107). Reflections of other buildings in the glass wall may appear to obey no apparent rules. Actually, if all the facts about the orientation, distance and size of the reflected objects were known, their reflections could be accurately predicted (as you will see in chapter eight), but without that knowledge all you can do is to simply draw what you see. There is often some distortion of the reflected image in any case, due to the imperfect flatness of many of the glass panes.

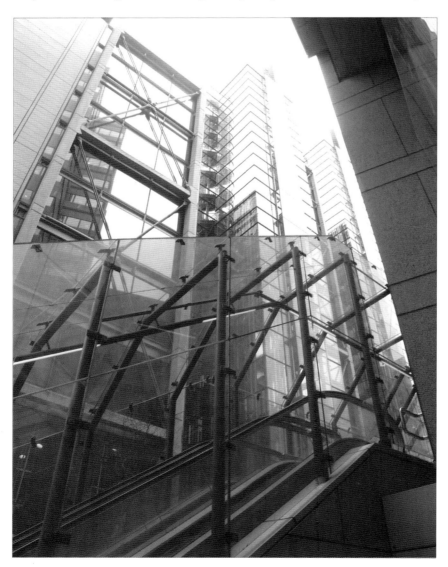

Modern materials
At first glance this photograph of an ultra-modern office block – built of concrete, steel and glass – looks challenging. Applying the rules of three-point perspective, however, as explained in the following steps, soon makes visual sense of the image.

Vanishing point for the escalator
In this diagram the green lines vanish to the two VPs of the main building on the horizon (red) and the pale blue lines converge on the third VP in the sky. Because the escalator, (dark blue lines) is in line with the building, its' VP should be above the right hand VP of the building (see Pitched roof, page 48). However, because all verticals are vanishing to the third point in the sky, the VP of the escalator, which is a rising plane, will be on a line from this VP in the sky to the right-hand horizon VP (orange). Just where it will meet this line depends on the steepness of the escalator.

1. Begin by drawing the two elements of the main tower block. Establish the overhead VP (even though it is out of the picture) by projecting some of the main verticals. Once this has been plotted continue by adding all of the other parallel verticals.

2. Continue by adding the parallel lines leading to the horizontal VP on the right. As this is not only out of picture, but off page too, assess these lines visually and judge carefully whether they appear to be converging on the same spot. Continue the lines as far as your drawing paper allows, the closer they get, the easier they are to assess. Correct as needed.

3. Repeat this exercise towards the imaginary VP on the left. Draw two lines with a reasonable amount of space between. It will facilitate the plotting of the subsidiary lines between. The three-dimensional quality of the building now begins to emerge in the picture.

4. Now begin to draw the basic structure of the glass-clad escalator. This, as it ascends, has its own VP until it turns at the top. Here, as it again becomes parallel to the building's horizontals, it converges on the right-hand VP.

5. Having established the plane of the vertical side of the escalator's glass wall it is possible to add the metal arms of the structure seen through the glass. Take care to evaluate your drawing constantly and check its accuracy.

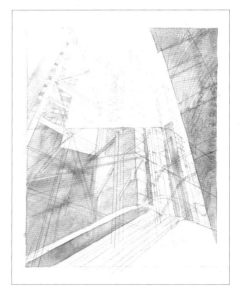

6. Draw the diagonal tie bars on the windows of the section of the building nearest the viewer. Notice how these are an architectural example of the laws of diminishing rectangles defining the rectangle's halfway point (see pages 20–21). Add the reflections of the tie bars seemingly sitting just behind the actual bars themselves. Begin drawing some of the more freehand details of the building such as its curved, right-hand edge. Start adding tone to stress the form.

7. Before adding color to the drawing erase the now superfluous construction lines. Begin by mixing a turquoise wash and lay down some of the larger, lighter colored areas using a broad and free technique. (Remember that watercolor is always a process of working from light to dark.) Use the translucent qualities of watercolor to echo the similar qualities in the glass.

8. With an ultramarine and black mix establish the area of the dark shape of the anonymous building on the right. (This is a preliminary wash prior to adding a darker one later.) Using a darkened but fluid turquoise mix other areas of "underpainting" are added towards the base of the image. Simple washes will be built up to represent the layers of reflections in the glass walls and windows.

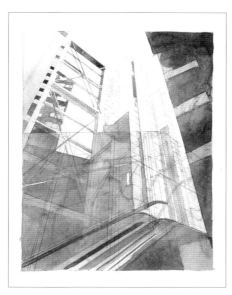

9. Use a dark wash to define the broad details of the escalator rails. Add a dark indigo glaze to the earlier underpainting on the right hand building. Leave areas of the previous washes showing as lighter details. With the same indigo wash render the linear details of the central building. As the tonal range of the glazes increases the forms of the buildings emerge.

10. With a fine brush add linear detail to the structure of the elevator. Work into the features of the further sections of the tower block, rendering in watercolor the original pencil drawing. Examine the whole of the image and carefully work over all of it, bringing it all to the same degree of finish.

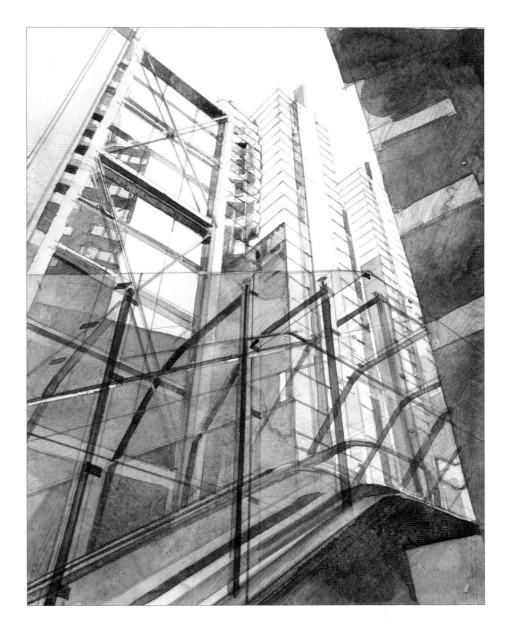

Skyscraper – high eye level

Looking down from on high it is possible to encompass a complete skyscraper in one human-eye view.

The difficulty of seeing the whole height of a high-rise building in one look when it is viewed from the ground is entirely absent when a similar building is seen from above. As long as other structures are not obscuring the view there will always be a position where the complete building can be included in the 60° cone of vision. Indeed, from a sufficiently high viewpoint, a whole host of skyscrapers can be included without distortions.

The severity of the perspective effect will also depend on your height above the highest building. Just as your distance from an object on the ground changes the sharpness of perspective convergence, so your distance above an object does the same. Looking vertically downwards from a viewpoint actually on the top of a tall building gives the very sharpest perspective to an often dizzying degree. A tall structure, even when quite broad-based, may appear from the top to have a dangerously small contact with the ground and a structure, such as a radio mast which has a small "footprint," will appear to be balancing on a needle point.

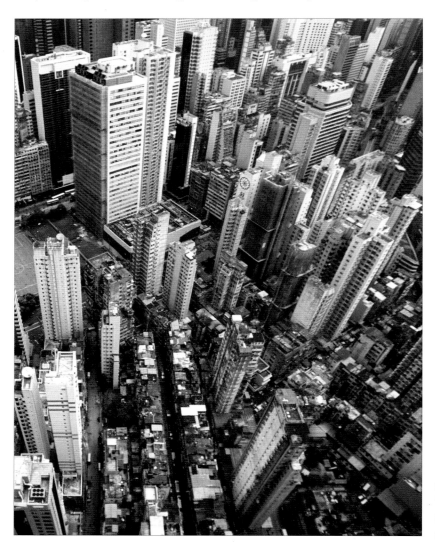

City from the air
This is a small section of an aerial photograph of New York taken from a low-flying helicopter. The convergence of verticals, therefore, is quite severe.

1. All the vertical sides of all the buildings, in this low level aerial view, converge sharply on a point not far out of the base of the picture. Establish this point by extending a few of the more clearly defined edges. I have used charcoal to give an overall, generalized impression of the extraordinary complexity of this view.

2. A large section of streets and buildings in the left foreground are set parallel to each other, so their horizontal VPs are well out of picture, both to the right and left. Start to indicate their roof shapes from observation.

3. Add areas of tone to differentiate the main forms of the buildings and define the streets. When using charcoal these tones can be easily modified but it is advisable not to be too bold at this intermediary stage.

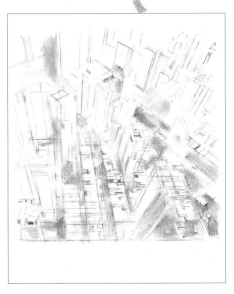

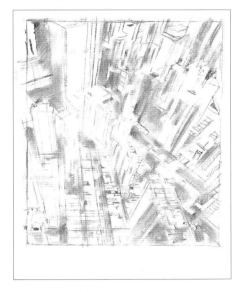

4. Streets in the top right-hand portion of the view are placed at an angle to those already indicated in the bottom left. This means that the buildings along these streets will have another pair of horizon VPs. As they are still a long way beyond the confines of the picture the convergence is very gentle and best judged by eye as before.

5. Of course, the verticals of all buildings, regardless of their orientation on the ground, still vanish to the same below ground VP. Adding more tone by applying charcoal and smudging it with your finger begins to give solidity to the rising columns.

6. At this point I decided to extend the composition by including more of the top portion of the reference photograph. You should never feel constrained by the reference provided; add or subtract to modify the composition as you think best.

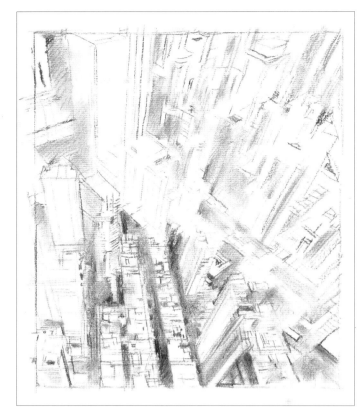

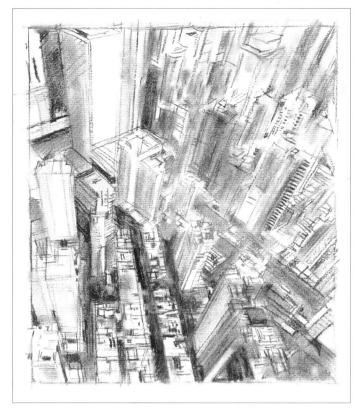

7. In the immediate foreground the dark surface of the street level can now be worked up together with the low-rise buildings of which little can be seen, other than their rather complex roof patterns.

8. Now the middle and background skyscrapers are given more form by applications of smudged charcoal. Some roof detailing helps to separate the high blocks.

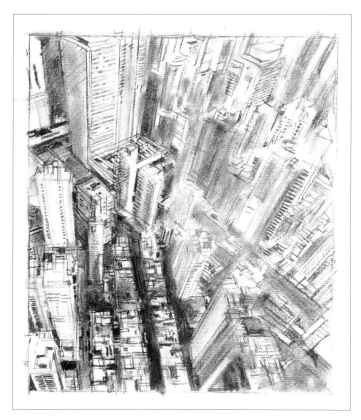

9. Lines of windows, rather than individual ones, while adding reality, also help to define the direction of the planes. As you approach completion of the study allow freehand drawing to dominate while following the underlying perspective framework.

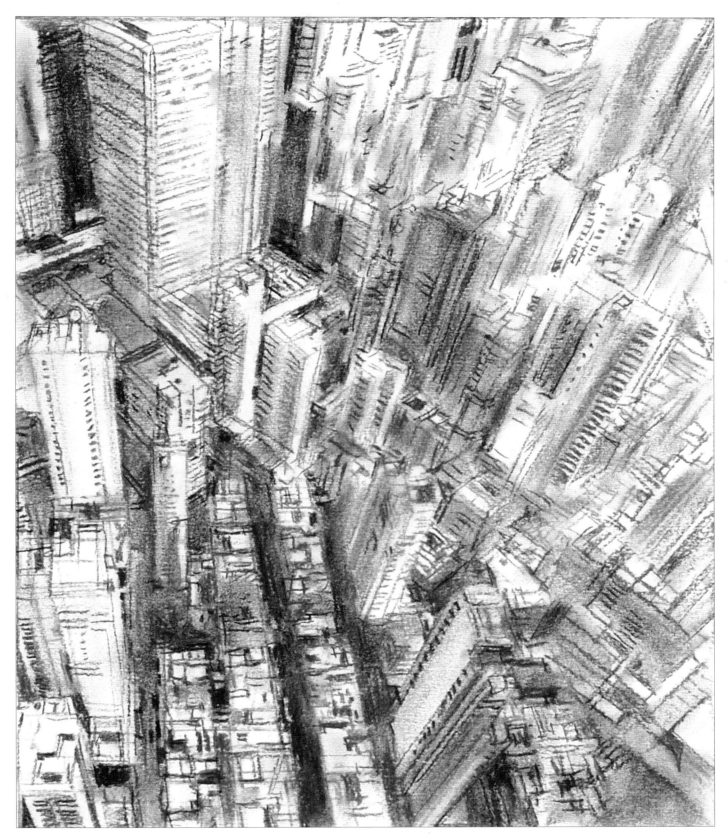

10. How much detail to include is always a matter of personal judgment. I added a some final window lines to the foreground blocks and just a few to the background ones. For an atmospheric study of this type and using this medium, invoking the sense of vertiginous height is paramount.

Cathedral interior

When looking up at the ceiling of a high building, such as this cathedral nave, the upward recession is as dramatic as the vanishing of the arches to a point on the horizon line.

Although this is technically three-point perspective, the third point to the left is a very long way away. Often the only way to find a VP like this is to extend the converging vanish lines with a long rule onto your drawing table or even an adjacent surface if necessary. For this to be useful, you will need to tape down your drawing, mark the VP with a pin or something similar, and then use the same rule, or a length of string tied to the pin, to find any other lines vanishing to that VP.

A new concept in this project is the construction of arches in perspective. Rounded arches involve ellipses and will be dealt with in detail in a later project (pages 83–87) but all that is needed for the pointed arches of this cathedral is to calculate the positions of their points. Since they are placed symmetrically between the columns these points can be located by joining the diagonals and so defining the halfway lines – the points must then lie on these lines (see diagram 1, opposite).

The ceiling is supported by similar pointed arches with some extra bracing provided by slightly more rounded diagonal arches (see diagram 2, opposite).

Receding arches
The tall nave of this cathedral seems to be vanishing to a single point on the horizon but closer examination reveals that, beyond the line of the north and south transepts, it does actually veer a little to the left. This extension of the nave, therefore, points slightly away from the east.

1. Finding the central point of an arch

As before, the perspective center (green) of the rectangle containing the arch is found by joining the diagonals (red). Note that the points where the curves of the arch cross the diagonals are also on a line vanishing to the same VP.

2. Extra ceiling supports

The ceiling support ribs of this cathedral look rather complex at first sight but observation reveals that there is a basis of regularly spaced, simple arches (red). From the beginning of every other arch an extra rib curves through the point of the next arch and continues the curve to the beginning of the next arch again on the other side.

1. For fine detail use an extra hard pencil such as a 9H. Work on an appropriate surface such as a gesso ground which readily accepts this otherwise extreme and unforgiving implement. Use a straight edge for the initial plotting of such a complex image. Through observation, position the main, central VP and build a grid using the arches on both sides of the cathedral. Check their accuracy by faintly running diagonals across the invisible rectangles formed by the matching arches. Observe how these recede towards the second VP way to the left of the drawing. Adjust the drawing as necessary.

2. Establish a network of the major verticals. These converge on the third VP high above the building. Indicate the central line of the roof showing where the arches cross. In checking the drawing against the actual building, it can be seen that the far section of the building – unusually – is out of alignment with the rest of the structure and consequently has its own, subsidiary VPs.

3. Return to the main arches of the nave. Build up a grid of rectangles and bisect them with diagonals and run a vertical through the crossover point to accurately plot the arches' apexes (see illustration 1, above). This vertical plotting line follows the lines of recession to the upper VP. Start shading some areas of detail in order to make sense of the drawing.

4. Drawing in freehand add the details seen through the arches on the left of the nave and continue to render shadow areas to give the drawing tonal as well as linear depth. As the arches recede and the space between them contracts, less and less inner detail is revealed. Start to define some of the molding on the nearer columns and their supported arches.

5. Work on the upper tier of the left-hand arches. Observe how allowance must be made for their recession from the main surface of the structure. Both the arches themselves and the small circular windows above are rendered as ellipses (see pages 83-85). Continue to use a straight edge where necessary.

6. Now render the right-hand side of the nave working in a similar sequence to the left. Constantly check the drawing's accuracy with crossed diagonals and adjust where needed. Notice how, as the main arches recede, more and more of their near edges are obscured by their supporting columns.

Observe also, because it is seen from a much sharper angle, how the recession of the upper tier of arches on this side is even more extreme than on the other.

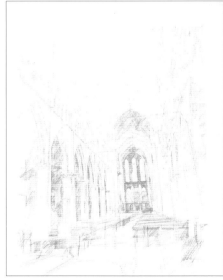

7. The interior roof space is now drawn. This is formed by series of vaulted, crossed arches enclosed within an outer arch (see diagram 2, page 77). Use a central vertical axis line receding to the main VP to accurately position the cross-over points. Add a little shading to define form.

8. Finish the drawing of the far end of the cathedral. Darken the deep shadow areas with pencil. (Although washes are to be added to the drawing these will be used as a means of introducing color rather than tone.) Complete the pencil rendition by adding the tops of the pews receding into the distance.

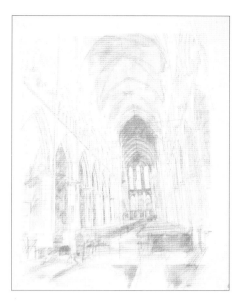

9. With a medium sized brush mix a blue-gray wash from ultramarine, black, and a little raw umber watercolor. Use this to define the darker shadow areas, thinning the wash with water to achieve the desired tone. This can be applied in a reasonably free manner – the pencil underdrawing will hold the image together. With a new mix of raw sienna and gamboge, add the warm color in the building's vaulted roof.

10. Finally, reduce some of the original construction lines across the nave with a soft eraser, add some spots of color to the stained glass windows and reinforce shadow tones over the whole drawing.

Using measuring points

The alternative to estimating the first cube in a three-point construction is to calculate it by using measured three-point (or oblique perspective) to find the vanishing points for each of the three axes – width, height, and depth.

This method can be used to construct any regular shapes but, as befits its place in this difficult section, it can be daunting so I have chosen to show the construction as applied to a simple cube placed in a central position.

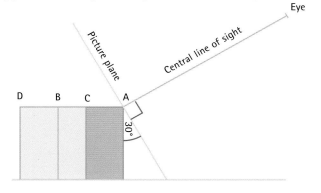

1. The situation in elevation

When the head is tilted backwards or forwards the central line of sight (CLS) remains at right angles with the PP. Therefore the PP moves with the head and makes an angle with the ground similar to the tilt of your head.

Assume that the viewer is high up with the head tilted and looking down on a large cube standing on the ground plane. This drawing shows the elevation of the situation with the PP tilted at an angle of 30° from the vertical.

2. A three-dimensional view

This view shows the situation a little more clearly. The front edge of the cube is at an angle of 30° to the PP.

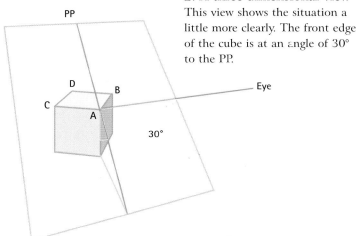

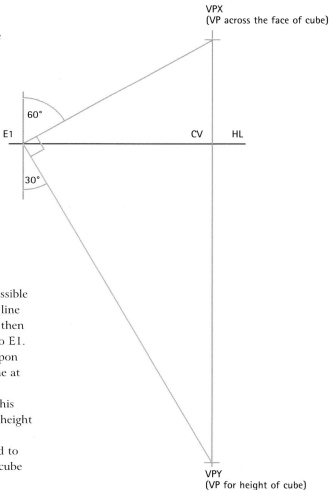

3. Beginning the construction framework

The top face of the cube is at right angles to its front edge and it is possible to construct the two angles it makes with the PP. First draw a horizon line and add the center of vision. The distance from the eye to the PP can then be chosen along the horizon line either to the left or right of the CV to E1. A vertical line drawn through the center of vision will become a line upon which the VPs for the verticals will be placed. Draw a short vertical line at E1 so that angles can be measured from it.

From E1 the angle of the PP from the vertical can be measured (in this instance 30°) and extended to VPY, which will become the VP for the height of the cube, the front edge and lines that are parallel to it. Also at E1 another angle can be measured at 90° to E1 VPY. This can be extended to VPX to create the VP for lines at right angles to the front edge of the cube or an imaginary line across the top face of the cube.

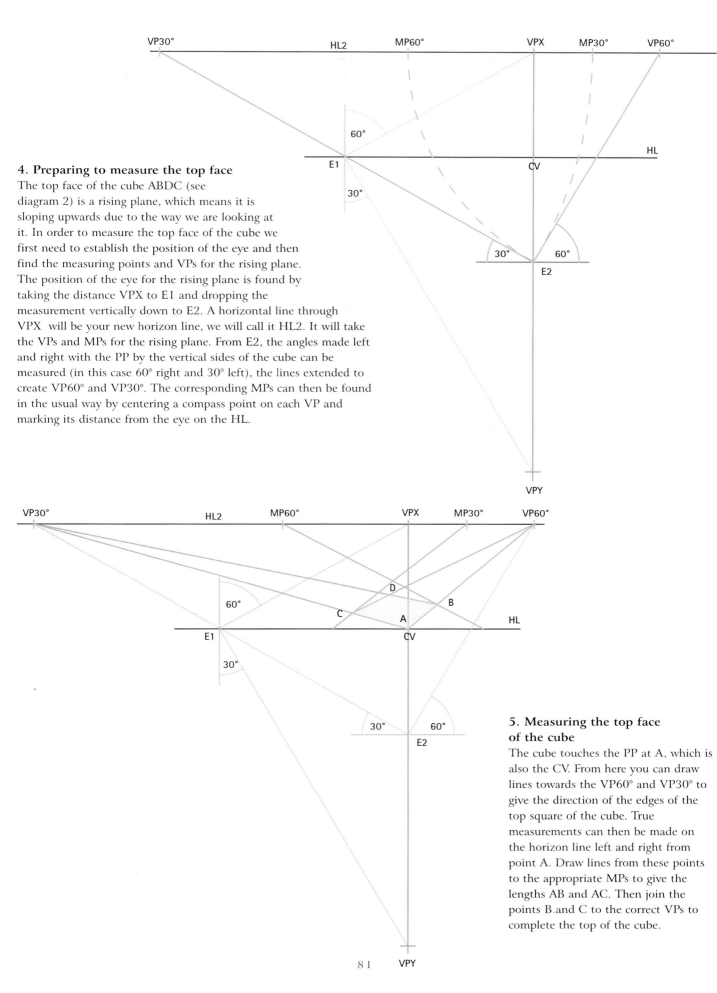

4. Preparing to measure the top face

The top face of the cube ABDC (see diagram 2) is a rising plane, which means it is sloping upwards due to the way we are looking at it. In order to measure the top face of the cube we first need to establish the position of the eye and then find the measuring points and VPs for the rising plane. The position of the eye for the rising plane is found by taking the distance VPX to E1 and dropping the measurement vertically down to E2. A horizontal line through VPX will be your new horizon line, we will call it HL2. It will take the VPs and MPs for the rising plane. From E2, the angles made left and right with the PP by the vertical sides of the cube can be measured (in this case 60° right and 30° left), the lines extended to create VP60° and VP30°. The corresponding MPs can then be found in the usual way by centering a compass point on each VP and marking its distance from the eye on the HL.

5. Measuring the top face of the cube

The cube touches the PP at A, which is also the CV. From here you can draw lines towards the VP60° and VP30° to give the direction of the edges of the top square of the cube. True measurements can then be made on the horizon line left and right from point A. Draw lines from these points to the appropriate MPs to give the lengths AB and AC. Then join the points B.and C to the correct VPs to complete the top of the cube.

ADVANCED

6. Finding the height of the cube

The vertical line running VPX–VPY can be assumed to be running across a direct descending plane and the horizontal line through VPY holds the VP and MP for the descending plane. Find the eye position for the descending plane by drawing an arc from E1 with a compass point on VPY to cross the vertical VPX–VPY at E3. Continue the arc until it cuts the horizontal from VPY at MP–VPY. This is a measuring point for lines running towards VPY.

To help you to understand this, imagine that the page has been turned upside down and compare this part of the set-up with that of one-point.

E3 is now the eye, HL is the ground line, the horizontal line through VPY is the Horizon Line and MP – VPY is the measuring point for the center of vision. The height of the cube can then be found by putting the true measurement along HL from A to F and projecting to MP – VPY. Where the line crosses VPX–VPY is the base corner of the cube G. Draw the vertical sides of the cube from C and B towards the VPY. Finally draw lines vanishing from G towards VP60° and VP30° to complete the cube. All the required points are now on the diagram for gridding-up the cube if necessary, and following the same procedure as for that of finding the height, width, and depth.

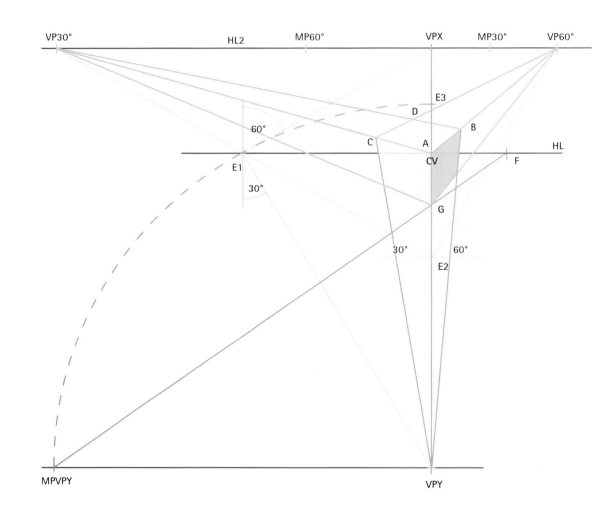

Circles and ellipses
Construction and theory

A circle in perspective has a unique characteristic. However obliquely it is viewed, the shape it makes is a perfect ellipse; a figure that is symmetrical about the lines dividing both its long and short dimensions.

The longer of these two middle lines is called the major axis and the shorter one, not surprisingly, the minor axis. An ellipse is defined as a figure formed by a point that travels so that the sum of its distance from two other fixed points is constant. It may sound obscure but, if you use the two pins and thread construction shown on page 84, you will see what I mean. As you grow familiar with the constructed shape of ellipses, realizing that all the changes of direction are smooth, with no points, you will find it easier to draw them freehand.

An often misunderstood feature of a circle seen in perspective, is that the major axis of its ellipse does not coincide with a line that bisects the circle, the line visually dividing the near half from the far one.

Just as the front half of a rectangle in perspective appears larger than the distant half, so the front half of a circle in perspective also appears larger than the rear half. Unlike the rectangle however, when the two unequal halves are added together, they make a symmetrical whole, a perfect ellipse. I feel there is something almost miraculous about this phenomenon; the only other figure which retains its shape in perspective being the sphere.

1. Seeing is believing
In this photograph of a circular table, the solid black line is adhesive tape precisely marking the circle's diameter. (A diameter is the length of a line passing through the center of a circle and touching its perimeter at two points.) The red square is also actual and is placed so that the black tape exactly bisects it.

The blue containing square has been imposed on the photograph using the vanishing point of the red square. As you can see the perspective is quite extreme, the rear half of the top appearing to be much smaller than the front half. But, proving my original statement, the whole shape is still a true ellipse, symmetrical about its major axis (dotted line).

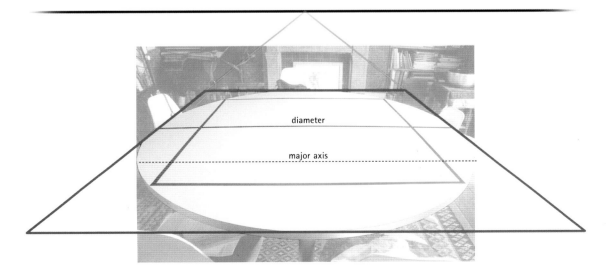

diameter

major axis

2. Pins and thread construction.

This well-known method of drawing an ellipse requires you to place two pins securely into your drawing surface and to tie a loop of thread loosely around them. If you then, with a pencil point, pull the thread taut in any direction, any points you can mark will fulfill the criterion of being a constant combined distance from the pins, the two fixed points. Carefully moving the pencil point around the pins, keeping the thread taut, will describe a perfect ellipse.

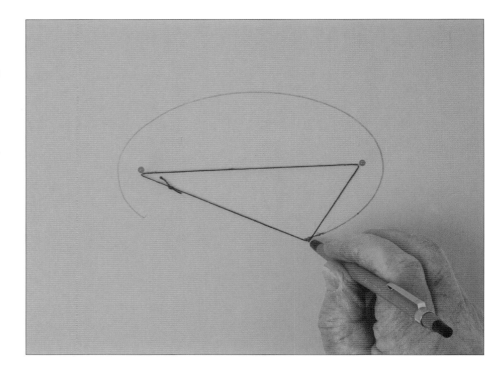

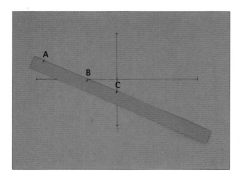

3a. Trammelling

A slower, more controlled method is known as trammelling. For this construction the major and minor axes are first set out.

Then take a strip of paper and mark two points A and B on its edge, representing half the length of the chosen shorter axis. Next, from point A mark a third point C at half the length of the longer axis. Now, place the paper so that point A coincides with the left-hand end of the major axis and point C is at the center. Rotate the paper a little as here, keeping point B continuously in contact with the horizontal axis while sliding point C down the vertical axis and mark a spot at A.

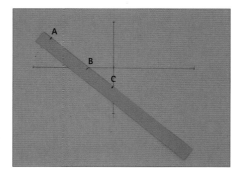

3b. Continue to mark more positions of A by sliding point B along the long axis and point B down the short axis. When the paper is finally in line with the short (minor) axis, a quarter of the ellipse will have been delineated in dots which can then be joined together.

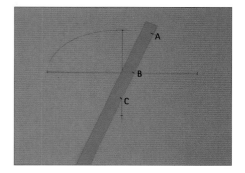

3c. The rest of the ellipse can then be trammelled in the same way, always keeping B and C in contact with the axes. However, you may find it easier just to trace off the quarter ellipse and transfer its reverse images to make a complete ellipse.

4. Matching an ellipse to a perspective square – the wrong way!
Here the perspective square is the same as the photograph. The square has been halved by joining the diagonals and the purple line appears to link the four center points of the sides of the square. But it is not an ellipse and we know from the photograph that it should be.

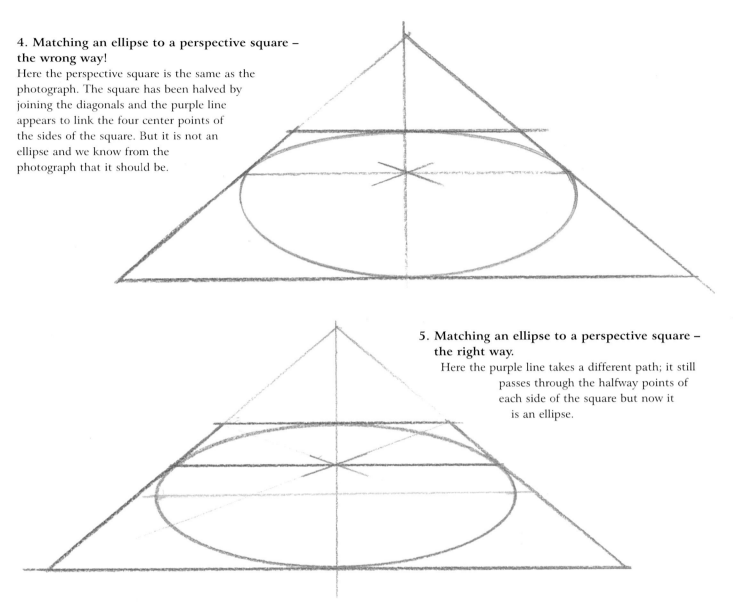

5. Matching an ellipse to a perspective square – the right way.
Here the purple line takes a different path; it still passes through the halfway points of each side of the square but now it is an ellipse.

6. Plan view
The view from above includes a square within the circle (red) as I marked it on the real table. As we have seen, the fact that the circle touches the enclosing square at the four halfway points is a useful guide to placing an ellipse in the perspective view but it still leaves ample room for error.

If the points of the red enclosed square are also fixed it provides four more points of reference. Luckily this can easily be done. (See diagram 7, next page.)

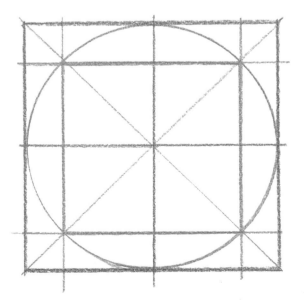

7. Finding four more points

On the base of the blue perspective square, draw a half circle of radius AD. Construct the square ABCD and join the diagonal AC intersecting the semicircle at E. Raise a vertical from E to F and project from this to the vanishing point. Where it crosses the perspective diagonals at G and H are two of the extra points you need. Horizontals from these give the other two.

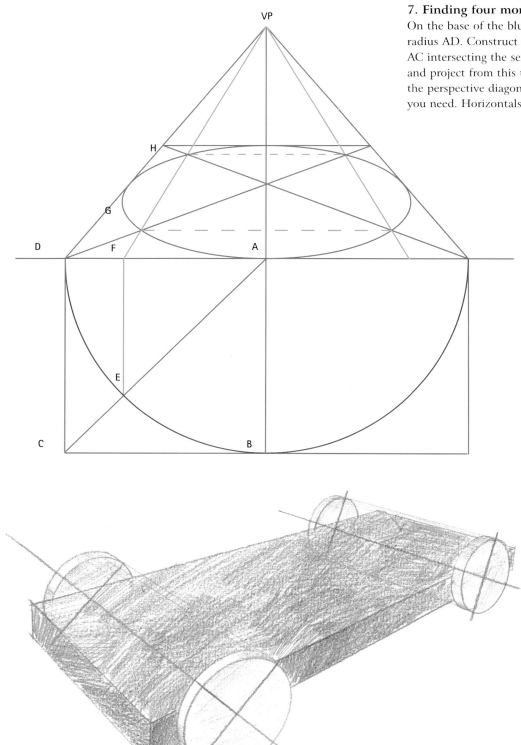

8. Cylinders

The cylinder is almost as common as the cube in the world around us. The cross-section of a cylinder is a circle so naturally each end will be seen in perspective as an ellipse. In perspective, any circular disc set at right angles to a rod through its center (an axle) adheres to the following rule. The major axis of an ellipse always forms a right angle (90°) with its axle. Obviously, since the minor axis is also at 90° to the major axis, the axle and the minor axis are synonymous.

To orientate the cylinder in space you could think of it enclosed in a long box, the end panels vanishing to the same VP. Then the ellipses conforming to the ends will be narrower as they approach the center of vision and broader as they depart from it.

9. Virtual cylinders

Cylinders exist not just as solid objects in various guises, but also as conceptual forms connecting wheels on an axle, for example. This form will be explored more thoroughly on pages 132–135 but this diagram shows the basic principle. In extreme perspective, i.e. wide-angle view, all the wheels of a rolling chassis may have differently orientated and different degrees of ellipses.

There may be occasions when you will want to draw a circular or semi-circular object which you know to be divided up into a number of equal sectors. I am referring to such things as spokes on a bicycle wheel, cars on a Ferris wheel, numbers on a clock face, teeth on a cog or bricks forming an arch.

It is quite easy to divide a circle up into equal segments when it is viewed in plan; all you need is a protractor to measure the degrees. Transferring these same divisions onto the perspective view requires a little more work. The photograph of my table top on page 93 shows what equally spaced radii actually look like. The divisions on the flattest part of the curve (nearest the minor axis) appear the largest and become progressively smaller towards the tight curve of the ellipse (near the major axis). The following drawings explain the simple construction required to work out where the divisions should come on an ellipse.

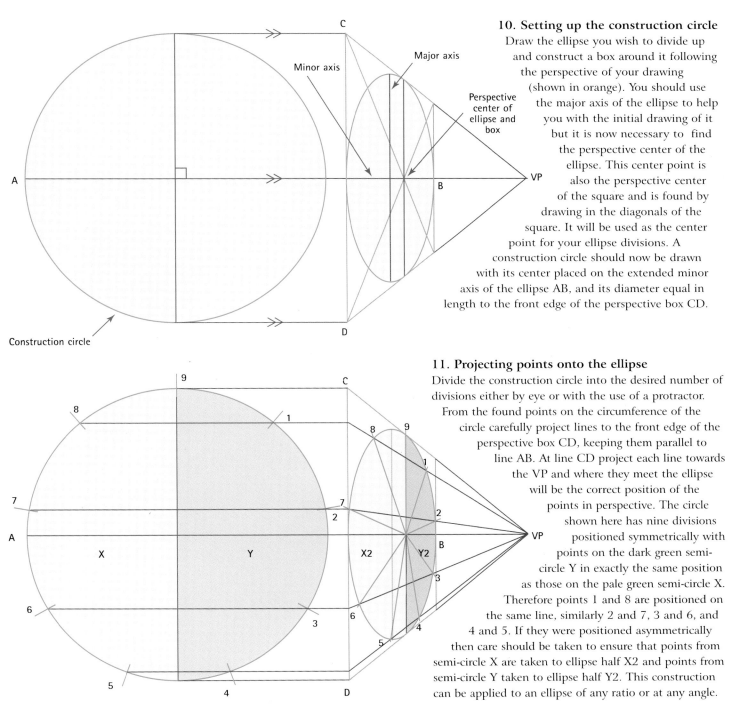

10. Setting up the construction circle

Draw the ellipse you wish to divide up and construct a box around it following the perspective of your drawing (shown in orange). You should use the major axis of the ellipse to help you with the initial drawing of it but it is now necessary to find the perspective center of the ellipse. This center point is also the perspective center of the square and is found by drawing in the diagonals of the square. It will be used as the center point for your ellipse divisions. A construction circle should now be drawn with its center placed on the extended minor axis of the ellipse AB, and its diameter equal in length to the front edge of the perspective box CD.

11. Projecting points onto the ellipse

Divide the construction circle into the desired number of divisions either by eye or with the use of a protractor. From the found points on the circumference of the circle carefully project lines to the front edge of the perspective box CD, keeping them parallel to line AB. At line CD project each line towards the VP and where they meet the ellipse will be the correct position of the points in perspective. The circle shown here has nine divisions positioned symmetrically with points on the dark green semi-circle Y in exactly the same position as those on the pale green semi-circle X. Therefore points 1 and 8 are positioned on the same line, similarly 2 and 7, 3 and 6, and 4 and 5. If they were positioned asymmetrically then care should be taken to ensure that points from semi-circle X are taken to ellipse half X2 and points from semi-circle Y taken to ellipse half Y2. This construction can be applied to an ellipse of any ratio or at any angle.

Bowls and mugs

Many domestic objects involve variations of the circle and the cylinder; in perspective, therefore, ellipses abound.

You have seen that circles viewed in perspective near to the eye level appear as narrow ellipses, fattening as their distance below (or above) the horizon increases. You have also seen that the major axes of ellipses connected by a cylinder always make a 90° angle with the center line (axle) of the cylinder. A straight-sided, circular-section mug demonstrates these principles perfectly and the checkerboard pattern here underlines them. Every

row of squares round the mug is following an elliptical path, each ellipse sharing the same axle but becoming increasingly fatter until the base of the mug is reached. The same applies when the cylinder is of varying width: the mouth of the carafe in this group forms a much narrower ellipse (smaller degree, see previous page and opposite) than the one describing the broad base.

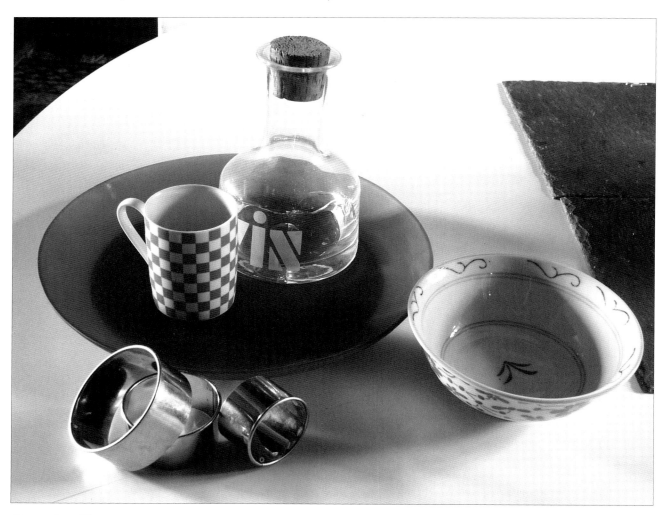

Group for ellipses
All the objects in this group need accurate ellipses to draw them with convincing solidity.

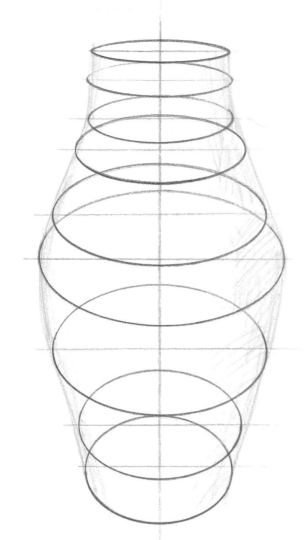

Vase ellipses
The nine ellipses here progress from 10° at the top, in 5° steps to 50° at the base. The degrees referred to are the classifications used by ellipse templates. As you can see, only a small suggestion of linking color is needed to give a convincing impression of solidity and perspective.

1. With a dip pen and dilute blue ink start plotting the central mug with the checkerboard pattern. Lightly draw the ellipse of the mug's rim and include the minor and major axes to check its accuracy. Continue the minor axis of the top ellipse to form the axle through the middle of the mug. Lightly sketch the checkered pattern, observing that each band of squares forms part of its own ellipse.

2. Use a less dilute mix of the same ink to render the carafe. When drawing the lettering etched around its exterior bear in mind that this too will follow an elliptical path. Seen from above, the carafe and mug in perspective appear to diverge as they rise from the picture plane. This is further exaggerated by the fact that the plate on which the items are sitting is slightly convex and not a flat plane.

3. Continue drawing the carafe, working upwards to its neck and rim. Be constantly aware that these will be constructed of a series of ellipses gradually becoming more shallow as they rise. (Note how much more compressed the ellipse of the cork is than that of the base of the carafe, which is closer to a circle.) Begin drawing the largest cookie cutter. Add the other cookie cutters whilst carefully observing their angled relationships to each other. Plot the axes of every ellipse as you draw it to check their accuracy.

4. Start plotting the china bowl and its subtle structure. This is formed by a series of ellipses within ellipses. Look for these and lightly sketch the major ones.

5. When the major structural ellipses of the bowl have been drawn and the overall structure completed the decorative patterns can be added. These, like the squares on the mug, will follow the bowl's elliptical structure.

6. Work over the whole drawing with the dip pen and ink, strengthening the line work where necessary. Correct any ellipses that are inaccurately drawn. Add the outlines of the strong reflections on the cookie cutters.

7. Continue to add detail to the drawing and build up the checkered pattern on the mug. Strengthen the drawing of the reflections on the cookie cutters and the carafe.

8. Finish the initial line drawing by rendering the carafe's cork with diluted sepia ink. Use a similarly watered version of black ink to draw the outlines of some of the harder-edged reflections within the carafe.

9. Change to a fine brush to begin adding areas of color. Use a watery sky blue to complete the pattern on the mug. Begin adding some of the darker, inky washes within the carafe's base. Dilute the ink for the lighter areas of color.

10. Use a slightly dilute mix of blue and black ink to color the reflections inside the cookie cutter. Although these may seem to distort the cutter's form this is in the nature of reflections. Have the confidence to draw what you see. Use added water to increase the range of tones of the dilute ink and notice the variety of color and tone that can be achieved with just two inks.

11. Use the same dilute mix to add more decorative details to this mostly monochromatic drawing. Add a very dilute mix of the blue for the shadow within the bowl's interior. Use a similar mix with a hint of black for the mug's internal shadow. An even more dilute blue – almost pure water with a hint of color – is needed to complete the mug's coloring.

12. Color the cork with slightly diluted sepia ink. Use a larger brush loaded with a blue/black mix to lay a dark wash on the slate slabs on the table top. With the same brush use a wash of pure blue to color the glass plate, varying the tones with a little water.

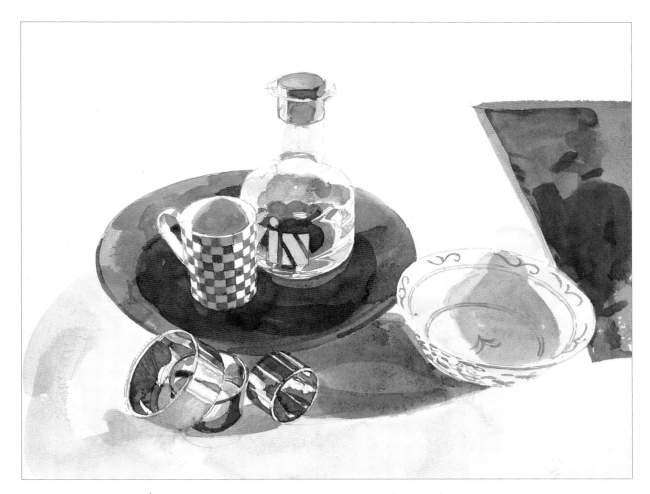

13. Reverting to the blue/black mix again, wash over the shadow areas below the glass plate and intensify the darker area on the slate to complete it. Heighten the base of the plate with an additional blue wash. Use this to strengthen its edge. A little dilute sepia is now used to complete the top of the cork. Finally, a large mop brush is used to lay down a very light tone on the table, killing the pure white of the paper.

Arched bridge

Most arches are semi-circular in form which means that in perspective they will take the shape of a half ellipse.

The major axes of ellipses representing wheels on axles are always at right angles to the axles and the same applies if the ellipses represent ends of cylinders (see pages 86 and 133).

Looking at the arches of a bridge from an oblique angle is like viewing a series of parallel cylinders all vanishing to the same point. Each of their axles is at a different angle from the next one so the 90° axes of the ellipses must also be at different angles.

Of course this only applies if the arches conform to arcs of circles. Although most do, occasionally they do not. If you do encounter perspective views of arches that you are certain are not elliptical then the arches must be following a non-circular curve and you will have to rely on careful observation to find their shapes. Although it is possible to plot the correct shapes from an elevation it is not very practical when you are drawing from the real thing out of doors.

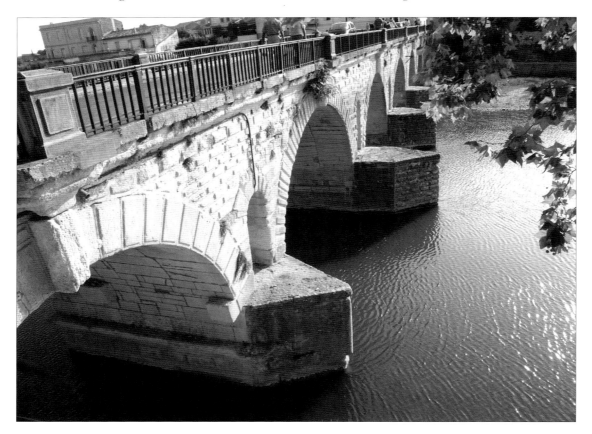

Arched bridge looking down
Although this viewpoint necessitates three-point perspective, it is fundamentally the same situation as in the top diagram opposite.

Each arch is half of a differently-angled ellipse and the major axis of each ellipse is at right angles to the axle of the notional cylinder of which it is a section. Remember, therefore, that this axle is an extension of the minor axis and will vanish to the same point as do the horizontal elements of the supporting column of each arch.

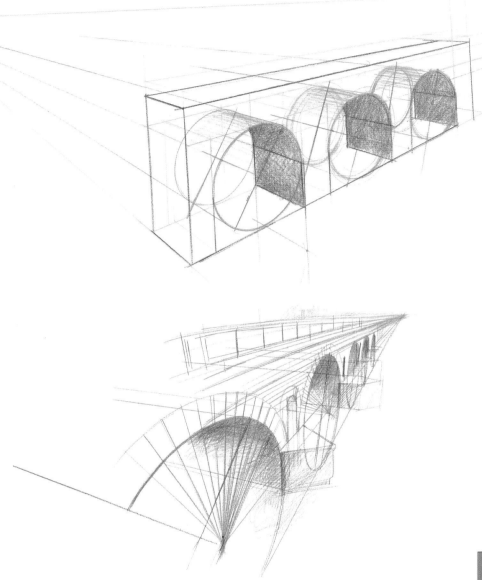

Arches in two-point perspective

The easiest way to construct arches in perspective is to pretend that each arch is a circular aperture and therefore elliptical when viewed from an angle. After you have correctly angled each ellipse, you can draw the line which represents the base of the bridge or where the arches change into columns, thereby bisecting the ellipses.

Plotting the bricks of an arch

For an arch to provide a proper support, its building blocks – stones, bricks, or whatever, must radiate from the center of the arch so that they are compressed and held tight by the weight above them. This diagram represents the situation in the photograph opposite. As you can see, the lines projected from the blocks in the arch meet at a point which is not at the center of the ellipse. This is because the center of the original circle is shifted backwards by perspective as seen on page 83.

Radiating spokes

Visual proof that the center of a circle in perspective does not coincide with the intersection of the major and minor axes. These tapes all radiate from the exact center of my table.

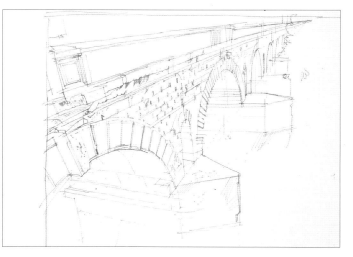

1. Using a dip pen and sepia, water-soluble ink find the VP for the stone courses. Note that the top edge of the bridge is slightly curved. The line where the buttresses meet the water indicates the direction of the axles of the arch ellipses, which means that the major axes can be drawn at right angles to them.

2. Now the arches can be defined, the stone courses detailed and the radiating bricks drawn to their offset center. Note that there is not a constant distance of projection of each buttress so their pointed ends do not make the expected line to the VP of the main bridge.

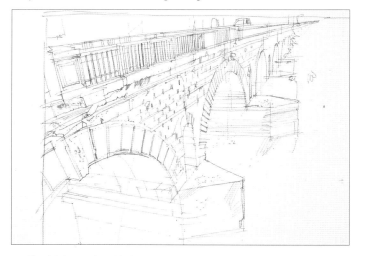

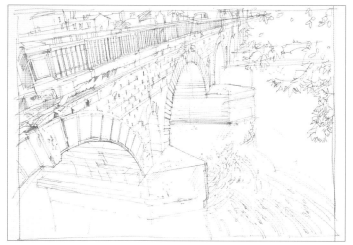

3. The high eye level brings the third point into play as can be seen by the angled balustrades. Make sure that the upright edges of the buttresses agree with the vanishing direction of the railings on top of the bridge.

4. Now draw the buildings in the background, their uprights also converging in accordance with the railings. Adding the pattern of ripples helps to establish the plane of the water surface. Give an indication of the leaf shapes that frame the view.

5. Apply the first washes of color beneath the arches to give solidity to the structure. Drawing with non-waterproof ink means that washes must be judiciously applied; to preserve detail do not apply any washes to the front face of the bridge.

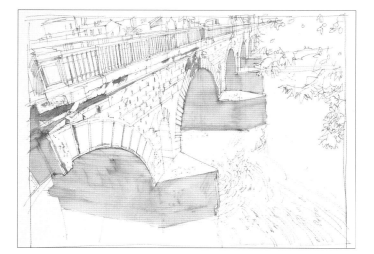

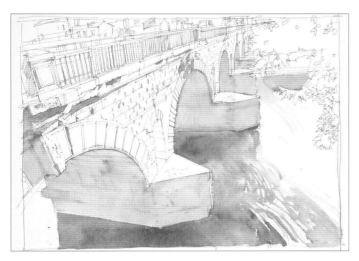

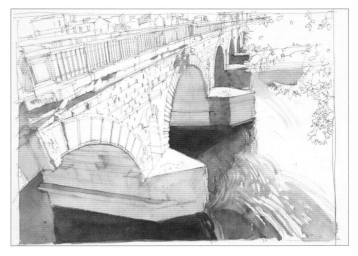

6. The water under the arches is shadowed both by the arches and their reflection, which combine to make a darker tone than is on the under sides of the arches themselves. Some of the ripple drawing is inevitably washed away but can be reinstated later.

7. Continue to strengthen the tone of the water and begin to reassess the tones beneath the arches, starting with the more distant ones.

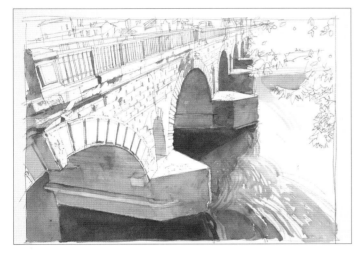

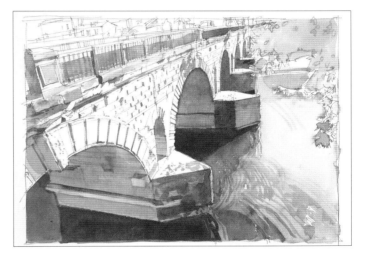

8. As you work forward, adding tone to the near arches, note how the reflected light bouncing off the water increasingly modifies the shadow and contributes to the feeling of recession.

9. Gradually add cooler tones to the balustrade and the road seen through it to increase the sense of form. Use a light green/yellow wash to read as light through the leaves when darker greens are later applied.

10. Add washes of color to the background buildings, some suggestions of brighter color on pedestrians and various darker tonal accents leaving the vertical face of the bridge as the only large area untouched by washes. A few very small drops of water on this face will be enough to give a little texture without destroying the line work drawn in water-soluble ink.

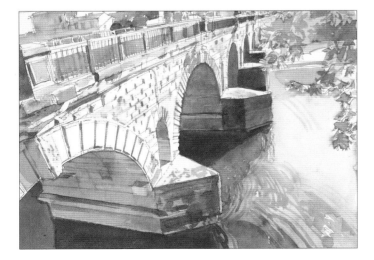

Inclined planes
Uphill street

Drawing an uphill or downhill street bordered on one or both sides with buildings seems to create more difficulties than almost any other perspective problem.

There is really no reason why this should be so. All that you have to remember is that buildings need to be erected on flat bases. On sloping sites, therefore, horizontal platforms must be created for them, either by digging out, or filling in, or both. In this way a series of buildings can ascend a slope in a series of steps.

A road, however, needs to have a smooth rise to negotiate a slope so when it borders a row of buildings it will reveal the contrasting, step-by-step progress of the flat-based houses. The perspective of the buildings is normal with all of the horizontal elements vanishing to the horizon. But the rising road or street has a different vanishing point, one that is significantly above the line of the horizon. If the bordering buildings are parallel to one another, and to the road, the VP for the road will be vertically above that of the buildings and the steeper the rise the greater will be the difference in height between their VPs.

Similarly, if you, the viewer, look down the descending street, the buildings on their platforms will behave normally while the road will plunge to a vanishing point way below the horizon.

Steep hill
The horizontal elements on these houses on a hill – window sills, lintels, stone courses, and railings - all seem to plunge down towards the road but, of course, it is actually the road that is rising up to them.

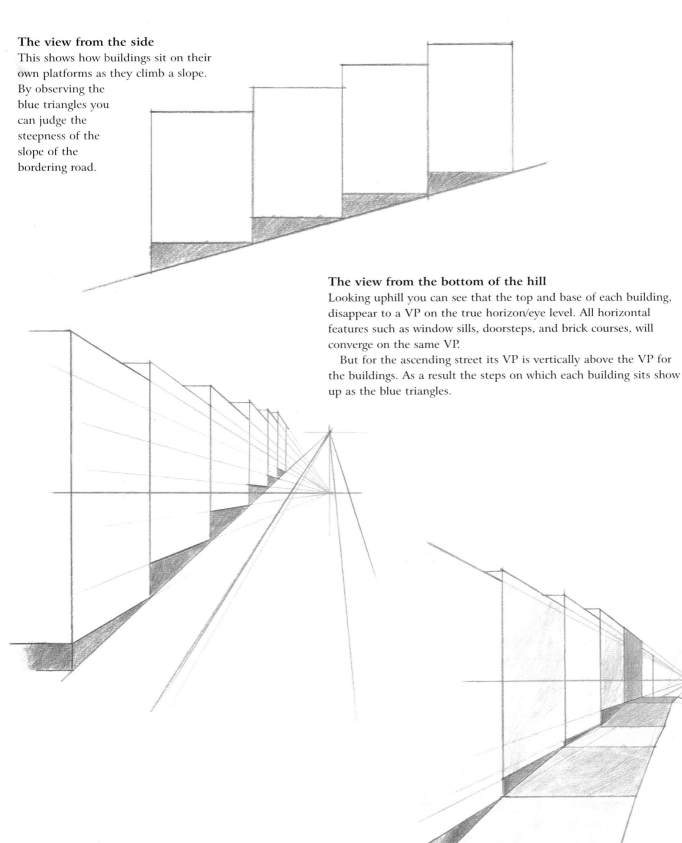

The view from the side
This shows how buildings sit on their own platforms as they climb a slope. By observing the blue triangles you can judge the steepness of the slope of the bordering road.

The view from the bottom of the hill
Looking uphill you can see that the top and base of each building, disappear to a VP on the true horizon/eye level. All horizontal features such as window sills, doorsteps, and brick courses, will converge on the same VP.

But for the ascending street its VP is vertically above the VP for the buildings. As a result the steps on which each building sits show up as the blue triangles.

A changing slope
You can't rely on roads rising or descending at a constant angle. If a change of angle is fairly sharp all you need to do is to change the VP up or down to plot the sides of the road. If the change in slope is smooth you must break it down into a series of small changes each with its own slightly adjusted VP.

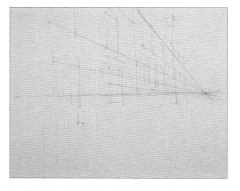

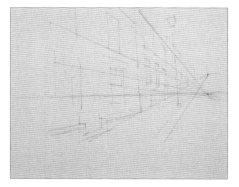

1. With a black pencil follow a selection of horizontals through to their VP and HL. In uneven stonework, such as this, the "horizontals" may not all exactly converge on the same point but it will be possible to establish a mean. Draw some uprights to anchor the composition.

2. Lightly sketch the HL. Notice how, from the middle distance onwards, upward perspective appears to make true verticals appear to lean to the left. Render the basic outlines of major elements such as windows and doors.

3. Follow the sides of the paving slabs to find their VP. This will be vertically above the VP of the true horizontals. Any features parallel to these lines, such as the railings in front of the building towards the top of the street, obviously also converge on this subsidiary VP.

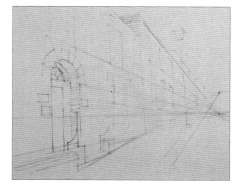

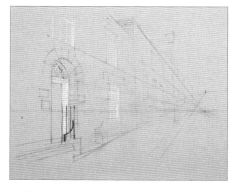

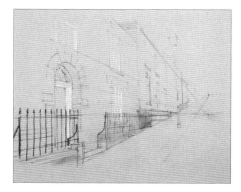

4. Begin detailing the main doorway. Notice how the radial lines of the stone arch have their own point of convergence. Observe too, how the planes of the building at right angles to the façades, such as the stone courses on the far, inner side of the doorway, also converge on their own VP. This perspective distortion is very subtle with the VP way beyond the composition's left-hand side.

5. Now use a white crayon to draw the door frames and glazing bars. (It is easier to draw these first before filling in the darker color of the small windowpanes.)

6. Using black again, establish the outline of the nearest street light, noticing its apparent slight left tilt caused by upwards perspective. Start drawing the railings paying attention to the way their uprights visually compact as they recede into the picture plane.

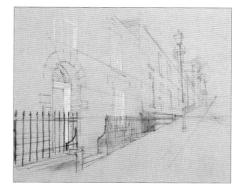

7. Keep the pencils well sharpened for drawing fine detail such as the cupola on the building at top of the street and other, similar distant features.

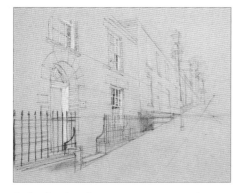

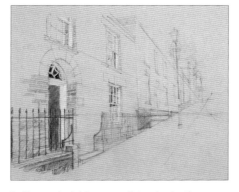

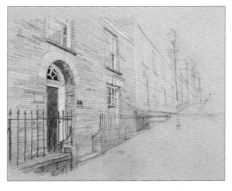

8. As the drawing progresses use a piece of scrap paper to protect it and to rest your hand on when drawing. Use a dark blue-gray pencil to darken the windowpanes. Notice how the returns on the sides of the window insets follow through to the far, left hand VP.

9. Use a dark blue pencil to shade the nearest door and introduce some subtle color into the image. Add dark shading to its fanlight to define it and give it solidity. Use a selection of beige pencils to give an indication of the stonework. Don't overdo this, localized suggestions are more effective than laboriously rendering every stone.

10. A lighter, yellowish pencil is used for the stone arch above the door. Work over the overall drawing of the façades, giving them color and weight. Use the darker pencils to add tone to shadow areas in the window and door recesses. Use a pale blue to color the areas of sky reflections on the upper windows.

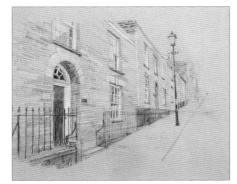

11. Sharpen up smaller elements such as the lamp on the nearer street light, noticing how the lines on its right side follow the lines of convergence on the main VP. A pale, warm gray is lightly used to give color to the distant buildings. Add the railings in front of the furthest building. Unlike the nearer railings they do not follow the horizontals of the buildings but are in line with the upward slope of the road.

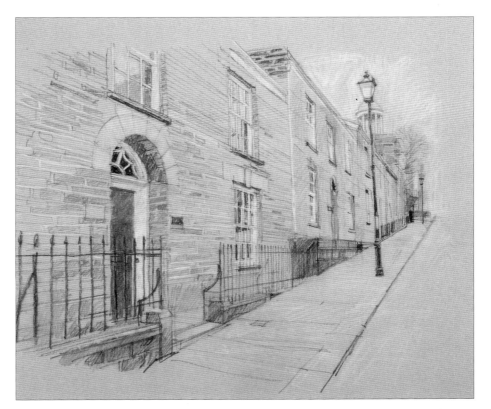

12. Complete the drawing by erasing the VPs and any, by now, superfluous construction lines. Lightly using a white pencil, allowing the color of the card to show through in places, shade the pale tone of the paving. Finally, use denser white shading for the sky, throwing the drawing of the buildings into sharper relief.

Downhill street

A downhill street is, of course, an uphill street viewed from the top. Drawing it is much the same as the previous exercise, but with the vanishing point of the descending road below the horizon.

All the observations of the previous exercise still apply – the buildings sit on their platforms and the street surface plunges or gently descends depending on how far its VP is below the horizon.

You need to look carefully at lines of bordering fences and walls: there is often no need for them to be built with horizontal elements such as brick or stone courses. In such cases they may follow the slope of the road surface and share its vanishing point rather than progressing in a series of steps vanishing to the horizon. Lines of posts or bollards often do the same thing. Remember, too, that although buildings almost invariably have horizontal bases and floors, they may contain other elements that are not horizontal; such things as pitched roofs (pages 48-51) and escalators (pages 68–71), all of which require VPs above or below the horizon.

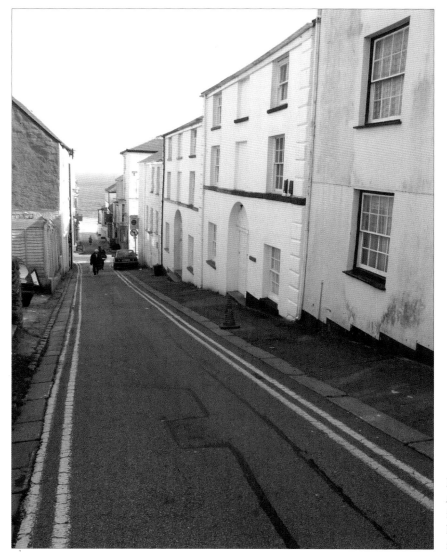

Down to the sea
A gradient that includes a view over the sea is useful because it gives a clearly identifiable horizon upon which all VPs for the buildings must be positioned.

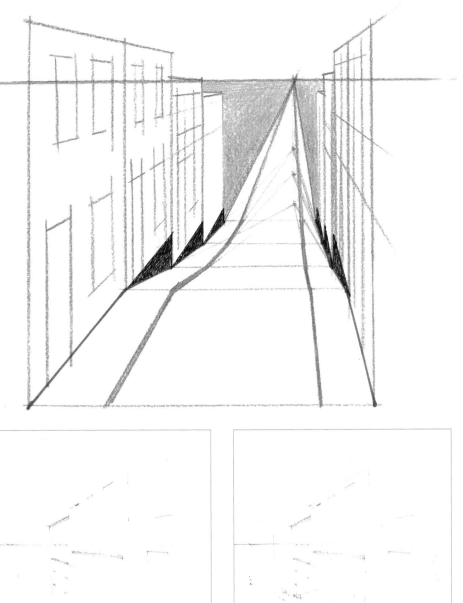

Down to a plain

This construction depicts a downhill street that starts from flat and descends steeply with its VP well below the true horizon. As it becomes less steep the VP rises until at last the road is flat again when it shares the VP of the buildings on the true horizon line. Remember that all the horizontal features of the buildings must vanish to this VP whatever the road is doing. Note the black triangles formed between the base of each building and the sloping road.

This is a simplified version of a real view that could be encountered at the top of a small hill town.

1. Drawing in pencil begin by establishing the VP, in this case on the true horizon which is also drawn in and extended. Plot the first major horizontal lines converging towards the VP on the horizon.

2. Now plot the VP of the road itself. As this runs downhill, although its VP will be much lower than that of the vanishing point of the horizontals, it will be directly below it. The position of this point will vary slightly as the road undulates. Lightly sketch some of the triangular "steps" where the horizontal bases of the houses meet the sloping road. These may be one single triangle or broken down into a series of steps as painted on the base of the nearest building.

3. Add further details of true horizontal elements such as the windows. Do not be confused by the fact that, occasionally, there may be elements such as the sloping roof line of the tall house in the middle distance that, coincidentally, appears to follow the lines converging on the horizon. Begin to add shading as you work over the drawing to give a sense of form.

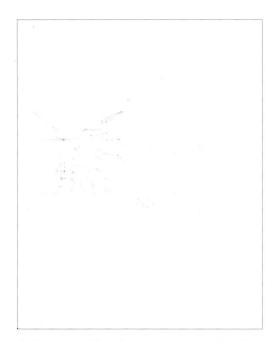

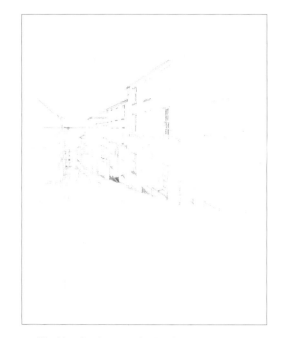

4. Continue adding the elements determined by the two VPs. Observe how the small figure in the distance is way below the viewer's eye line whereas on a horizontal plane its head would be level with it. Notice, too, how on a steep slope, there are odd details such as the right-hand window ledge of the second house down, which touches the street level on its nearer side.

5. Working back towards the foreground, the nearer windows are close enough for their glazing bars to be visible. Again, make sure that the horizontal divisions vanish to the same VP as the other features.

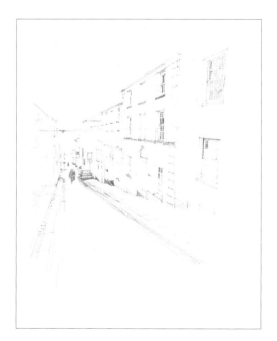

6. When drawing the corner stones on the near side of the second house take care to follow the lines through to the VP on the horizon. Inaccurate drawing of a series of closely related horizontals, such as these, can damage the picture's sense of credibility.

7. Draw in the details of the road itself including the parking lines down either side which emphasize the diminishing perspective of the road's uneven surface. Use rounded, horizontal shading strokes to describe the slight curve of its surface.

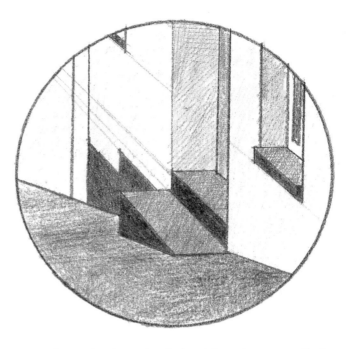

8. Close up detail of center of drawing and explanatory diagram. The door with the second step is worth a careful study as it shows how the fill-in triangle can be displaced from the outer wall of a building on a slope by a step.

9. Begin completing the drawing by erasing the, by now, unnecessary construction lines. Add the faint tone of the distant sea. Finally, strengthen the shading and drawing in the foreground to give tonal as well as linear depth.

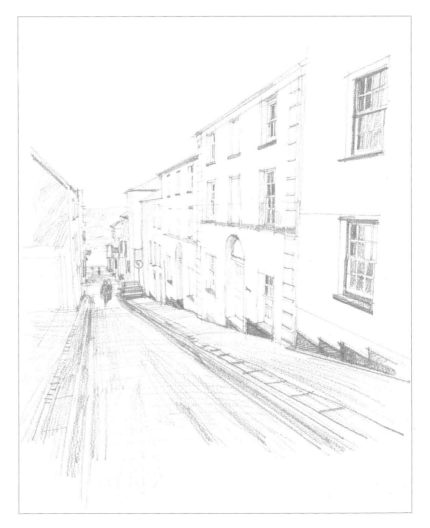

Staircase

Staircases are similar to uphill and downhill streets, with the skirting and banister rails representing the gradients and the steps replacing the horizontal platforms required for buildings.

In this view three levels can be seen at once. First, there is the ground-floor hall with its floorboards and rug converging towards a fairly central VP on a very high HL. Then there is the middle level on which the viewer is standing, twelve steps up from the ground floor.

From this level, five more steps are needed to reach the final level – the upper floor. Of course, each step has its own mini-level and all these horizontal planes vanish to the same near-to-central VP. Assuming that the pictures on the walls are hanging straight, their top and bottom edges also vanish to the same point.

Looking down the main flight of stairs, because each step raises the level by exactly the same amount, the average of their ascent is a straight line which is confirmed by the line of the balustrade and of the skirting board, all sharing a descending VP directly below that of the eye level.

In contrast, if you look at the smaller flight of steps and its balustrade and skirting board, they are all seen to converge on an ascending VP directly above the first one.

The right-hand (second) VP on the horizon is a long way out of the picture so the edges of individual steps, the base of the front door and the line of the top passage converge only slightly towards it.

However, from such a high viewpoint it is impossible to ignore the third VP which is the vanishing point for all the banister rails, the edges of the pictures, door uprights and any other vertical elements. It is this VP that throws the view into three-point perspective.

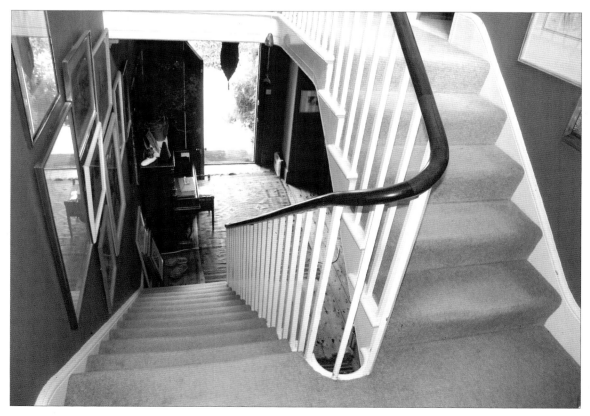

Staircase in two directions
Standing on the level where the staircase turns, both flights of steps can be seen.

104

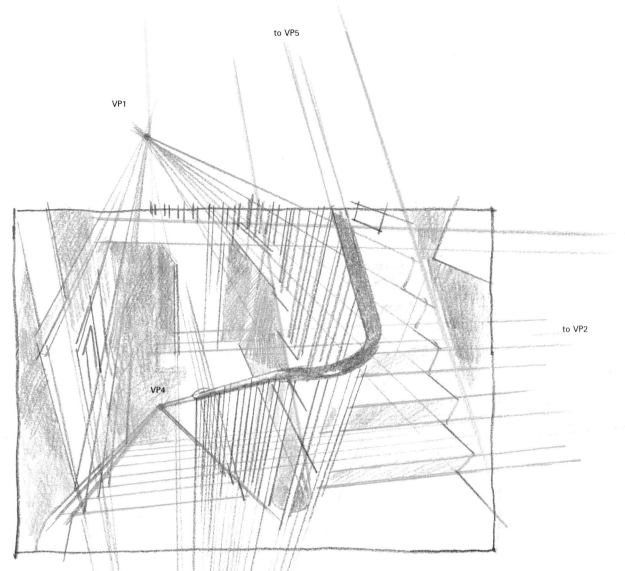

to VP5

VP1

to VP2

VP4

VP3

Five vanishing points

The red VP here is the one for all the horizontal and
vertical surfaces vanishing to the left, in this case quite
near to the center. The right-hand VP is a long way out of
picture: the orange lines show how slight is the convergence
in that direction.

All the vertical elements are vanishing towards the blue
point. Note that the vanishing lines from the vertical picture
edges don't meet exactly at this point. This is because the
pictures are hanging out slightly from the walls and so are not
truly vertical.

The descending, vanishing lines and VP of the first flight
of stairs are colored purple and the ascending vanishing
lines for the short flight are green, but again the VP itself is
way out of picture, this time in the upward direction. Because
the individual levels of floors and stair treads all share the
same VP (red), their gradient VPs, of their ascending and
descending streets (see pages 96 – 103) should be directly
above one another.

And so they are; purple, red and the long distant green all
lying on the same vertical line.

1. A steel dip pen and dilute, waterproof sepia ink mixed with black is used for this initial stage of the drawing. Following the lines of the main horizontals plot the position of the primary, central VP. Using this, construct the main horizontals of those elements that converge on it including the floor on the ground level, the tops and bottoms of the hanging pictures and the horizontals of both staircases.

2. The, descending, subsidiary VP4 was established by drawing the converging edges of the lower staircase and balustrade. Lastly, although well out of the image area, the ascending subsidiary VP5 was indicated by establishing the edges of the rising staircase. All these three VPs, the central VP and its two subsidiaries, are positioned vertically, directly above or below each other.

3. With a dilute mix of blue ink, plot the vertical banister rails of both levels of staircases noticing how these all converge towards a downward VP well out of the picture. Although the second, true VP has not yet been established, this is actually the third, true VP in this three-point perspective exercise.

4. The leading horizontal edges of the upper and lower staircases are now added. These converge on the second of the three, true VPs. Seen from this view, this is way beyond the right edge of the picture making the lines of convergence very subtle. When drawing the carpet covering the risers of the upper staircase, note that these are not true verticals as the horizontal treads project beyond the vertical plane of their supporting risers beneath.

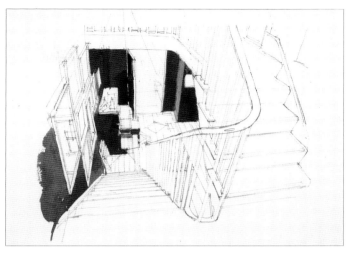

5. Having constructed the basic framework of the composition subsidiary details, such as the piano in the hall can be added. Make sure that these, too, adhere to the basic perspective structure. Occasionally, similar to the carpet over the risers in step 4, items such as the framed pictures in front of the piano may break one or more of these rules. In this case, because they are leaning forwards slightly, and are not truly vertical.

6. With a small watercolor brush, add dilute washes in appropriate colors to begin distinguishing the different areas in this complex image. As the initial line drawing was made in waterproof inks this will not be affected by the addition of water-based paint.

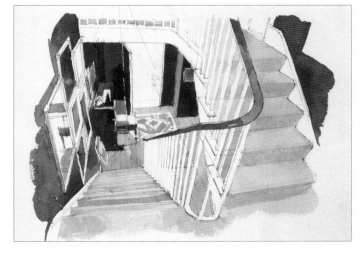

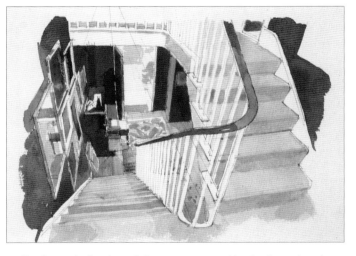

7. Add further washes to define the strong linking elements of the white banister rails and skirting boards, both of which are left unmarked, reading as plain, white paper.

8. Finally, an indication of the greenery outside the front door is added together with some tonal darkening of the risers of the upper flight of steps, tonal additions to the hall floor and some extra color on the pictures.

Reflections
On mirror

Reflections in a horizontal mirror are similar to those seen of floating objects or objects near the water's edge in the still surface of a lake or river. For reflections of objects on land further from the edge other rules apply, see next project.

We tend to speak of a mirror image as a simple reversal of the image, in fact it is often a continuation of the image as in the tumblers opposite.

The plastic box in the photograph right, having a flat base, is in close contact with the mirrored surface. As a result the real box and its reflection can be seen together as a deeper box sharing the same vanishing points. A small separation can be glimpsed between the two; this is because the reflective silvering is on the lower surface of the glass, the gap is the distance to its top surface – the thickness of the glass.

When the reflected object is not in continuous and close contact with the mirror, the reflection may reveal an underside which is not visible from the chosen viewpoint as with the bird sculpture here, where the normal eye level view is reflected as a worm's-eye view.

You may find that the pink vase looks rather confusing; it is actually a flower-like trumpet shape curled into a single open loop upon which it sits. The second loop is a reflection of the first one, below which is the reflection of the underside of the trumpet.

Composition on a circular mirror
The box, vase, sculpture, and nuts are all reflected in the mirror on which they are standing but each poses its own perspective problems.

Tumblers on a mirror
The reflection of a cylindrical object in contact with a mirrored surface is like a continuation of it in the same perspective, making a cylinder of double the original length.

1. Sketch the major outlines of the objects on the mirror, establishing the foundations of a drawing in three-point perspective as seen from above. All three VPs are way out of picture.

2. Complete the outline drawing of the plastic box and its translucent lid. Notice how the four corners of each of these two items align with the corners of its reflected counterpart below. (See inset.) The slight gap between the surface of the box sitting on the mirror and its reflection is caused by the thickness of the mirror's glass.

3. Repeat the exercise with the bird sculpture. Draw a box enclosing the legs and continue this through into its reflection as if the sculpture's feet were clear glass. Notice how, with this irregularly shaped object, the base of the bird's body, hidden in reality, is now revealed in the reflection.

4. Working with and around the construction lines, complete the drawing of the bird. Add more construction lines if needed, erase them when redundant. Observe how some elements are revealed in the reflection, while others, such as the lower legs, are obscured.

5. Now draw the vase – the most complex shape in this still life. In order to distinguish between the actual vase and its reflection, begin by only drawing the shape of the actual vase.

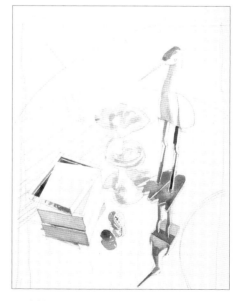

6. Applying the principles employed in drawing the other two items, construct the reflection of the vase. The seeming disparity in length between its actual stem and its reflected image is due to the top part of the stem being obscured by the bowl. Complete the initial pencil drawing by including the pecan nut, the walnut and the edge of the circular mirror and extraneous items reflected in it.

7. Before coloring, erase any remaining construction lines and clean any smudged areas with an eraser. With a medium brush apply simple, fluid areas of a cerulean and pink wash to the vase and reflection, varying the densities of liquid and pigments to achieve a range of tones and colors. Use a gray-blue wash to define the bird's form and shadows. The box is similarly treated. Notice how the subtle color of the mirror's glass gives a cooler hue in the reflections.

8. Add more color washes, working over the different elements within the composition, bringing them all to a similar level of finish before adding the background wash.

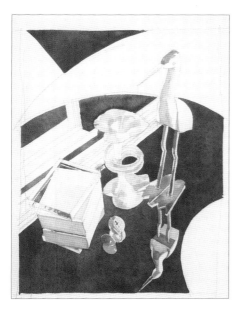

9. Mix a generous amount of an indigo wash and use it to color the surface of the mirror, carefully defining the outlines of the objects standing on it. When adding washes over large areas turn the painting round to give easy access to all parts of the image.

10. When the painting of the mirror's surface is dry use light washes to color the semi-abstract areas surrounding it. Complete the exercise by working over the whole image again, defining the details of the objects in the still life and darkening any areas that may have dried a paler color than intended.

By lake and river

When still water is the reflective surface, it behaves similarly to a mirror with objects on or in it, but rather differently with buildings and other objects on adjoining land.

Landscape features close to the edge of still water are reflected in their entirety just as in a mirror. As their distance is increased from the water's edge, though, more and more of the features will be obscured from view by that very edge. The amount of cut-off is also affected by any rise in the level of the landscape. It is a principle that is difficult to clarify in words alone but the model and diagram opposite show it clearly.

If you wanted to calculate exactly how much of an object could be seen reflected in a lake it would be necessary to know just how far it was from the water's edge and to have an accurate cross section of the land upon which it was standing. This, of course, is not only impractical but also unnecessary because all you actually have to do is to look and you will see the effect; understanding why it is so, however, will help you to see it more perceptively.

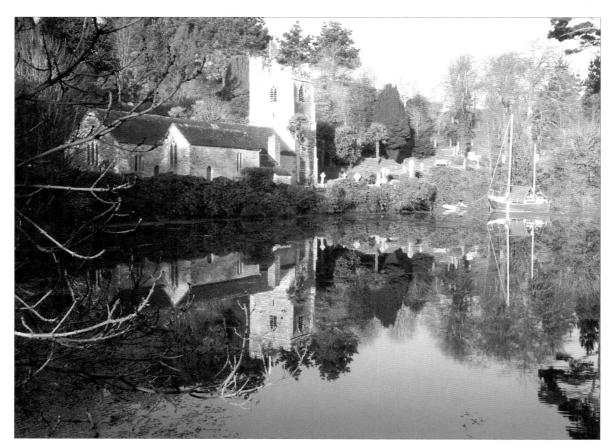

Church by a creek
In this picture the church is seen across the water from some distance so the perspective is subtle and its two VPs are well outside the picture area.

Tree reflections

My model on a mirror represents a section of land sloping down to the water's edge. The trees are placed at various distances and heights relative to the water/mirror but it is not immediately clear why the reflections are as they are.

A lower eye level

In this view the four trees, well spaced and at different levels, appear in their reflections almost in a straight line. Note that some of the rising ground is also reflected.

A look at the section

This diagram should be read in conjunction with the first photograph. Look at the visible section of the rising land colored red; its reflected shape in the mirror is colored blue. The tree near the water is unaffected by the rising surface and so appears in totality but the tree higher up the section can only begin to be reflected from the same point on the reflection of the section.

Of course this cross-section and its reflection are conceptual and invisible unless sliced in this way, but the principle remains.

1. Proceed as usual when drawing a building in two-point perspective by searching out the gently converging horizontals of the main blocks.

2. Draw the water line and lightly sketch the form of the land between the church and the river to help understand the spatial depth between the two. Then, as in the mirror project, draw the main elements of the reflection taking care to ensure that the horizontals converge towards the same VPs as the original.

3. Add vertical elements and lightly follow the lines through to the reflection below to ensure that the drawn reflection is exactly in line with its image. Notice how, as in the diagrams, elements of the original are hidden in the reflection according to their distance from the water's edge – the further back they are the less one sees in the reflection. Only elements actually sitting on the water, such as the dinghy on the right, have a perfect reflection.

4. As you continue to add more detail follow the drawing of the original when adding its reflected image. Complete the drawing of the church.

5. Now render the trees surrounding the church, once again observing how the reflection changes from the original according to how far behind the church the actual trees are. Bear in mind the fact that reflections in water are always a shade darker than the original. This is especially noticeable in the almost leafless trees to the right of the church.

6. Work over the whole image, adding further detail until the preliminary drawing is completed. The branches of a sunlit tree on the viewer's side of the river are now included in the composition, adding to the sense of depth.

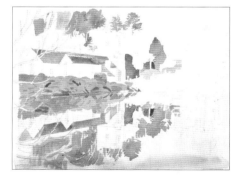

7. Now add color. Make two separate dilutions of cobalt and raw sienna. Turn the drawing upside down and, with a large wash brush loaded with the cobalt, quickly apply the wash to the lower water area changing to the sienna as it recedes, blending the two washes as you do so. This will both knock back and give a darker tone to the reflection.

8. Turn the drawing the right way up again. Mix a slate color from black and cobalt for he church's roofing. Apply with a medium size brush to both the drawing of the actual church and its reflection. With a watery mix of viridian modified with black repeat the exercise on the dark foliage immediately in front of the church and other dark leafy areas.

9. Use a mix of gamboge darkened with a little viridian to paint the grassy area to the right of the church With another wash of pure viridian add some broad details to the earlier foliage wash. As with the original drawing follow each wash on the actual image with their reflections.

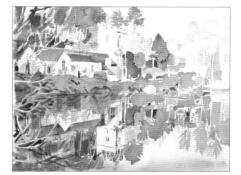

10. Use a mix of ultramarine and raw umber to add the shadow areas on the church walls, varying its density according to the depth of shadow tone. Use this mix to intensify the dark areas on the water's surface, throwing the sunlit branches in the foreground into sharp relief. Work over the whole painting, adding pockets of color and gradually defining the assorted elements in the composition.

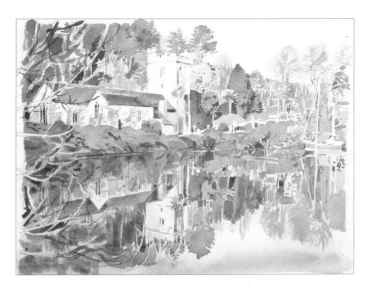

11. This is a complex scene – much of the remaining work comprises filling in details of trees and foliage. While doing this do not lose sight of the primary object of this exercise which is to show how reflections work in still water. Although such a mirror-like surface reflects a surprising amount of detail, the real image is still sharper than the reflection.

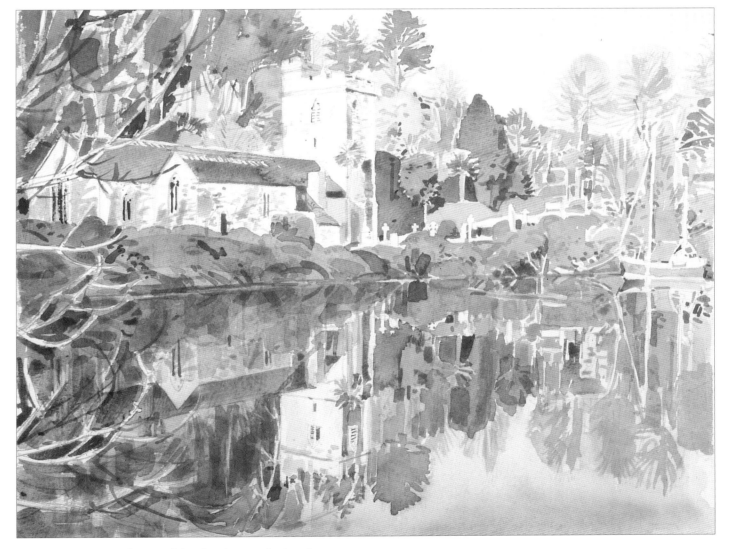

12. The brightest, sunlit part of the church tower is almost undiminished in its reflection but the sky and shadowed areas are noticeably darker. To further separate the real scene from its reflection, flood a wash of ultramarine over the water area.

Upright mirrors

Looking into upright mirrors gives a strangely persuasive, alternative version of reality. No wonder it has led to fantasies of stepping through the mirror into a parallel world.

We have seen that a horizontal mirror whether of glass, polished metal or still water gives an upside-down version of a real scene or object. The reflected image responds to the same perspective laws as the reality but, because it is not the right way up, it is usually clear which is which.

Reflections in a vertical mirror however, are the right way up. As a result, observing the reflection of a room, for example, can be like looking into another similar room. The walls and objects will appear to be in the same perspective and although the image will be reversed, it may not be immediately noticeable, unless there is an obviously reversed feature such as lettering.

For one particular subject, the self-portrait, it may be necessary to do something about the reversed image. Many self-portraits are drawn from a single mirror reflection but the resultant, reversed image is not familiar to anyone but the artist; everyone else knows the non-reflected version. The two images can be surprisingly different, not just in details such as hair parting, clothes and buttoning, but also in little asymmetries that almost everybody has but which are only noticeable when they are seen in unaccustomed reverse.

To counter this problem, a second mirror can be arranged so that you can see the a reflection of the reflection which is then the right way round.

Mirrors for self-portrait
Here is what an observer would see of my sitting position relative to two mirrors placed to give a right way round reflection. As you can see there is a reversed reflection to the left and two correct versions in front of me (note the pencil in the right hand) giving you a choice of slightly different views.

Mirror plan
To get a self portrait view the right way round, first place your chair or yourself with a mirror alongside you. Then a second mirror must be placed at an angle of slightly less than 90° as shown in the plan diagram below. Make adjustments until you get a view as others see you which looks reasonably natural.

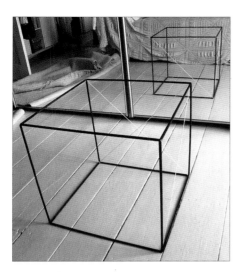

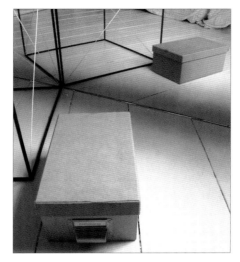

Converging into mirror-land
This photograph shows the open cube placed in line with floorboards in front of a mirrored door. See how the floorboards continue converging into the virtual space beyond the mirror and how the second version of the cube appears compressed just as it would if there was a real cube at that distance into the view. If you were to place a second mirror facing, and parallel to the first one, you would see reflections of reflections of cubes stretching back into infinity.

Angled mirror
When the mirror is placed at an angle to the parallel floorboards, their reflections change direction and then continue to converge to a different vanishing point on the same HL. The deviation from straight-on that the object makes with the mirror is exactly equalled by the opposite deviation of the reflection.

Reflections in an inclined plane
For this photograph I stuck a piece of wood with one end cut at 45° onto a roof slate. This was then doused with water to make it reflect the wood, like a real chimney on a rain-soaked roof. At first sight it does seem extraordinary that the reflection is at almost 90° to the chimney.

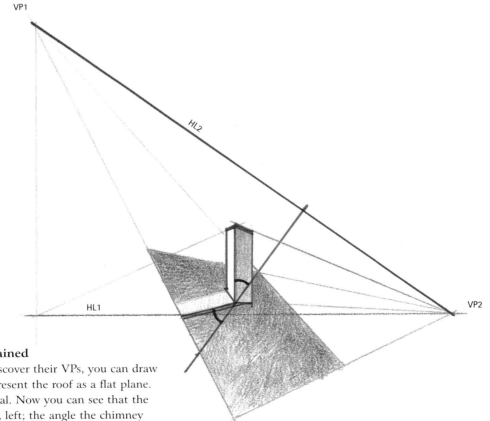

Reflections in an inclined plane explained
If you continue the sides of the slate to discover their VPs, you can draw the hypothetical horizon which would represent the roof as a flat plane. Rotate the diagram to make HL2 horizontal. Now you can see that the situation is the same as in the photograph, left; the angle the chimney makes with the plane of the roof (mirror) being repeated in the reflection.

Shadows
Against the sun

A shadow cast by a simple shape, a pole for example, is quite easy to plot. Objects that are more complex throw shadows that may be rather more difficult and time-consuming to work out by calculation.

Therefore my intention here is to offer just enough theory to give you a general understanding of the shadows that you will observe in the real world.

The length of a shadow on level ground depends on the height of the sun in the sky and its direction is dictated by the direction of the sun relative to you, the observer. If the sun is shining from the front, any centrally viewed object will be mainly or completely in shadow and will cast a shadow towards you.

Because the sun, source of all natural light on earth, is so far away, its rays are effectively parallel. This means that shadows of verticals cast by its light on level ground

will also be parallel and will vanish to or from a VP on the horizon. This VP we will call the vanishing point of the shadows or VPS and on a horizontal plane it is always on the HL vertically below the sun's position. Shadows of all verticals will now appear to diverge from this point.

The length of a vertical shadow is determined by the height of the sun and is found by a line drawn from the center of the sun itself past the top edge of the object to where it crosses the vanishing line to the VPS (diagram 1).

Shadows from horizontal edges share the same VP as the horizontals themselves except when they are viewed straight on as in one-point perspective.

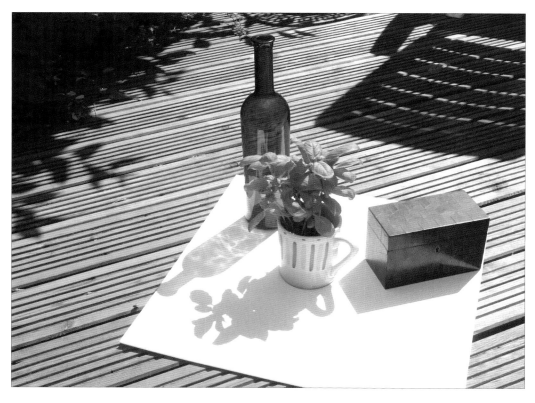

Objects against the light
Being simple geometric shapes, the box and the bottle throw shadows that can be easily predicted but the more complex shadow of the plant's leaves can only be drawn from observation.

1. Shadows from posts

This diagram shows how the shadows of vertical posts diverge from a point on the horizon vertically below the sun position. Light rays from the sun (orange lines) define the length of these shadows.

High sun and verticals

Theory says that the shadow lines in this photograph should meet at a point on the horizon; in fact, they don't, as you will see if you try drawing them. Why is this so? The reason is that the path is not precisely flat and horizontal; it slopes down towards the gutter and therefore becomes a rising plane upon which, as we have seen (chapter 6), horizontal parallels vanish to a new, raised HL.

2. Horizontals added

The positions of the horizontal and the diagonal rails are found by projecting the sun's rays through the intersection points of the middle and diagonal rails onto the shadows of the vertical posts. Note that horizontal shadows vanish to the same point as the rails themselves.

1. With colored pencils establish the main framework of the items and their shadows. Follow a few construction lines through to indicate the position of the sun and the main, right hand VP. As the bottle is tapered towards its base its vertical outline is not a true vertical and the outlines of its shadow are also tapered and do not converge on the VPS. A line drawn through its center would, however.

2. With appropriately colored pencils continue the drawing by defining the shapes of the main three items of the still life. Observe how, in this overhead view, three-point perspective (see chapter 4) comes into play with the lower VP well outside the bottom of the picture.

3. Sharpen the edges of the shadows and start adding areas of colored tone. Add the striped patterns of the decking which converge on their own VP, also well beyond the picture's edges.

4. Continue adding color shading to intensify the hues in this strongly contrasting contre-jour image. When adding color be constantly aware of the underlying perspective structure as indicated by the converging verticals of the patterns on the mug. Blend colors together to achieve a wider range of hues.

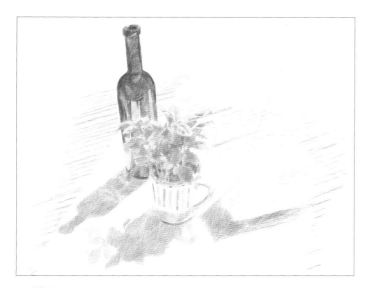

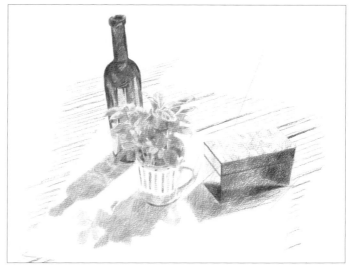

5. With a selection of blue crayons concentrate on drawing the bottle, observing the nuances of translucent color effects. With colored pencils dense shades have to be built up slowly in order to achieve a chromatic intensity. When completing the drawing of the bottle take care to make the ellipses narrow vertically as they rise up the bottle (see pages 86–89). With a light shade of blue color the bottle's shadow and the mottled effects of light through glass. Complete the shadows of the mug and plant and the box, both of which are nearly as richly colored as the bottle's shadow.

6. Using a mix of brown and blue pencils shade the wooden box. Its highly reflective surfaces throw up a number of reflections including that of the cast shadow on the left-hand side of the box and the right-hand corner. Notice how, when drawing the geometric pattern on the top of the box, its regular shapes follow the lines of convergence towards the two VPs on the invisible horizon.

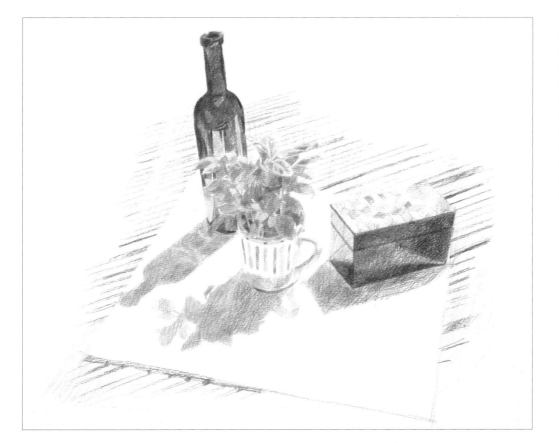

7. Delete any remaining construction lines. Begin to complete the drawing by adding a tone of light gray over the area of decking, throwing the white surface on which the still life is placed into sharp relief. Finally, work over the whole drawing with a range of pencils sharpening up line work and defining edges as necessary.

Sun behind the observer

When an object is lit from a sun position behind you, it will cast a shadow away from you towards the horizon.

If the sun is directly behind you, the observer, the shadow of an object positioned exactly in front of you will vanish to your center of vision on the horizon, the CV, as will your own shadow. Any deviation from this precise position behind you will place the vanishing point of the shadow (VPS) to one side or other on the HL, just as in the previous project, except that now the shadows vanish towards the VPS instead of away from it.

As before, the length of the shadow depends on the height of the sun but, this time it is determined by a point vertically below the VPS to be called the vanishing point of the sun's rays or VPSR (see diagrams opposite).

This point will be only a short distance below the VPS if the sun is low in the sky and an increasingly long distance below as the height of the sun increases. Lines from the top edges of all objects converging on this point and intersecting the vanish lines towards the VPS, will define the length of their shadows.

To discover the shape of a shadow thrown by a less regular object it is first necessary to descend verticals from points on its edges down to the ground plane. Lines from these ground points are drawn towards the VPS and lines representing the angle of the sun's rays projected through the edge points. The intersection points will represent the shadow shape (diagram 2).

It is important to remember this principle of dropping verticals to the ground plane before projecting the contact points to the VPS, as this is the only way to define shadows of features that have no direct connection with the ground.

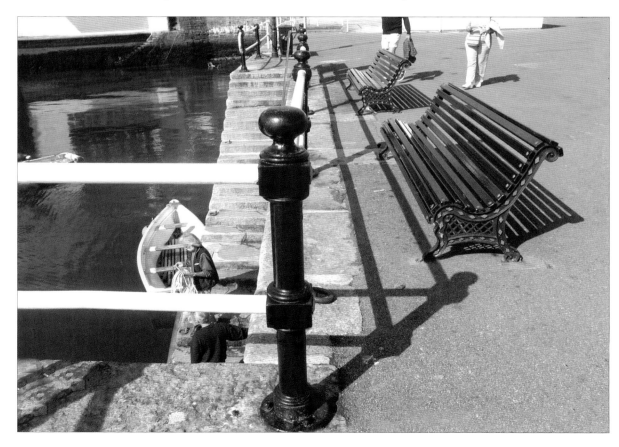

Pier railings and seats
In this quayside scene a high summer sun positioned behind the viewer's left shoulder casts short shadows at an approximate angle of 45 degrees.

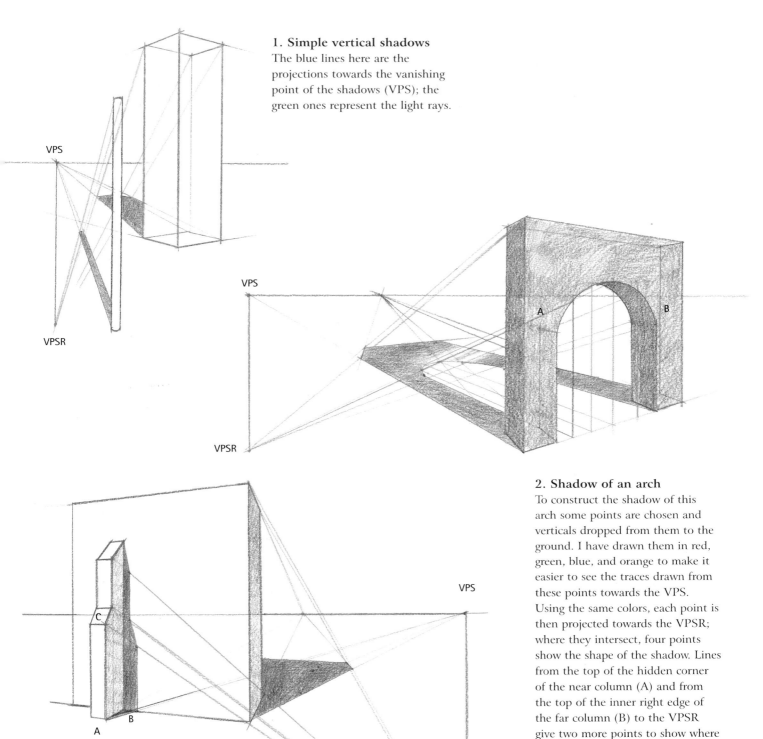

1. Simple vertical shadows
The blue lines here are the projections towards the vanishing point of the shadows (VPS); the green ones represent the light rays.

2. Shadow of an arch
To construct the shadow of this arch some points are chosen and verticals dropped from them to the ground. I have drawn them in red, green, blue, and orange to make it easier to see the traces drawn from these points towards the VPS. Using the same colors, each point is then projected towards the VPSR; where they intersect, four points show the shape of the shadow. Lines from the top of the hidden corner of the near column (A) and from the top of the inner right edge of the far column (B) to the VPSR give two more points to show where the curve of the arch shadow begins and ends. For more complex shapes any number of points can be chosen and projected in the same way.

3. Shadow of a buttress on a wall
To plot this shadow, first project a line from the base of the buttress (A) towards the VPS. Where it cuts the base of the wall at B, the shadow line is raised vertically until it is intersected by a line towards the VPSR from C which is the place where the buttress narrows. To find the other points, you need to think of the top section as a new narrower buttress. Project its edge down vertically to the floor, then across towards the VPS and up vertically from its intersection with the bottom of the wall. This is now your new line for intersection points as shown.

1. As the seat and railings in this image are parallel they converge on the same VP (There is a slight curve on the railings which has to be taken into account.) Use a 2B pencil to plot the VP. There is another VP a long way to the left of the picture but as the lines of convergence towards this are so subtle this image can be treated as one-point perspective. Lightly establish the main ellipses of the post in the foreground (see ellipses, pages 83–85).

2. As shown in the diagrams on the previous page, shadows are defined by the crossing points of lines vanishing to a VPS and a VPSR. Both VPs in this case are out of picture but they can be found quite easily. For the VPS extend the shadow line of the near bollard diagonally upwards until it crosses the HL (assessed). A second, extended shadow of a bollard will confirm this. We know that the VPSR must be on a line vertically below the VPS, so a sun ray line drawn from the top of the near bollard, past the top of its observed shadow until it crosses this vertical, will fix its position. (As many of the elements in this drawing, including the ground plane, are not geometrically perfect there will be slight undulations in all of this initial plotting.)

3. Add further construction drawing to the ellipses of the main post, starting with the most shallow at the top and working down to the deeper ones approaching the base.

4. To visually construct the seats, begin by carefully drawing in freehand the nearest seat's side support. Add the slatted seating whose lines converge on the main VP. Follow the outline of the side support at the far end of the seat, allowing for its reduction in scale. Repeat this exercise for the furthest seat.

5. Work up the detail on the seat's iron support, then establish its cast shadow. Begin by drawing the main outline and adding the light areas of the sun's rays projecting through the slats of the seat. These, of course, all converge on the main VP. Continue this on the further seat.

6. Define the steps leading down to the water from the quayside. Although these follow the general rules of perspective, allowance must be made when drawing these for their unevenness of construction. Add the main horizontals towards the top of the picture

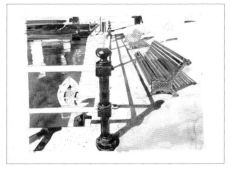

7. Complete the initial pencil stage of the picture by adding ephemeral details such as the moving figures and the small boat moored on the quayside. Elements such as these heighten the sense of depth by giving contrast of scale. Delete extraneous construction lines and work over the whole drawing, sharpening detail and adding controlled shading in darker areas, prior to adding color washes.

8. Now add watercolor washes. Make a light and fluid blue-gray mix of ultramarine and raw umber. With a medium brush float this over the whole of the tarmac ground plane. Allow this to cover the two seats (apart from their brightest highlights); the seats' darker colors can be picked out later. Use a mix of Prussian blue and viridian green to establish the color of the water. As this does not impinge on the previous wash it can be applied straight away.
Add more green to the wash for background areas in the top left of the image. Spatter the areas of stone along the quay's stone edges.

9. Mix a wash of black and ultramarine for the base color of the cast iron columns supporting the railings. Use a dilute version to paint the lighter slats on the larger seat. Work over the whole drawing adding washes to self-contained areas. Now, with a dark umber/ultramarine mix, add the cast shadows. Add the ambient shadows, too, to items such as the large column, accentuating its form.

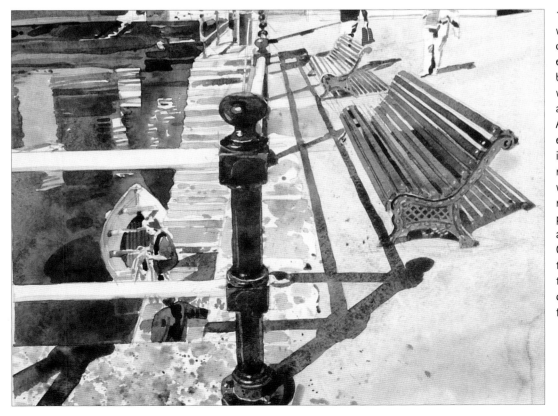

10. With a watery ocher wash daub areas of broken color over the quayside edging stones, the steps and boat. Vary the color of this wash by adding small amounts of green and blue. Add more spatter to the large edging stone in the immediate foreground, having masked the adjacent areas with scrap paper. Gradually move across the whole painting, sharpening up and adding detail where needed. Complete the painting with a touch of scarlet by adding the red focal point of the coat being carried by the figure in the middle distance.

Artificial light

Light from an electric light bulb radiates in all directions from its center so shadows that are cast by its light radiate in a similar way..

Unlike the sun, whose vast distance from the earth renders its rays essentially parallel, the relative closeness of artificial lights means that they cast shadows of surrounding objects outwards from their centers.

Although the theoretical situation demonstrated below uses a hard source of light, most artificial light sources are diffused to some extent with the resultant cast shadows having soft edges. A normal household electric light bulb radiates light from a small sphere. Other fittings come in many forms with reflectors, baffles, filters, lenses and various devices, all of which change the nature of the shadows that they throw.

A typical, modern shop interior has so many light sources that it is impossible to predict where and what shape the shadows will be, the intention sometimes being to make the lighting completely shadowless.

For the artist, however, a subject lit by a single light source with, perhaps, a certain amount of reflected light, is often the most satisfying; a single candle flame casts wonderfully sharp shadows although at a very low light level.

Single light source
Predicting the size and shape of shadows in this situation uses similar methods to those for the sun's shadows except that a point vertically below the light source, on the ground plane instead of on the horizon, is now used to find the direction of the shadows.

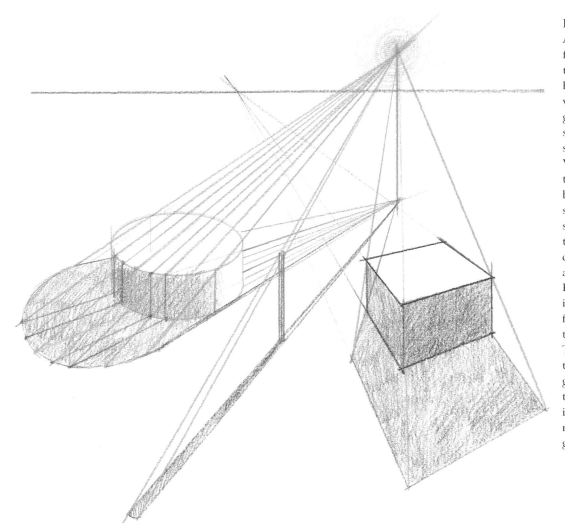

Box, pencil and drum

A position has been chosen for the light source here so that its height above the horizon and the point vertically below it on the ground plane (VPS) give a substantial but not too long shadow. The fact that the VPS is not on the horizon is the principle difference between this and the same scene in sunlight. The shadow of the drum-like truncated cylinder is calculated in the same way as the arch on page 123. First choose some points on its upper rim and draw rays from the light through them towards the ground (orange). Then drop verticals from these same points to the ground and draw lines from the VPS through them to intersect the orange light rays (blue, orange red and green). Join up the dots.

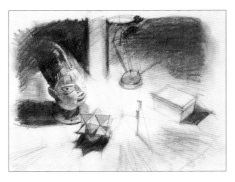

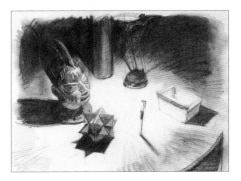

1. Using a charcoal stick, establish the point on the table's surface immediately below the light source from which the cast shadows radiate. Charcoal is an excellent medium for such a high-contrast subject. Quickly sketch in all the major items and their shadows, making sure that their edges converge on the radial point. Lightly plot these convergence lines as an initial guide. Other radial lines from the light source itself can also be added to check the further edges of the shadows.

2. Using the edge of the charcoal's point, refine the drawing by adding and heightening detail. Used judiciously, charcoal can produce very fine lines. Add patches of tone with hatching; these can be softened by blending with a fingertip. Intensify the darkest areas by building up hatching to achieve deep tones.

3. Carefully work over the whole picture, sharpening detail in tonal areas. Add more tone to the deeper shadows, building up their intensity by alternately shading with the charcoal and blending with a fingertip. Finally, carefully use the edge of a soft eraser to delete superfluous construction lines; eradicate unwanted smudges and "draw" highlights by eliminating tone. Always remember that drawing in charcoal is a combination of both addition and subtraction.

Irregular forms
Boats

Although boats evolved independently at different times and all over the world, they often share a similar hull form.

Trial and error in boat-building seems to have arrived at the best compromise between buoyancy, stability and speed of movement. Drawing the shape of boats requires very careful observation but a certain amount of logical application of perspective principles will make it easier to understand. From superficial observation the temptation is to try to depict the curvaceous shapes with exaggerated sweeping lines everywhere, often resulting in a gross caricature of the subtle reality. In fact the combined effect of a shape that is fattest at its waist but pointed at one or both ends and rising sharply at the front (bow) end and less so at the rear (stern) is often a straight line for much of its length on the far side and a more rounded curved on the near side (see diagrams opposite).

After constructing a typical boat shape a few times by using these principles you will find that the sweeping curves can be suggested by much simpler means than is at first obvious.

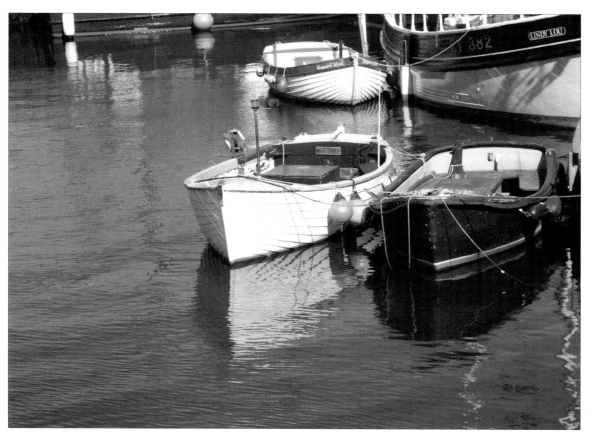

Boats at mooring
When they are moored in water boats like these are effectively flat bottomed – their shape beneath the water is normally invisible from the outside and is often obscured by flat decking on the inside.

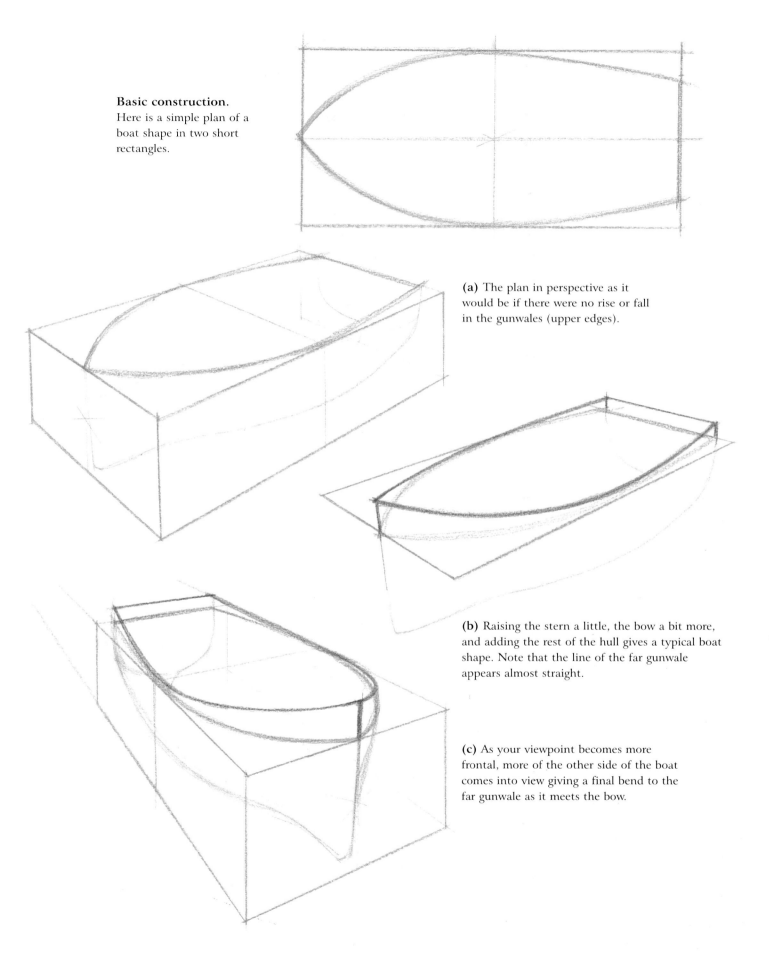

Basic construction.
Here is a simple plan of a boat shape in two short rectangles.

(a) The plan in perspective as it would be if there were no rise or fall in the gunwales (upper edges).

(b) Raising the stern a little, the bow a bit more, and adding the rest of the hull gives a typical boat shape. Note that the line of the far gunwale appears almost straight.

(c) As your viewpoint becomes more frontal, more of the other side of the boat comes into view giving a final bend to the far gunwale as it meets the bow.

1. Working with water-soluble, colored pens, begin by carefully plotting the basic outline of the nearest boat. Observe how the rising bow is pushed into a different plane to the main body of the boat's hull. Having established the drawing of the first boat repeat the exercise on the one adjacent to it.

2. Using fine mid-blue and black cross-hatching, build up areas of dark tone in the shadows between the two boats. Start lightly defining some of the rippled reflections. Using a light blue pen hatch the boat's brighter side.

3. Add definition to the gunwale of the main boat. The key to drawing a convincing representation of a small boat lies in the careful rendition of this upper edge. Carefully modify some of the hatched areas with a wet brush to give localized wash effects.

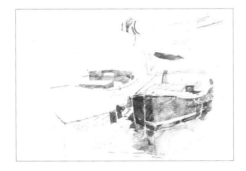

4. Add detail to the boats' interiors. Continue working into the shaded areas with the brush. The less water the brush holds the easier it is to control the spread of color; light applications of water leaves some of the underlying linear drawing showing through the washes.

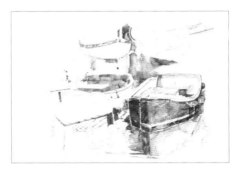

5. Now start to define the third boat by carefully plotting points on its outline as before. Establish the edge of the larger boat cropped in the top right hand side of the composition. Allow the line of the drawing to emulate the boat's graceful, sweeping curves.

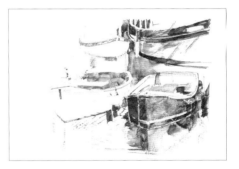

6. Work over the whole drawing, sharpening up detail. Observe and carefully reconstruct the fine, linear patterns on the sides of these clinker-built boats. Build up areas of tone on the water to start defining the semi-abstract forms of the boats. Use a wet brush, once again, to introduce patches of wash to the water's surface.

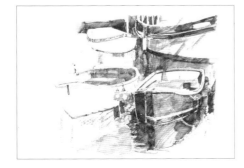

7. Using broad brush strokes, add color and shadow to the side of the largest boat. Define the drawing of the fenders hanging over the side of the hull of the nearest boat.

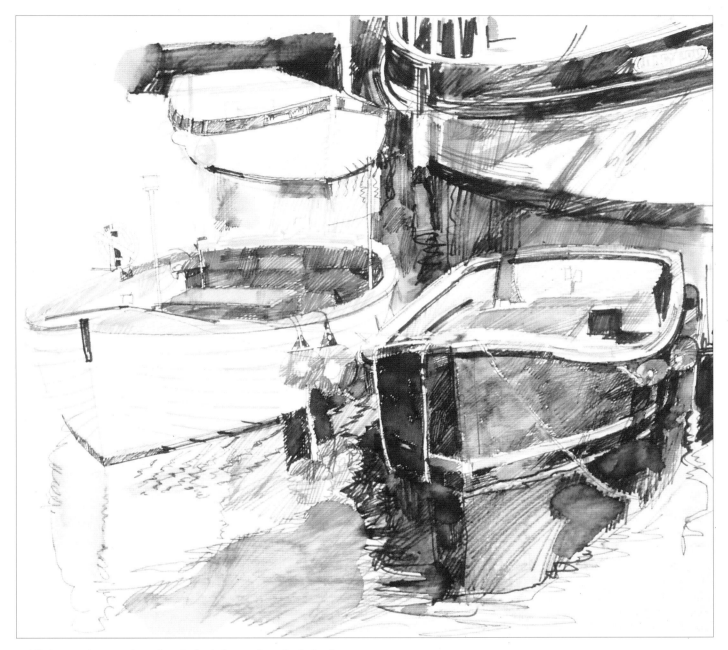

8. Work over the water's surface in both line and wash, darkening the tones and exploring the abstract patterns of the broken reflections. As the shades on the water are intensified the boats are thrown into sharp contrast. Conclude by strengthening their outlines where necessary.

Wheeled vehicle

Some motor vehicles are so near to being cuboid that they hardly qualify as irregular forms, but we are looking here at designs where curves predominate.

Because wheeled vehicles must share roads and be able to roll and steer efficiently, a basically rectangular plan is more or less universal. It is this underlying regularity that allows us to analyze its perspective and make sense of some observations that seem, at first, improbable. However, within this framework, designers have enjoyed a freedom to play with curvaceous forms that are not so readily amenable to perspective explanations.

For these variable shapes and volumes, much as with boats, you will need to combine the perspective of the regular underpinnings of the vehicle with first-hand observation of the outer form. The presence of wheels, generally placed symmetrically, gives more clues to the underlying perspective. Despite this, however, it is astonishing how often the elliptical shapes of wheels attached to vehicles are erroneously misinterpreted, even to the extent of actually not believing what can clearly be seen. The same applies to other circular forms such as headlamps and steering wheels, so, if you want to get them right, it is worth making sure that you understand the quite straightforward principles involved.

Classic sports car
A close, fairly high, three-quarter viewpoint is recommended as a suitable means of exploring and demonstrating the ellipses and the variety of their axes in this stylish vehicle.

Bicycle

If a vehicle has only two wheels, the axle of each wheel (drawn as the shorter of the pair of red lines) may be very short. But the rule still applies; the major axis of the wheel ellipse (the longer in each of the pair of red lines) must form a right angle with its axle. Do not fall into the trap of assuming that because a wheel is upright, that the major axis of the ellipse is also upright.

1. On a curved, subtly shaped object, such as this classic car, parallel horizontals are not immediately obvious. Some, such as the line through the center of the hood, may have to be guessed at intuitively. Others, such as the alignment of the tops of the small lights on the front wheel trims and other symmetrical features, will be geometrically accurate. Using a B pencil on a not-surface, watercolor paper, plot these and other parallels to establish a two-point perspective framework leading to the left and right VPs outside the picture area.

2. Continue constructing the car's outline by adding the main, fixed ellipses. Notice how, on the car's primary headlamps, which are formed from a series of ellipses within ellipses, there is a slight distortion caused by the bulge of the outer lens of the light. The axes of these lights follow the parallels leading to the left hand VP.

3. Now add the basic wheel ellipses. Because the front wheel is turned out of alignment with the car's body it will have its own independent axes. Establish these and begin drawing the form of the wheel and tire, noting how, like the lights, these are formed from ellipses within ellipses. Observe, too, how the five main spokes rise as they approach the wheel's hub whereas the subsidiary spokes are parallel to the wheel's plane. Carefully establish the front wheel arch. The rear wheel, which revolves but does not turn on its axis as do the front wheels, is parallel to the car's major planes.

4. Continue by adding further detail such as the radiator. First establish its vertical center before building further detail around this. Any pairs of features such as the housing of the headlamps, should be drawn sequentially, carefully following their shared lines of perspective.

5. As the three-dimensional form of the car emerges add other details such as the louvered vents along the hood and the leather strap which describes its shape. When adding reflections, such as those on the bumper and within the headlamps, remember that on convex surfaces the reflection is the right way round whereas in a concave surface, such as the headlamp, the image is reversed. Reflections, including those on the car's body itself, should define form, not destroy it.

6. Add the roll bar to the rear of the car. This is almost rectilinear with the top a true horizontal leading to the right hand VP whereas the sides converge slightly as they rise. It can help to plot faintly some true verticals as a guide before drawing the tapering sides. Carefully draw cast shadows such as those on the wheel trim enclosing small highlights.

7. As the pencil drawing nears completion the now-redundant construction lines can be erased. Use pencil to add tone to the darker shadow areas. Finally, define the outlines of the car's cast shadows as a guide prior to adding watercolor.

8. With a medium brush begin the coloring process by washing in a watery but sharp pink over the whole of the car's bodywork except where the few, brightest, white highlights occur. As always, when using watercolor, remember to work from light to dark.

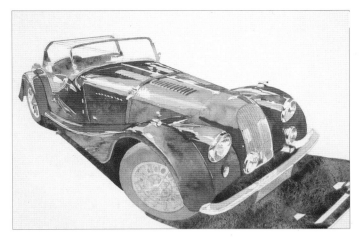

9. Use warm red to add a further wash over the car's body leaving the pink to read in light areas and around the highlights. Dilute the wash by dipping the loaded brush in water to give variety to the color's intensity. Use hard edges and tonal changes to differentiate between hard and soft reflections. Observe how the reflections compress as they approach an angled edge. Turn the painting round as you work to avoid smudging wet areas. Mix a dark wash from ultramarine and raw umber to render the deeper shadow areas, including those beneath the car. Dilute this wash slightly to add the lighter shadow in front of the car.

10. With a fluid wash of cobalt modulated with a touch of black add color to the radiator and the areas on the front and rear wheels that are in shadow. Add color, too, to the seating area and the strap over the hood. Use a cleaner, light cobalt wash to glaze the areas of reflected sky on the bumper and within the headlamps. With a blue-black mix lay down the first, mid-tone wash on the front and rear tires.

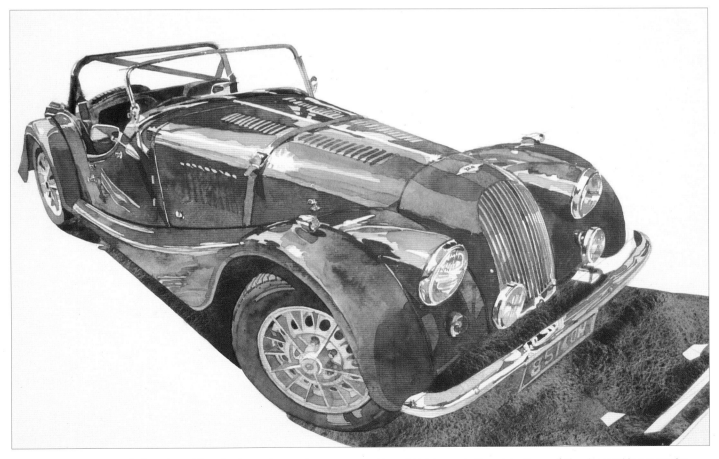

11. Heighten the image's form by adding further color washes over selected areas such as the leading edge of the main wheel housing. Sharpen elements such as the ventilation louvers on the top and sides of the bonnet. Complete the painting by working over the whole of the image and adding fine detail such as on the radiator, wheels and bumpers.

The horse

Irregular man-made forms can often be constructed entirely from perspective principles but the subtle shapes of live creatures do not conform so readily to analysis by the same methods.

When drawing forms as complex as animals and humans, it is better to observe them and to imagine boxes that could contain them than to try to arrive at their form by constructing measured containers in formal perspective. This is not to say that it would be impossible to construct them in this way, given sufficient measurements, but it would be extremely difficult and laborious compared with informed observation.

However, an understanding of the effect of recession on such forms can be gained by tracing the outline of a horse, for instance, and then imposing a grid on the outline and plotting it on a perspective version of the same grid.

It is important to understand that this has little or no direct utility in actually constructing a drawing of a three-dimensional horse: it only serves to demonstrate a two-dimensional effect. But it does show you what to expect when a horse (or any other four-legged animal), is viewed from a three-quarter viewpoint.

If the perspective is extreme, as it would be if your viewpoint was close to the rear end of the horse, your plotting will show a very large rump with the body narrowing to a small head, (or the reverse if viewed from the head end).

Viewpoints from further away will be progressively less subject to these apparent proportion changes, just as it is with buildings and other straighter sided objects.

It may seem obvious that this would be so, but it is often overlooked or underestimated.

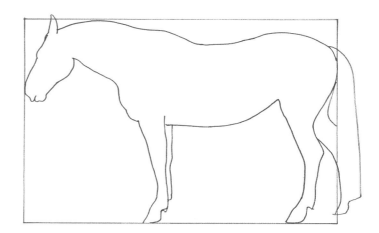

1. You will need a photograph of a horse in profile and one of the same horse, taken from a three-quarter, back view. Trace off the outline of the side view and draw a rectangle around it to tightly enclose it.

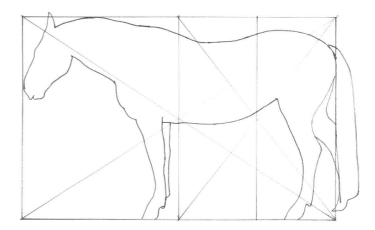

2. Draw the diagonals (yellow) and bisect the rectangle (blue). Then halve one of the resulting rectangles in the same way.

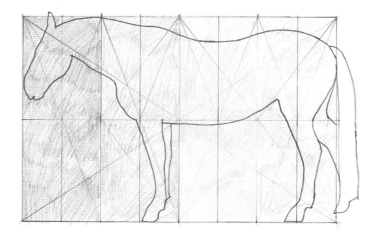

3. Continue bisecting the rectangles until you have, say, eight sections. It is not important how many sections you have; the more complex the shape, the more sections you may need to plot it.

4. Then construct a similar grid in perspective, a practice that should by now be second nature. I have colored both grids to aid plotting and to accent the recession.

5. Plot the outline silhouette of the horse onto the perspective grid in just the same way that you would plot a regular straight-sided object. Note that in this case I have left the tail and the tip of the ear out of the grid.

When you come to draw a real horse in perspective your grid projections of the two-dimensional outline show what you might expect in terms of size recession but, as I have said, you will need to make most of your drawing from observation.

The following exercise is based on a photograph taken from a position close behind the horse and, consequently, shows quite extreme perspective recession.

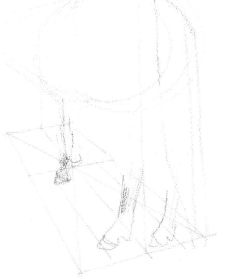

1. Although it is likely, as here, that your horse will not have its hooves placed symmetrically, a guess can be made about where they would be by reference to your original tracing. Your photograph may give some indication of the position of the horizon and lines through the hooves will point to the nearest VP.

2. I must stress again, from now on, that the drawing must proceed primarily from observation and judgment of proportion whilst being constantly aware of the laws of perspective recession learnt from previous projections. To this end you may find it useful to suggest the barrel-like form of the horse's body as I have here – a loosely defined, receding cylinder.

3. As you continue to construct the body of the horse over the feet that you previously established, it will not surprise you to see that the rump occupies a much larger area than the long body and that the neck and head are very small.

4. As the drawing of the horse's form is solidified the distortion of its proportions appears both acceptable and convincing.

5. Check the accuracy of the drawing by running some major parallels through to its main VP, making any adjustments as necessary. Finally, complete the drawing by color rendering the whole of the image, allowing the lines of shading to follow, and describe, the horse's bulky form.

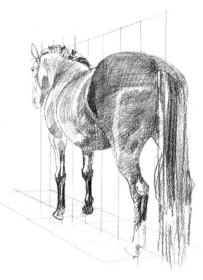

Extreme, three-quarter front view
A viewpoint from the other end of the animal completely reverses the distortion, of course. From a close position the head becomes very dominant, in this case almost unbelievably so, and the rear quarters, correspondingly, much smaller.

Less extreme, three-quarter back view
By moving away from a view position close behind the horse, a less extreme perspective is revealed, as can be seen on the upright grid and ground plan. The rump is still large but not so dominant, the body does not obscure the forequarters, and the head and neck are less diminutive.

Less extreme, three-quarter front view
As with the three-quarter back view, moving to a viewpoint a little further away makes the apparent recession less extreme, the head becoming a more "normal" size in relation to the rest of the horse.

Human form 1

As with the previous subject in this section, drawing the human form in perspective is more a matter of being conscious of its existence in a three-dimensional grid than of trying to construct it from the use of vanishing lines and points.

It is possible to build a grid that contains sufficient predetermined points of reference which, with use of a computer, can produce a convincing representation of a figure in space in an almost infinite variety of positions. Film animators now use such systems. The calculations necessary, however, are formidable and the results, although impressive, are often very formulaic and lacking the subtlety of real human figures.

So, although the human form is no less subject to the laws of perspective than a box or a building, the lack of straight lines and regular sided forms makes it virtually impossible to deduce from perspective rules exactly how its form will appear in space. The same applies to drawing other animals but it is even more the case with human

figures and faces because, for most of us at least, the slightest variation between what is seen and the drawn image is so instantly obvious.

We are constantly seeing people in different positions, in varying situations and changing light conditions and subconsciously extrapolating their "normal" shape from the "distortions" due to perspective.

The surest way to draw the objective reality of the infinitely diverse shapes that human figures can present, is to observe and use whatever patterns and correlations you can find between the observed forms and simple perspective concepts, one of which is the sense of enclosure within a geometrical volume which is subject to perspective laws.

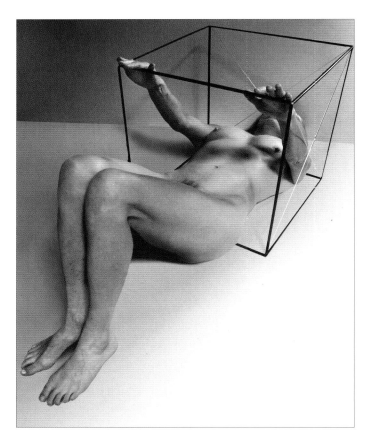

Prone figure with cube
It is rather too much to expect everyone to have an open cube available when drawing a human figure but, since I did have such an object, used in earlier demonstrations, I posed the model partially inside it to show the effect of an imaginary enclosure in assessing the perspective effect.

The enclosing box
Visualizing a box around an irregular form is rather like imagining the block of stone a sculptor would need to carve a figure. It will contain the form but also contain areas of space which must be removed. Producing a mental image of the first big pieces that the sculptor would need to eliminate in "roughing out" helps us to see the way the figure sits in its virtual box.

1. Using a selection of Conté pencils, here a pale green one, the structure of the metal grid was drawn and extended conceptually to enclose most of the posed model's form.

2. With a mid-blue pencil establish the model's basic shape. Draw in the diagonals on the side areas of the frame and use these to evaluate the position of the arms.

3. With a dark pink pencil plot the position of the buttocks, shoulders, head, chest, and feet. All of these elements, apart from the feet, which are at a slight angle to each other, are symmetrical.

4. Using the pink again begin drawing into the model's shape, softening and defining the form. Observe how, as detail is added, such as the elbows and ankles, the lines of symmetry are sustained.

5. As the drawing progresses use more naturalistic colors, such as sanguine, to give a sense of realism to the drawing. Start adding detail such as the toes and begin areas of light shading to express form. Keep all of the drawing simple, however, whether linear or tonal.

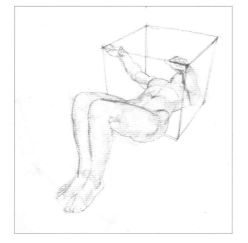

6. With an orange pencil build up lighter tonal areas on the figure establishing the major planes of the form. As the drawing of the figure progresses the original imagined grid becomes obscured. The actual grid, which the model is using to steady her arms, is now redefined with charcoal. Use the sanguine again to sharpen areas of the upper body and define the arms

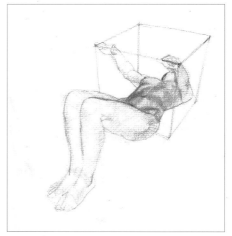

7. With a Naples yellow pencil, build up and solidify areas of tone on the chest and abdomen. Use the sanguine to strengthen areas of under-drawing that may have become obscured by later rendering. Use blue to add cool, tonal shading to the shadow areas.

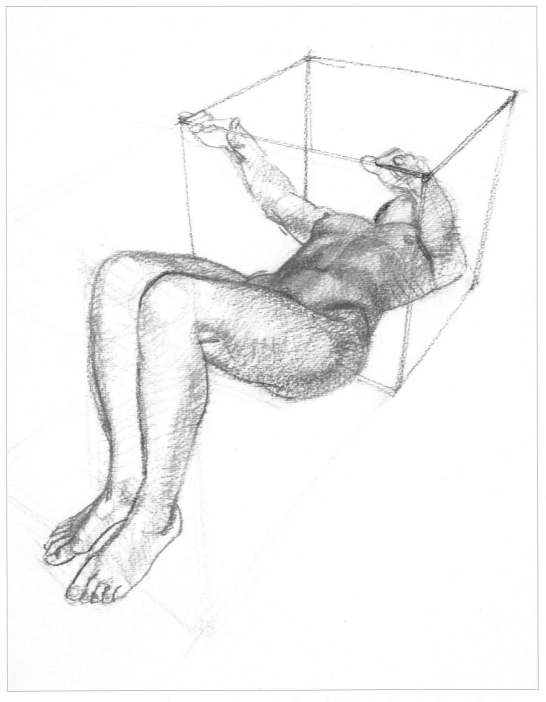

8. Add finishing details, blending tonal areas into each other to solidify the form. Finally, redefine the linear drawing where needed, giving greater strength to the lines furthest forward in the picture plane to emphasize the sense of depth.

Human form 2

Looking down on a standing figure from a high viewpoint, the perspective effect becomes inescapable.

For this project I positioned the model to be as near as possible to a diagonal plane across an open upright box. The two upright panels have been divided horizontally into six equal parts. The pole across the model's shoulders forms a diagonal at the fifth level and in the diagram I have joined all the other levels with orange pencil to define this plane. Note that the model's navel is nearly in line with the third level, representing the halfway point in the height of the model, as is often the case in an adult figure.

Standing figure from above
The half box around the model serves to demonstrate the downward recession. Without it, the degree of foreshortening due to the extreme perspective view would be revealed by measuring.

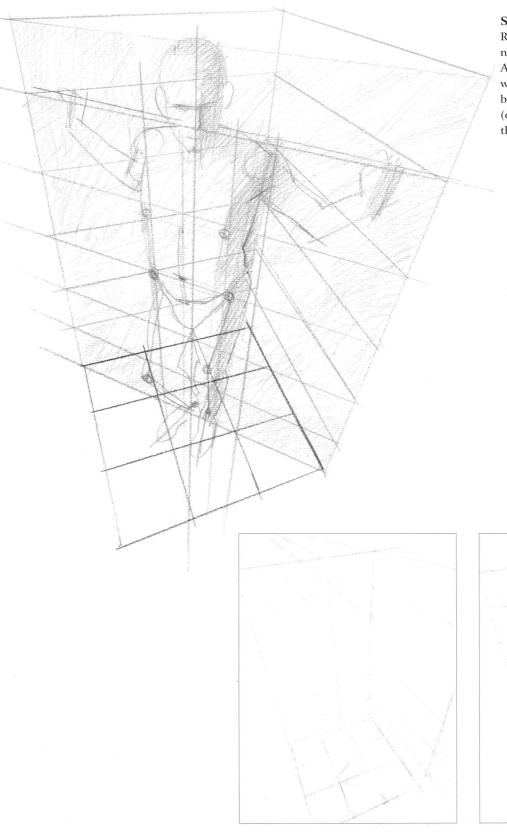

Standing figure in a halved box
Red circles mark salient points at nipples, hip bones, knees and ankles. All except the knee points are in line with the diagonal levels across the body. The model's bent right knee (on the left in the image) projects it through the plane.

1. With a bold use of charcoal establish the floor grid and upright panels within which the model is posed.

2. Drawing the pole over the model's shoulders shows his positioning across the diagonal; this line can be repeated through the torso and even across the front of the feet.

3. Now make the preliminary marks to position the head. It is not necessary to concern yourself with the main body outline at this stage – just try to find the lines across the body at the shoulders, chest, and hips. Note, that as a result of the bent knee, the line joining the kneecaps is not parallel with the others over the body.

4. Now start solidifying the body, trying to show how the upper torso slots into the hip structure.

5. From such a high eye level the whole length of the foreshortened legs is only a little more than half that of the torso. Keep checking these dimensions – they are important in accurately conveying the sense of downward perspective.

6. When adding the arms and hands take note of the fact that they lie in the same diagonal plane as the front of the torso. As horizontals on this plane vanish to the left, the arm and hand on the right appear much larger than those on the left.

7. As the drawing proceeds, try not to become too involved in superfluous detail. Instead, try to make sure that every mark contributes to the sense of form and space.

8. Adding tone on the panel behind the figure and indicating the cast shadow on the floor and the right-hand panel helps to clarify the space containing the figure. The dark background also heightens the sense of drama.

9. Finishing the drawing is not just a question of copying all the tones that you can see; use tone and line to clarify form as best you can. For example, I have applied more tone than actually exists on the left side of the model's chest to emphasize the central plane of the torso. Also, the use of a strong line around his right shoulder (on the left in the drawing), puts it in front of the upper arm, while the outline has been omitted entirely on the left side of the midriff where I wanted the abdominals to come forward.

Atmospheric perspective

If one considers perspective, in the broadest sense, to apply to all visual devices that contribute to the illusion of depth, then atmospheric recession – or perspective – must be included.

We live in air and view the world through the myriad particles of which it is both made up and contains. The greater the distance between an observer and object, the more atmosphere the reflected light has to travel through before the observer can see it. This tends to render distant objects paler in tone and color than near ones. The passage through atmosphere has an effect on the saturation of color too, vivid foreground colors gradually being transmuted to shades of blue and mauve as distance increases. Weather conditions obviously affect the levels of transparency and clouds themselves contribute to the sense of recession as they recede to the horizon.

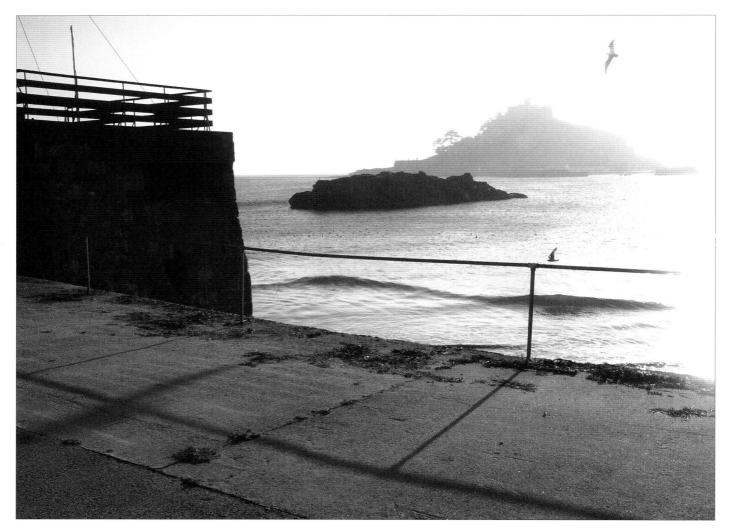

Looking into haze
Because this photograph was taken looking into the sun, the shapes are silhouetted
and the hazy atmosphere increasingly lightens the silhouettes as they recede.

Clouds in perspective.
Clouds are, by their very nature, amorphous and irregular but
they often have a clearly discernable common base forming a
platform on which large overhead details become smaller as they
near the horizon.

1. Lightly draw the basic elements of the scene in pencil. The
essence of the final image will rely on the subtlety of the
watercolor washes so the pencil line should be kept deliberately
light so as not to dominate the later color technique.

2. Use a mop brush to cover the whole of the drawing with an
very dilute wash of light blue. Turn the paper upside down and tilt
the board, with the top of the image at the base, to allow the fluid
pigment to collect here and give a slightly darker, gradated tone.

3. When the first wash is dry use a fine brush loaded with a dilute gray/blue mix to add another wash over the shape of the island. Rock the board gently from side to side and back to front to spread the liquid paint evenly over its shape and strengthen the outline.

4. Add a slightly darker tone to the harbor walls in front of the island and a gradated tone to the left hand side, furthest from the sun. With a medium brush lay broad horizontal strokes over the sea using a clear blue wash. It is not necessary, at this stage, to paint around the dark, rocky outcrop, simply work over it. Observe how the sea, like the island, becomes lighter on the right as the sun's rays dilute its color. When the sea wash is dry add the dark tone to the rocks in a similar manner to painting the island.

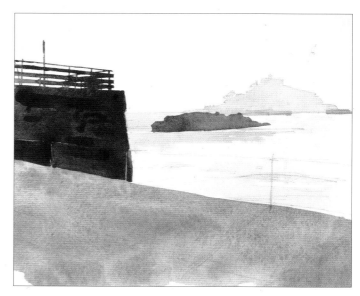

5. Use a large mop brush to lay down a dark blue/gray area of color over the vertical harborside and the high wall to its left.

6. With a fine brush use a mix of ultramarine and raw umber to paint the railings on top of the high wall. Add a dark glaze to the wall over the earlier wash. Always keep some translucency even in the darkest washes of watercolor; a very dense black will look dead and unreal.

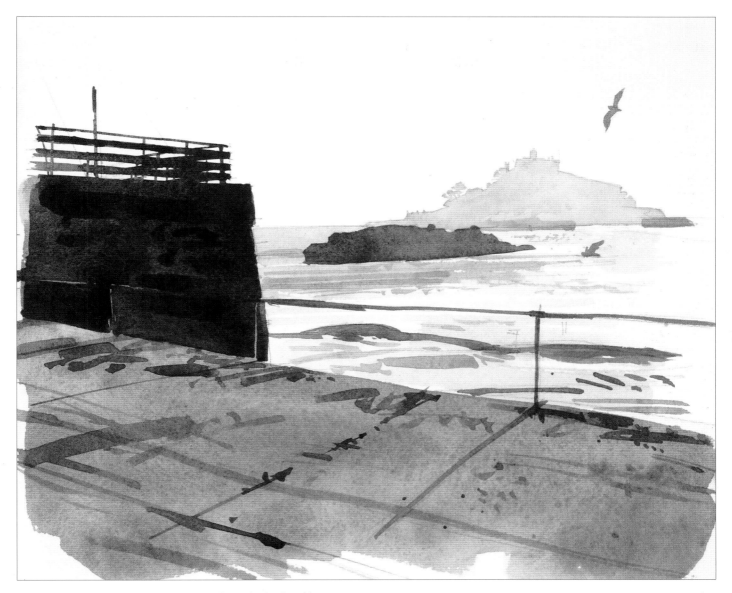

7. With a fine brush now add such details as the harborside railings, the gentle waves close to the foreground and the harborside itself. As a finishing touch add a little spatter to the paving to give an impression of texture.

Anomalies

From time to time you may encounter perspective situations that are slightly puzzling; here are a few with their explanations.

Strange shadow

This photograph shows a light and shade situation which at first sight looks a little odd. I spotted it in a neighbor's kitchen where two work tops met in a corner. The tops were illuminated from above by strip lights situated beneath the wall units. You may wonder, as I did, what caused the sharp-pointed triangular shadow. The answer is quite simple if you consider the situation in two halves. Look at the two illustrations below.

With both sets of lights switched on, as in the photo, both unit fronts are lit except for the two triangular cast shadows which combine to make the top-pointed large triangle of shade seen in picture 1.

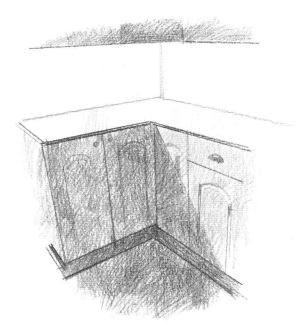

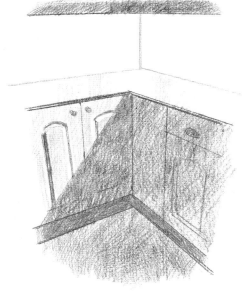

Left-hand light on
If the light over the left-hand work surface is switched on and the right-hand one is switched off, the left-hand units are shadowed and a cast shadow is thrown by the worktop across the otherwise fully illuminated right hand unit fronts.

Right-hand light on
When the situation is reversed the right-hand units are in shadow, the right-hand light illuminating the left-hand units except for the slanting cast shadow of the edge of the worktop.

A confusing roof line

This is my version of a drawing that a student was making of a group of buildings in France.

Just the roof to draw

At this point, the student perceived, quite correctly, that the roof of the topmost building was pitched upwards from the near gutter edge. This prompted her to believe that the line of its edge was rising at an angle as indicated (in blue). But the tiled surface of the roof was not visible. How could this be? Careful lining up against a pencil showed that the line should slope downwards a little (red) but now the roof looked to be flat.

Making the pitch

Adding the side windows, sloping steeply downwards to the vanishing point on the very low horizon, instantly and surprisingly transformed the slightly downwards sloping roof line into the edge of a rising single pitch.

Try drawing the windows in yourself – the vanishing point I used is marked in red on the main sketch.

This gives the clue as to why the single pitch was initially recognized; the observer's brain took in all the salient facts, including the extreme angle of the side windows and without conscious reasoning "saw" the reality of the rising roof. When it came to drawing the building, the same observer tried to reason it out piecemeal and without all the features in place it didn't seem to make sense.

Imperfect infinite regression

This seems to be a classic infinite regression where an image is reflected in a mirror which, in turn, is reflected in a facing mirror with the repeated reflections stretching to infinity. In this case the images should line up within straight vanishing lines to one shared vanishing point.

But the images don't line up as they should; the lines that link the reflected images are curved upwards as they regress further into the mirror. The reason is, of course, that the two mirrors are not exactly parallel to each other, one is tipped forward slightly. If they had been angled to each other in the other plane the regression would have been curved laterally.

Repeated reflections
Although subtle, the curving lines of recession can be seen in the photograph. Drawing these lines over the image, as in the diagram above, would verify this.

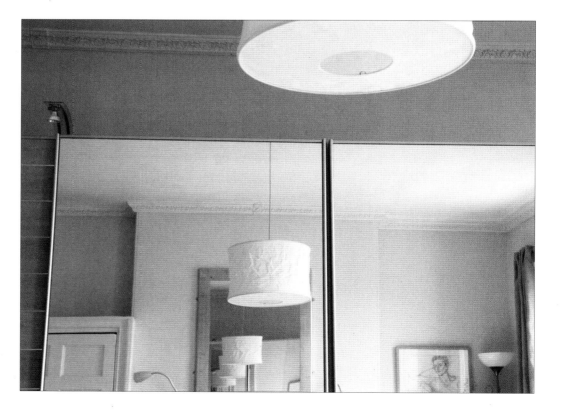

Acute-angled corner

I have used this example elsewhere, but I believe it is interesting enough to bear repeating.

The building is in Brisbane, Australia. From most frontal viewpoints it appears to be a façade with nothing behind it.

A three-quarter front view
The projecting canopy on the ground floor reveals a left-hand VP and the façade features indicate a distant right-hand VP. But where is the left-hand, side wall?

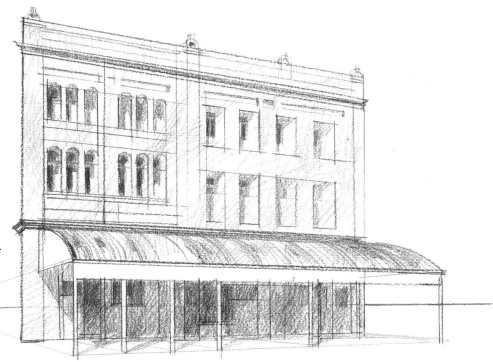

Plan view
I have drawn an estimate of the plan of this building, which accounts for the hidden wall. The orange triangle represents the part missing from what would normally be expected. Of course it is not possible to be sure whether the plan is exactly correct but the fact that there is an acute angle between the front and left-hand side wall is certain.

Corner view
Only when the viewpoint changes sufficiently to be able to see around the near corner can the bulk of the building be seen behind the façade.

Again, the orange triangle and lines show where a more usual right angled wall would have been.

Index

A

animals
 horse 136-137
 human form 24-25, 140-147
arched bridge 92-95
artificial light 126-127, 154
atmospheric perspective 148-151

B

boats 128-131
bowls and mugs 88-91
bridge 92-95
buildings
 acute-angled building 155
 cathedral 76-79
 cottage 48-51
 French house 153
 grand 52-55
 the Mall 30-33
 multi-sided 56-59
 skyscraper 72-75
 tall building 68-71

C

camera lens
 fish-eye 7
 telephoto 11
 wide-angle 11
 zoom 11
canal scene 34-37
cars 132-135
cathedral interior 76-79
center line of sight (CLS) 23
center of vision (CV) 14
changing viewpoints 10-11, 155

circles 83-95
 circle segments 87
cone of vision 6, 7
 checking 38-39
cottage 48-51
curvature of the earth 8-9
cylinder 86, 92, 109, 127

D

depth, measuring 21, 23, 46
distortion 6-7, 10

E

ellipses 83-95, 132, 133
eye level 16, 17
 establishing 12
 finding hidden 12-13
 high 12, 16, 17, 18, 72
 low 12, 16, 17, 18, 68
eye level line (see horizon line)

F

fish-eye lens 7
focal length 11
foreshortening 10

G

grand building 52-55
ground line (GL) 14
ground plane (GP) 14

H

halving by diagonals 21-22
hexagons 56
horizon 8, 9, 12
horizon line (HL) 12, 20
 establishing 12, 16-18
horse 136-139
human form 140-147

I

inclined planes 96-107, 117
interiors
 cathedral 76-79
 kitchen 26-29, 152
 staircase 104-107

K

kitchen interior 26-29

L

lake and river 112-115
landscape
 arched bridge 92-95
 bench 124-125
 boats 128-131
 canal scene 34-37
 downhill street 100-103
 lake and river 112-115
 trees and columns 30-33
 uphill street 96-99
lighting
 artificial 126-127
 sunlight 118-125

single source 126-127

lines

 converging 6, 15, 16, 17, 18, 20, 52, 64, 66, 76, 117

 curved 6, 7, 9, 129, 154

 diagonal 21-23, 31, 46, 47, 48, 66, 76, 86

 horizontal 6, 12, 13, 19, 20, 22, 24, 45, 48, 52, 81, 86, 119

 parallel 15, 22, 52, 117

 straight 6, 154

 vertical 10, 18, 19, 23, 24, 44, 45, 47, 48, 64, 80, 82, 119, 122, 123, 127

M

major axis 83, 84, 86, 87, 88, 92, 93, 133

measured perspective 9

 one-point 38-43

 three-point 80-82

 two-point 60-63

measuring depth 21, 23, 46

measuring point for the center of vision (MPCV) 40, 60, 62

measuring points 40, 60-61, 80

minor axis 83, 84, 86, 87, 93

mirrors 108, 116, 154

multi-sided building 56-59

O

octagons 56

one-point perspective 9, 16, 19-43

 measuring depth 21, 23

 creating a space 22-23

 photographic example 44

placing objects in space 24-25

 setting up 20

orthogonals (see also perspective vanishing lines) 9, 15

P

parallel perspective (see one-point perspective)

pentagons 56

people 24-25, 140-147

perspective

 interpretive 26

 predictive 26

 terms 12-18

 theory 6-11

perspective vanishing lines (see also orthognals) 13

photographic examples

 angled mirrors 117

 arched bridge 92

 atmospheric perspective 148, 149

 boats 128

 bowls and mugs 88

 canal scene 34

 cathedral interior 76

 circle center 93

 circles and ellipses 83

 converging lines 117

 cottage 48

 distortion 10-11

 downhill street 100

 fish-eye lens distortion 7

 grand building 52

 human form 140, 144

 mirrors for self-portrait 116

 multi-sided building 56

 one-point perspective 19

 reflections on inclined plane 117

reflections on mirror 108, 109, 154

reflections on water 112

repeating reflections 154

shadow anomalies 152

shadows from artificial light 126

shadows from sun 118, 119, 122

skyscraper 72

staircase 104

tall building 68

telephoto lens view 11

three-point perspective 64

two-point perspective 44

trees and columns 30

uphill street 96

viewpoint 10-11

wheeled vehicle 132

wide-angle lens view 11

picture plane (PP) 13

prime horizontals 22-23, 35

R

receding size 8, 10-11

reflections 108-117

 repeating 154

rising plane 48-49, 81, 119

roof line 153

roofs 48-49

S

scale 20, 23

segmenting a circle 87

self-portrait 116

setting up perspective

 one-point 20

 three-point 65

 two-point 45

shadows 118-127

 anomalies 152

skyscraper 72-75

staircase 104-107

still life 126-127, 120-121, 108-111

 bowls and mugs 88-91

street

 downhill 100-103

 uphill 96-99

sunlight 118-125

T

tall building 68-71

tall ship 9

three-point perspective 9, 18, 64-82

 photographic example 64

setting up 65

trammelling 84

trees and columns 30-33

two-point perspective 9, 17, 44-63

 creating space 46-47

 measuring depth and height 46

 photographic example 19

 placing objects in space 47

 setting up 45

V

vanishing point (VP) 6, 8, 15

 theoretical 8

viewfinder 13

viewpoint 6

W

wheeled vehicle 132-135

Acknowledgments

Nicky Guest, without whose invaluable participation this book could not have been written. Nicky has for many years taught the theory and practice of Perspective, together with drawing, computer studies, information technology and other specializations at the Arts Institute at Bournemouth, in the UK. Her knowledge in the field of perspective goes well beyond the level that has been required for this book and certainly well beyond mine. All the text and drawings for the "difficult" pages were contributed by her as well as most of the theoretical general principles in the first two chapters.

Photograph and drawings on pages 76–79 were taken with the kind permission of the Chapter, Truro Cathedral.

About the author

John Raynes is a practising artist and an experienced teacher of art to students of all levels. He has written a number of highly successful books on drawing and painting, including *The Figure Drawing Workbook, Drawing and Painting People, The Complete Drawing Course* and *The Complete Watercolour Course*. With these books, John is the only author to have been awarded the prestigious Artist's Choice Practical Art Book of the Year Award three times. John lives in Cornwall, UK.